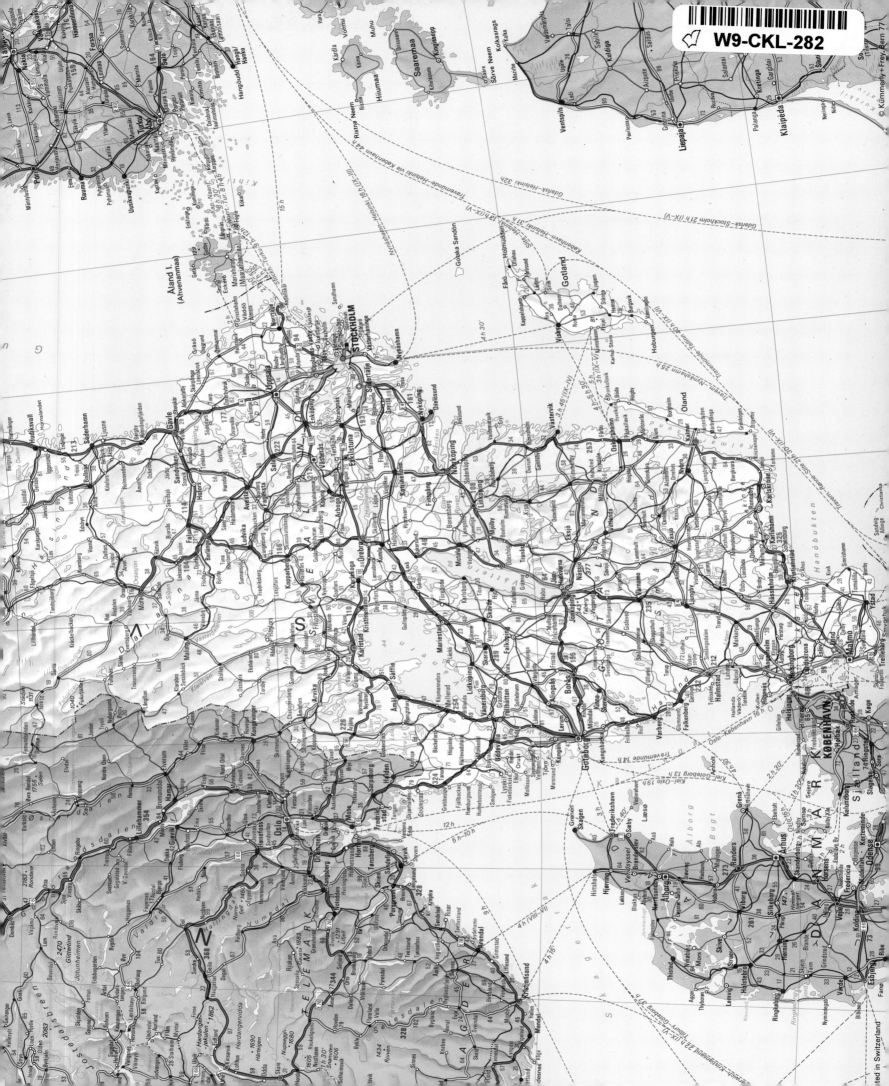

Sweden

Sweden

Walter Imber Wolf Tietze

Joseph J. Binns, Publisher, Washington-New York

Bibliography

Aario, L.: Waldgrenzen und subrezente Pollenspektren in Petsamo, Lappland. Helsinki 1940

Ahlmann, H.W. et al., ed.: Norden i text och kartor. Stockholm 1976

Ahlmann, H.W. et al., ed.: Sverige, Land och Folk, Stockholm 1966

Ahlmann, H.W. et al., ed.: Sverige nu, 2nd edn. Stockholm 1961

Atlas över Sverige. Stockholm 1953–1971

Broensted, J.: Die grosse Zeit der Wikinger. Neumünster 1976

Bylund, E. et al., ed.: Ecological Problems of the Circumpolar Area. Luleå 1974

Eriksson, G.A.: Bruksdöden i Bergslagen. Uppsala 1955

Falk, T.: Urban Sweden. Stockholm 1976

Franzén, A.: Das Kriegsschiff Vasa, 3rd edn. Stockholm 1966

Gullers, K.W. and Trentner, S.: Gamla Stan. Stockholm 1953

Gullers, J. and Gullers, K.W.: Jul. Stockholm 1957

Helmfrid, S.: Östergötland «Västanstång». Studien über die ältere Agrarlandschaft und ihre Genese. Stockholm 1962

Hultén, E.: Atlas över växternas utbredning i Norden. 2nd edn. Stockholm 1971

Larsson, L.: Sverige–ett år. Uddevalla 1968

Liljequist, G.H.: Meteorologi. Stockholm 1962

Lindgren, G.: Falbygden och dess närmaste omgivning vid 1600-talets mitt. Uppsala 1939

Lundquist, M., ed.: Det moderna Sverige. Stockholm 1969

Magnusson, N.H. et al.: Sveriges geologi. 4th edn., Stockholm 1963

Manker, E.: De svenska fjällapparna. Stockholm 1947

Nummerdal, A.: Stone Age Finds in Finnmark. Oslo 1929

Roberts, M.: Sweden as a Great Power 1611–1697. London 1968

Ruong, I.: Studier i lapsk kultur i Pite lappmark. Uppsala 1943/44

Schefferus, J.: Lapponia. Frankfurt 1673

Sömme, A., ed.: Die Nordischen Länder. 2nd edn., Braunschweig 1974

Stenberger, M.: Vorgeschichte Schwedens. Neumünster 1977

Svärdström, S.: Die Bauernmalerei in Dalarna. Stockholm 1957

Vorren, Ø. and Manker, E.: Die Lappen. Braunschweig 1967

William-Olsson, W.: Stockholm. Structure and Development. Uppsala 1961

English translation by Ewald Osers

Revised from the Swedish by Astrid Witschi-Bernz

Graphical presentation Kümmerly + Frey, Berne
Cartography, photolithography and offset-printing:
Kümmerly + Frey, Berne
© 1979 Kümmerly + Frey, Geographical Publishers, Berne
Printed in Switzerland ISBN 3-259-08363-5

Published in the United States 1979
ISBN 0-89674-004-8

Contents

18 Nature and Structure of the Country

46 Flora and Fauna

66 The Swedish State

90 Sweden's Population

106 The Lapps

122 Swedish Life round the Year

151 Rural Settlements

170 Urban Settlements

176 Culture—Education—Politics

206 Sweden's Economy

The country of Sweden, a part of Europe, is of considerable size—and is often underestimated in this very respect. It provides the Swedish people with a lot of space, a lot of elbow room. It is hardly surprising, therefore, that the well over 8 million individuals, though at times they live tightly crowded together, strike other Europeans as loners. They swarm out into the vast silence of their forests, they do not fear the solitude of the rocky mountains, and they love the cool water of their lakes and coasts. Living amidst the nature of their country is in fact part of this nature of the Swedish country and of the Swedish way of life. This unrolls in a small circle of friends or within the family. Each individual tolerates the other. His peculiarity is not questioned. Conformist behaviour is not demanded and, perhaps for that reason, is the more readily offered. Each Swede enjoys equality with his fellow citizens.

Temperamental arguments with one's neighbour are the exception. The harmony that exists between them and their domestic environment also characterizes their attitude to time and its passage. Haste is avoided but punctuality is appreciated.

This peaceability by no means results in monotony of perfection. The open-mindedness towards the outside world which the Swedes have achieved, certainly in the present century, with the total urbanization of their way of life is enjoyed with calm self-assurance. They permit themselves, both as individuals and as groups, and indeed as a whole nation, the luxury of new scales of values or at least of experiments with them. In doing so they find their own paths, judging them by their own yardsticks. In spite of all transformations they remain what they are—Swedes.

This constancy in development has something fascinating about it. Tolerance as the lubricant of Swedish co-existence is made particularly pleasant by two widespread qualities—humour and taste.

They bring uninhibited cheerfulness into social contacts and guard them against excessive demonstrativeness. In economic life they ensure achievement through reliability and quality. They invest Swedish everyday life with cordiality and common sense; they make its elements practical or attractively purposeful.

Toleration, a sense of humour and good taste also prove excellent helpers in the education of children and the self-education of adults. All three characteristics leave their imprint on the Swedes' deliberately enjoyed leisure. They set suitable yardsticks for every age and provide a sure sense of form, colour, meaning and sound, in other words, for artistic and musical creativeness. That, too, is part of the Swedish way of life without the ambitions of genius or for world records in sport. The observer will find his effort to understand this Swedish symbiosis of man, fellow-man and nature through attentive reflection well rewarded. It will provide him with useful stimuli or with a model for shaping his own life situations accordingly. The ability to identify destructive exploitation of the natural or the human potential and therefore to avoid it is of fundamental importance in national planning and the shaping of the democratic will.

I know that any attempt to characterize more than eight million people should take into consideration the innumerable exceptions which exist. Nearly three decades of critical observation never-theless lead me to venture the attempt. The following text, together with the superb pictures by my colleague, the gifted photographer Walter Imber, is designed to stimulate the reader and viewer into forming his own reflections and observations. Only then can he get anywhere near a valid judgement. I should like to thank the publishers for giving me the opportunity of speaking about a country and a people with whom essential phases of my life have been closely linked.

<div style="text-align: right">Wolf Tietze</div>

1 The Swedes are a nation of sociable individualists. They observe their festivities joyfully and they treasure tradition without freezing into veneration. On Walpurgis Night, 30th April, the students of Uppsala gather on the hill by the castle to welcome spring. On the dot of three they observe the traditional ceremony of putting on their white, peaked caps, the traditional headgear of Swedish students. In their thousands they then rush down Drottninggatan. The day is observed by songs, student choirs and, in the evening, by dances at the various clubs. In 1977 the University of Uppsala observed its quincentenary. Thousands of white-capped students and former students met for the occasion. Predominantly, of course, the jubilee was observed by less noisy scientific events in the lecture theatres. The local pride of this university is reflected in the blunt statement: "Uppsala is best". At the rival university of Lund in Skåne they add simply: "But Lund is better".

2 The Rapa valley in the Sarek National Park in Swedish Lapland terminates in a wide delta at Lake Laitaure. The water is milky from the silt of some 30 glaciers. Sarektjåkkå, the highest peak of the range, attains a height of 2,089 m (6,860 ft). The delta is growing rapidly. On a warm or rainy summer day the river can transport 5,000–10,000 tons of glacial mud into the lake. – At Aktse, the highest *fjäll* homestead of the valley, occupied and used by the Lapps, Kungsleden, the Swedish Tourist Association's hikers' trail—which runs for 400 km (250 miles) through the mountain world of Lapland crosses Laitaure.

3 People nowadays forget all too readily that Sweden is an ancient country. Nearly three million hectares (7.5 million acres) are still in cultivation. Crops today predominantly serve the provision of animal fodder, even though winter wheat achieves the impressive yield of just on 5 tonnes per hectare (2 t/acre) on a national average. The small patches of lime-rich soil in Skåne and Halland, on the islands of Öland and Gotland, around Falköping, Billingen and on the Kinnekulle between Lakes Väner and Vätter, around Vadstena and Örebro in central Sweden, on Lake Siljan in Dalarna and in the Far North the Silurian region around Östersund in Jämtland (illustrated) were farmland even in prehistoric times. The summer barley, whose silky panicles are waving here in the wind, forms the northern boundary of cereal culture.

4 The winter, however, is severe, long and dark. Frost and drifting snow make traffic difficult. But these difficulties are mastered by experience, determination and the generous and skilful application of technological aids. Sweden's complex economy goes on functioning, especially in the winter when considerably more hours are worked than in the summer.

5 Technology and design are striking features of modern Sweden. A supply of impeccable drinking water at all times, even during persistent severe frosts, and in sufficient quantity, is a vital prerequisite of a demanding civilization. Modern water towers, such as the one at Malmö (illustrated here) are found throughout the country.

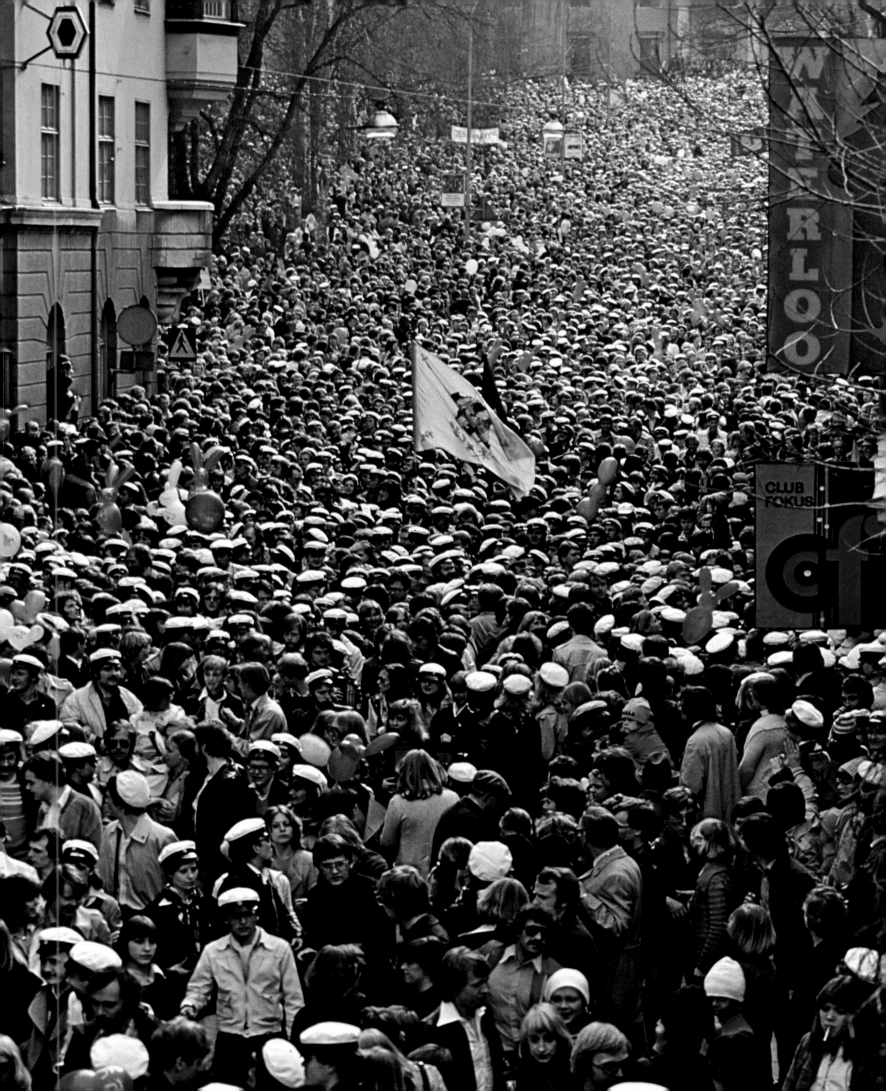

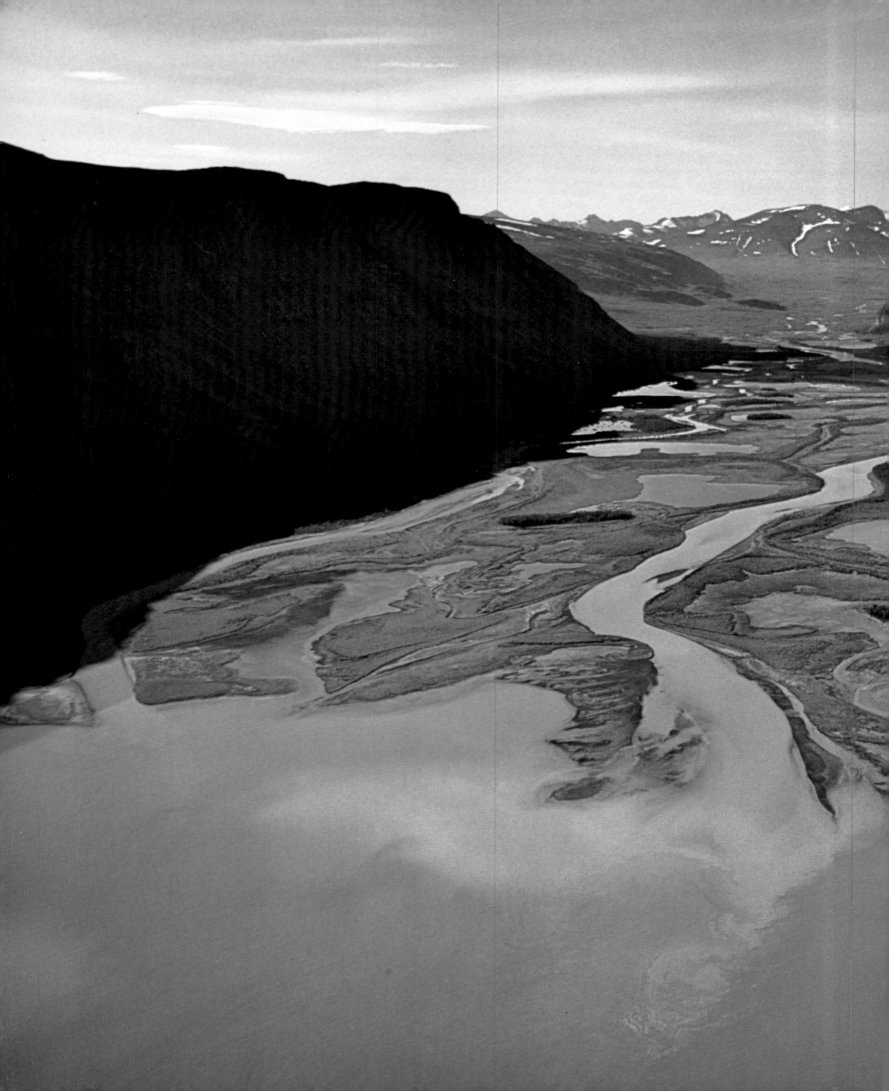

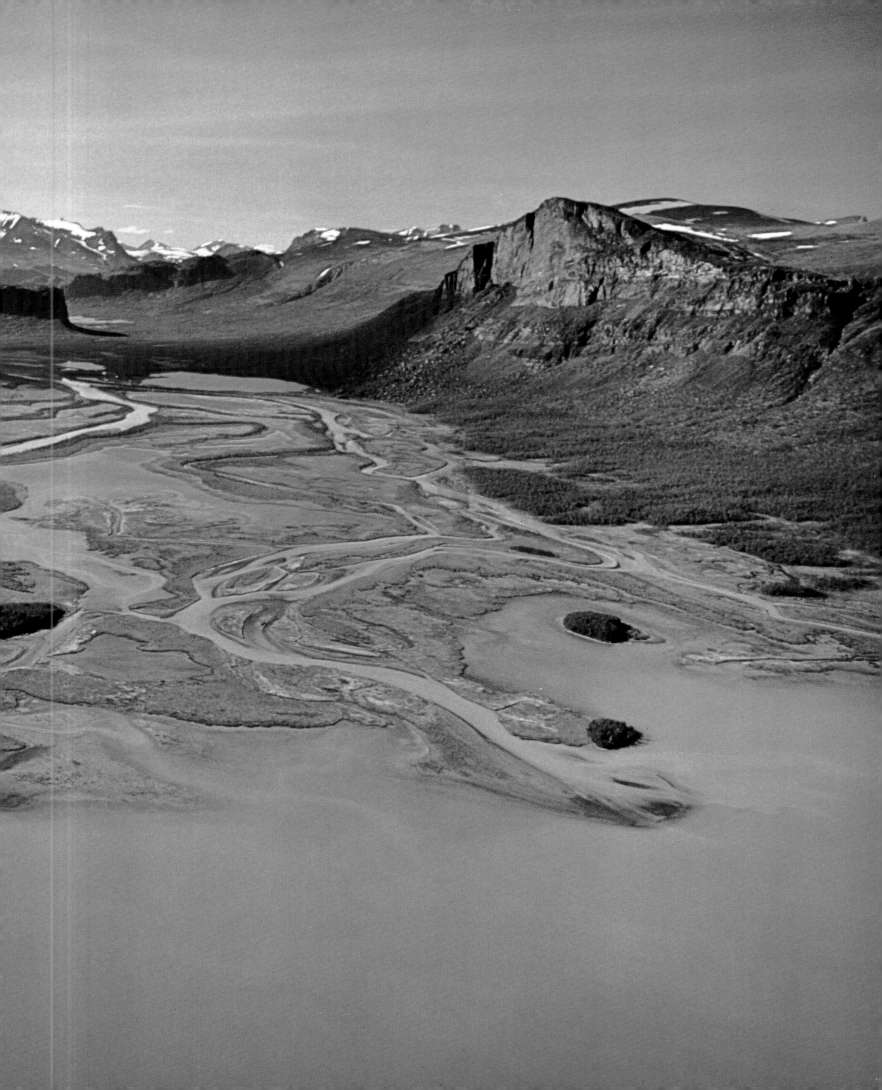

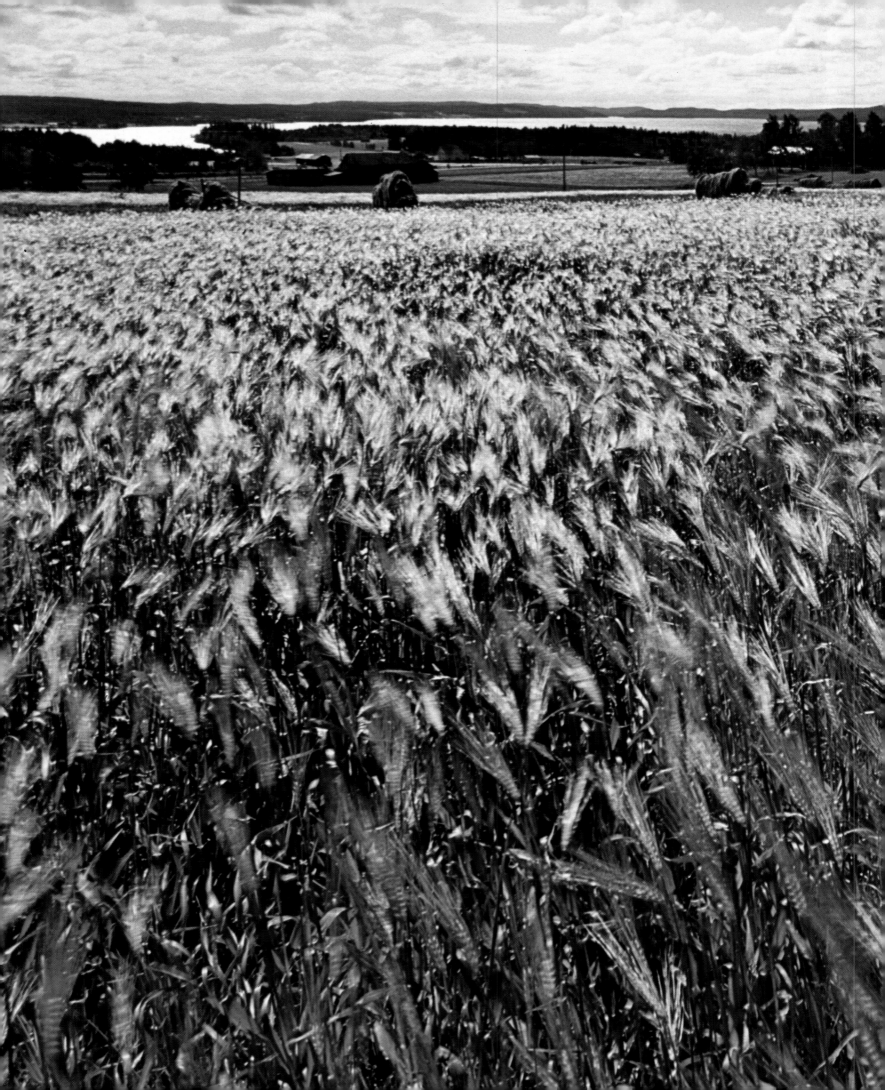

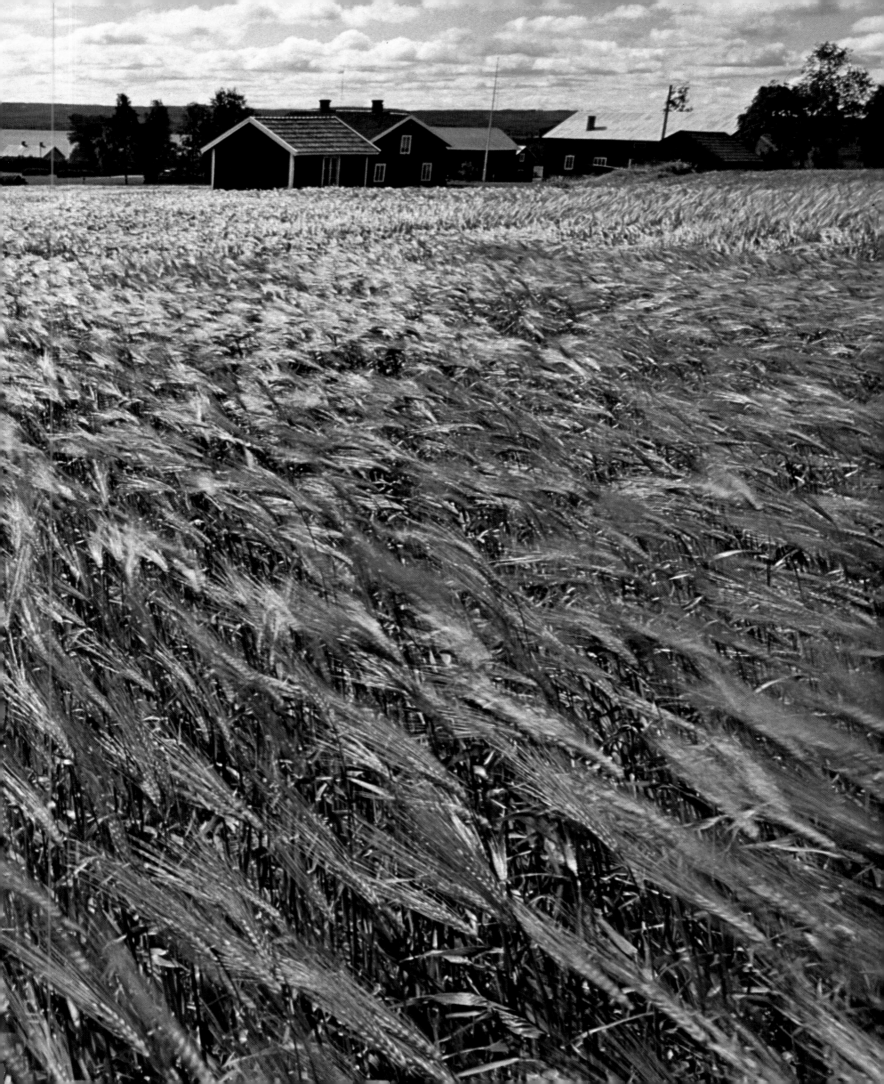

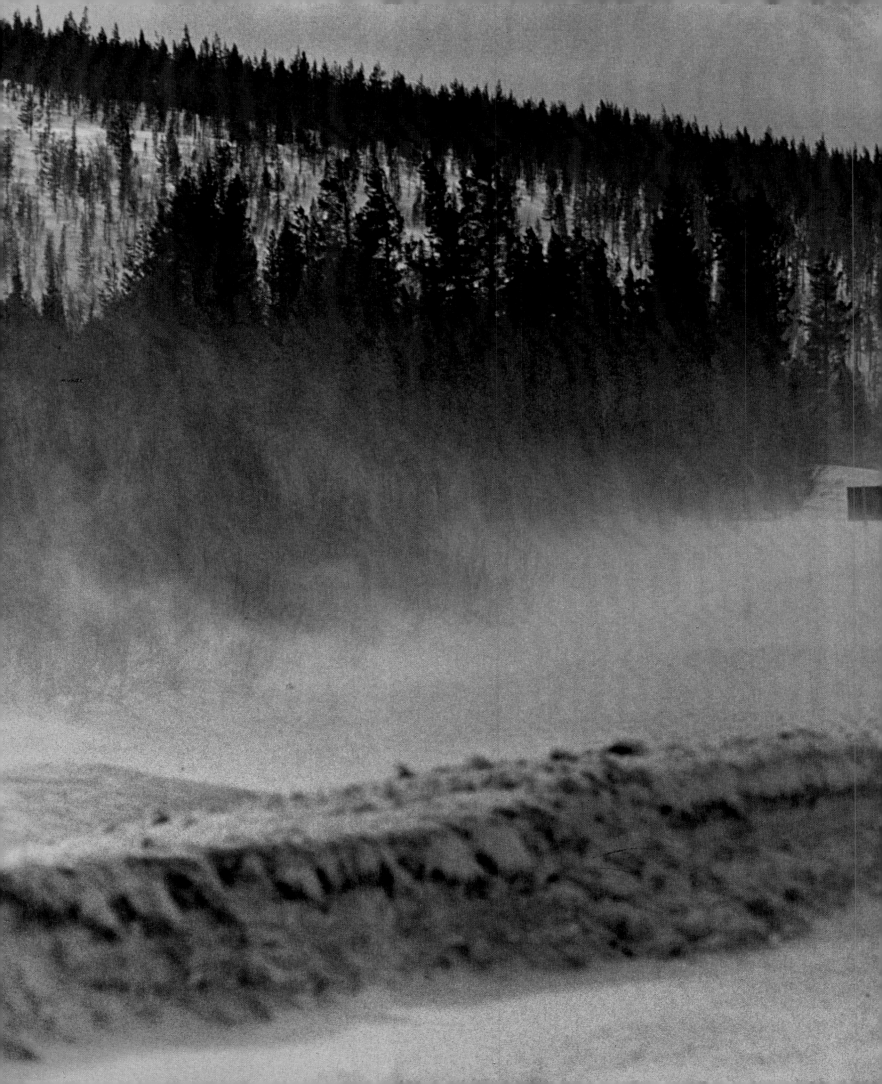

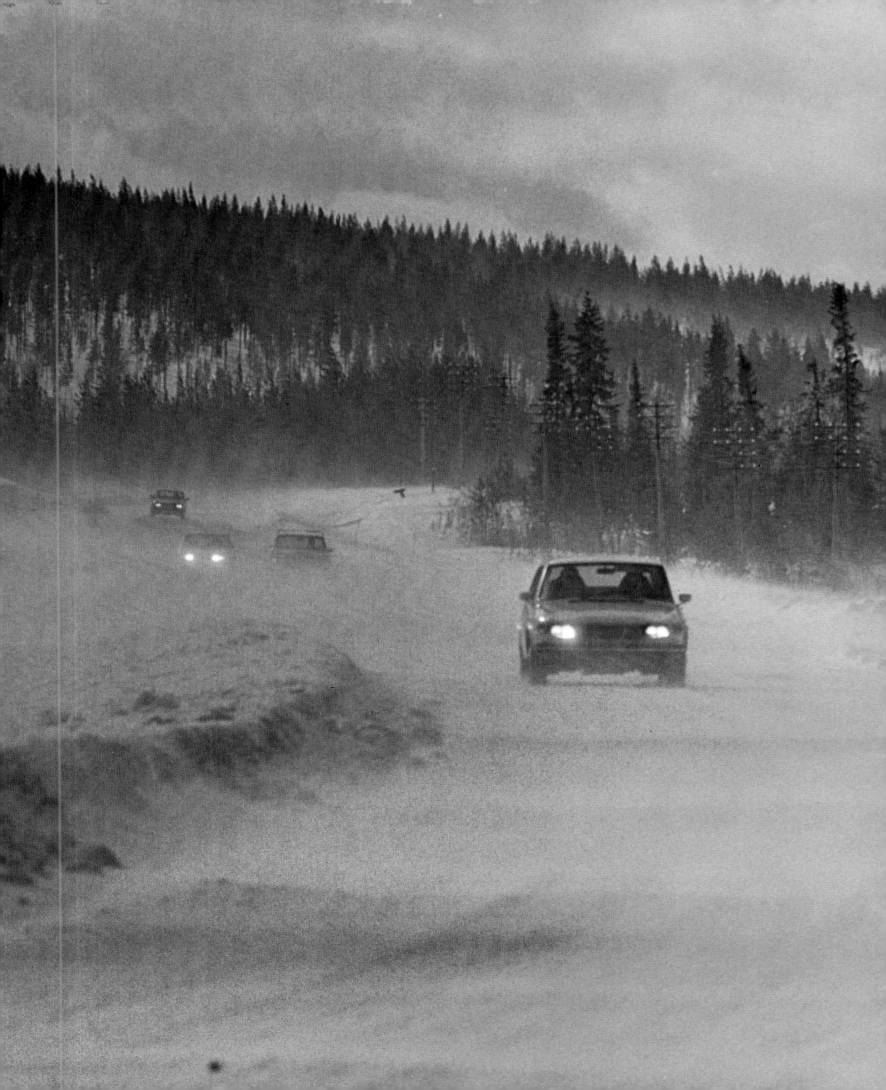

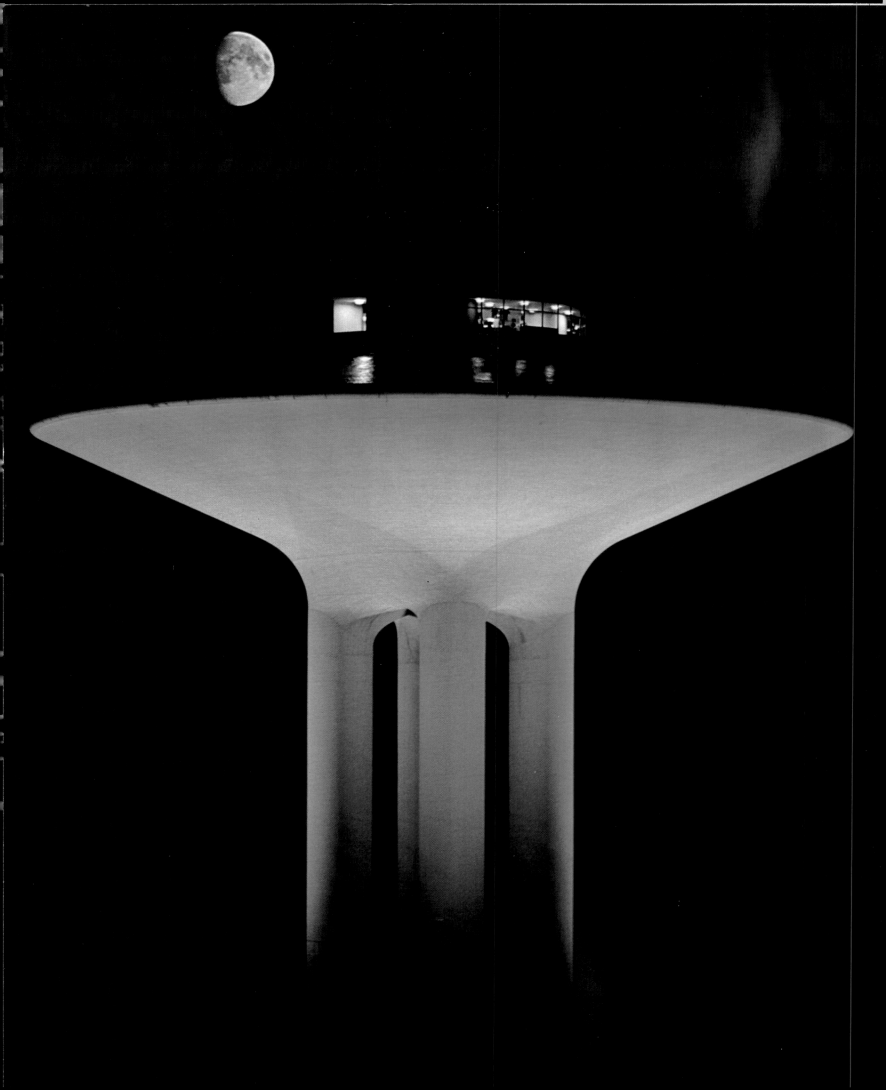

In area and population Sweden is the largest of the Nordic countries, disregarding Greenland which politically belongs to Denmark but geographically to the American continent. However, the proportion of Swedish citizens among the five Nordic nations, which are united by bonds of friendship, has declined over the past two hundred years from 50% to roughly 37%. This trend continues to this day, even though Sweden's population, in absolute terms, is still increasing—by half a million over the past decade, by two millions over the past forty years. For the next twenty years, however, the population increase is now estimated at a mere 150,000, assuming that the present low birth-rate will not rise again. But that is a question of attitudes and not of statistical accuracy. And it would seem that attitudes are already beginning to change. Not only Sweden's population total is changing but also the area of the country. Over the past 40 years Sweden has grown by 1,239 square kilometers (473 square miles). This phenomenon is due to a rising of the land which has been taking place for the past 20,000 years as a result of the removal of the weight of the Ice-Age glaciers. On the coast of Ångermanland, where the upward movement of the land is greatest, the increase has been no less than 300 m (1,000 ft) since the end of the Ice-Age.

At present the land in that area rises by roughly 10 mm (just under half an inch) per year. This uplift of the land is taking place also in neighbouring Norway and Finland although not to the same extent there as in Sweden. Only the country's extreme South, Skåne, no longer participates in that movement. The consequences of this uplift of the land are numerous. They are reflected in the spread of recent marine deposits and in the continual adaptation of inland waters—rivers, lakes, and marshes—to the new altitude conditions. This uplift of the land thus has a major effect on the natural environment and its utilization by man.

Nature and Structure of the Country

That area which has been affected by the uplift of the land since the end of the Ice-Age encompasses the Scandinavian— or, more accurately, the Fennoscandian—Shield. This is a piece of very ancient earth's crust of hardened rocks of an age of up to approximately 1.8 billion years. These rocks, primarily granites and types of gneiss, have varying compositions in different parts of the region, with names given them by the geologists to indicate their geographical distribution. Seen as a whole, one can distinguish the following ancient mountain zones within Sweden as belonging to primary rocks:

The Fennoscandian Shield

1. The southern Swedish gneiss area which extends from Skåne to western Värmland.
2. The Sueccofennian area, from Östergötland to Kiruna in Lapland, and, in addition, a zone in Bohuslän and southern Dalsland.
3. The Gotian area, from Blekinge to eastern Värmland, as well as an area extending southwards from western Värmland.
4. The Karelian area, eastern Norrbotten.
5. The Dalslandian area, which includes parts of Bohuslän, Dalsland, and Dalarna.

These mountain ranges were totally worn down rather quickly: by the time the Precambrian period—more than 600 million years ago—was succeeded by the Cambrian, the land was fairly level. Even though the peaks remaining from earlier geologically unsettled times rise to heights of over 1000 m (3,300 ft) above sea level, their slopes as a rule have such a slight inclination that they scarcely give the impression of a mountainous relief. Instead, they resemble a gently undulating surface, as, for instance, the Uplands of Småland, where Tomtabacken rises to 377 m (1,237 ft). In terms of rain catchment, however, even such a modest rise produces a perceptible effect.

The Scandian Range Much more striking is the massive Scandian range—nearly twice the length of the Alps, though admittedly only about half their height—which extends from the southern tip of Norway, along the Swedish-Norwegian border all the way up to the Arctic Ocean.

In the border region between Norway and Sweden the types of rocks in the Fjäll—the Scandian range—have been dislocated towards the east by so-called overthrust nappes. The chain of the Fjäll is like a spine in the topographical relief of the Scandinavian peninsula. Where it forms part of the border it is also known as *Kölen* (meaning keel). The highest mountain in Sweden, Kebnekaise, is situated in northern Lapland, not far from Kiruna. Its glacier-covered peak, according to the most recent measurements, is 2,111 m (6,928 ft) above sea level. The Scandian range forms part of the Caledonian Range which has its continuation in Scotland and Ireland. It is about six times as old as the Alps—350 million years—has been subject to erosion, and has been greatly degraded at certain periods. Strictly speaking only the bases of the original mountain chain remain. The Ice Age effectively

18

rejuvenated the relief through the movement of ice which created deep valleys containing elongated lakes.

For northern Sweden the Scandian range is an important climatic divide. The moist Atlantic air cools as it is forced up over the mountains, and the precipitation therefore falls primarily upon the western slopes. To the east of the Scandian range the air is heated up, so that here it descends as rain-drained Föhn-type winds. In southern Sweden the moist westerlies sweep in direct over the Uplands of Småland where, as a result, the westward slopes are among the areas with the greatest amounts of precipitation, second only to the western mountainous regions. The Baltic coast—and, in particular, the coast around Kalmar and Öland—by contrast has a very dry climate.

Although the Scandian range today is the main watershed between the Atlantic and the Baltic, with Sweden almost exclusively occupying the eastern flank, the ice-shed of the Pleistocene ice shield at different times more or less coincided with Sweden's present-day Baltic coast. The thickness of the weathering cover in Sweden prior to the Ice Age is not known; the more than 3,000 m (10,000 ft) thick layer of ice that covered the land acted as a tremendous road scraper and virtually removed every trace of it. The loosely-packed layers of earth in Sweden today are the result of glacier movement or of the intervening time. These recent deposits consist of moraines and meltwater sedimentation, ice-flow gravels, often in the form of ridges ("hog's backs"), along with lacustrine and marine clays. The ice-rivers, through their stratification—reminiscent of the annual rings of a tree—have supplied scientists with an accurate, almost year-by-year, picture of glacial diminution.

Peat-bogs occupy large areas, especially in south-western Sweden and in the interior of Norrland towards the mountains. The gradual cultivation of the clayey plains followed their successive rise from the sea. They now constitute the most important agricultural area of the country. The peat-bogs have also played a certain role in the Swedish economy, a role which, in view of today's energy situation, is the object of discussion and hope. The extension of the predecessors of the Baltic from the end of the glaciation to the "highest coastline" has thus exercised a decisive influence on human settlement patterns.

Relief altogether influences Sweden's suitability for settlement in a variety of ways—by its controlling effect on the climate

Consequences of the Ice Age

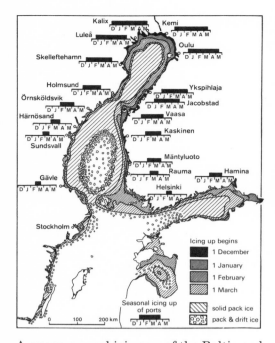

Average annual icing up of the Baltic and
its ports
From: Die Nordischen Länder, 2nd edn.,
Braunschweig 1974
(see Plates 109 and 110)

and, sometimes jointly with the climate, through the distri-
bution and quality of the soils. Even the distribution of land
and sea has considerable climatic consequences because of
their very different heat budgets. Climate and soil, and
occasionally useful mineral wealth, are the decisive factors
in ensuring human life. This applies particularly whenever a
country is situated close to the edge of the *oecumene,* the
inhabited—or, more accurately, the inhabitable—world.
Sweden, like its Nordic neighbours, is very close to that edge.
At a time when complex urban structures already existed
elsewhere, Sweden was only gradually being included in man's
living space, progressively from South to North; plants and
animals, for their part, had only taken possession of that land
a short while before. After all, barely 10,000 years have passed
since the ice shield again freed northern Europe. For plants
and animals the process of resettlement continues to this
day. This is a clear indication of the near-Arctic situation.
Sweden, it should be remembered, lies between 55° and 69°N,
and roughly 10% of the country's area is within the Arctic
Circle. North of 60°N, or north of the Central Swedish De-
pression, as a rule means winters with several months of
frost and reliable snow cover. All lakes are frozen over,
rivers and even some of the waterfalls turn to ice. The Baltic
coast, too, is blocked by ice. Often the whole Baltic freezes
over so firmly that not until quite recently have heavy ice-
breakers been able to keep a channel clear to the principal
ports all year round. The Baltic ice only forms several weeks
after the onset of frost and the appearance of a permanent
snow cover inland—as a rule not before December. On the
other hand, it may persist well into May, even though the
snow has long since melted inland. The Baltic waters, there-
fore, not only prolong the autumn but also postpone the end
of winter. In contrast to the temperatures, and hence also
to snow and ice, the variations in the length of the day,
which are seasonally very marked in view of the country's
extreme northerly situation, follow, of course, a strict calendar
rhythm. The light summer nights and indeed the midnight sun
are quite an experience for visitors, and welcome to natives
as well. The cold dark winter days, on the other hand, do not
make for a tourist attraction. Compared with the Continent,
the winter sports season therefore is much later in the year.
It begins with the Spring school vacation in February, and
is at its height in March and April, during the Easter holidays.
The northernmost mountain areas usually offer the oppor-
tunity of skiing by the light of the midnight sun.

Although, in dealing with the Scandinavian peninsula as a whole, one may refer to an Atlantic and a Baltic side, for Sweden the Atlantic character is confined to the South-West of the country, more particularly the Skagerrak and Kattegat coasts. The Baltic side, on the other hand, is marked by a predominantly continental climate: open to the air masses from the Balto-Russian region and the Barents Sea, but shielded against the Atlantic by the Scandian range. This is seen most clearly in the span between summer and winter temperature extremes. This span reaches more than 80 degrees C in the northern interior of the country, ranging from –46°C to +34.6°C (e.g. at Jokkmokk on the Arctic Circle), whereas in the south it amounts to only 40–50 degrees C on the West coast, and to 60–70 degrees C on the East coast. Every Swede has experienced severe winters with heavy frosts of between –20°C and –30°C. The absolute minimum of –53.3°C (–64°F) was recorded at Lappträsk in Lapland. In the South, as well as in the North, the long dry and warm summer days are a pleasant compensation for the low temperatures in winter. Temperatures over +30°C (86°F) are not at all unusual.

High atmospheric pressure over north-western Russia occurs at all times of the year. In winter this means, for the Baltic side of Sweden, clear air and dry cold south-easterly winds. In summer, however, these winds are wonderfully dry and warm. The long sunny days heat up the rocks of the Skärgård, polished smooth by Ice Age glaciers. Water temperature in lakes and shallow bays of the sea can exceed 20°C (68°F); superb holiday and swimming weather is to be found even on the Arctic Circle. Records over many years have confirmed the Nordic summer's wealth of sunshine. Places such as Tärnaby and Stensele have an average of over 2,100 hours of sunshine—mainly, of course, because of their very northerly situation near the Arctic Circle—during the summer. Växjö in the South, on the other hand, only scores 1,405 hours of sunshine annually on an average taken over many years.

There is a relatively wide fluctuation in precipitation around the long-term averages. In some months rain may easily amount to double the normal amount. It has even happened that on a single day one-sixth to one-quarter of the entire mean annual precipitation has fallen. Negative divergences from the norm are recorded mainly for winter snowfalls. In some places this does not even reach one-tenth of the monthly average. The long-term annual averages usually lie between 400 and 700 mm (16 and 27 inches). The areas which receive

Climate

Temperatures °C

| Locality | 1931–1960 | | |
	Mean	Maximum	Minimum
Karesuando	−1.5	+32.5	−48.1
Umeå	+3.1	+33.5	−38.0
Östersund	+2.9	+33.5	−41.0
Stockholm	+6.6	+34.6	−28.2
Göteborg	+7.6	+32.0	−26.0
Lund	+7.8	+33.9	−26.3
Visby	+7.1	+32.0	−25.0

| Locality | 1975 | | |
	Mean	Maximum	Minimum
Karesuando	−1.2	+24.5	−36.0
Umeå	+4.6	+28.6	−25.0
Östersund	+4.2	+29.2	−21.2
Stockholm	+8.4	+35.4	−13.3
Göteborg	+9.3	+33.5	− 9.2
Lund	+9.1	+33.8	− 9.9
Visby	+8.6	+29.3	− 5.8

Precipitation mm

| Locality | 1931–1960 | | |
	Mean	Maximum[1]	Maximum[2]
Karesuando	380	155	50.2
Umeå	601	224	73.5
Östersund	532	183	71.8
Stockholm	555	192	68.3
Göteborg	670	236	74.0
Lund	587	199	81.2
Visby	529	188	89.3

| Locality | 1975 | | |
	Total	Maximum[1]	Maximum[2]
Karesuando	439	72	23.5
Umeå	598	84	40.6
Östersund	552	83	33.2
Stockholm	386	70	38.3
Göteborg	633	111	30.1
Lund	496	67	22.6
Visby	312	59	18.6

[1] per month
[2] per day

Locality	Hours of sunshine per year	Duration of snow cover
Karesuando	c. 2000	25. X.–20. V.
Tärnaby	2111	27. X.–2. VI.
Östersund	1465	10. XI.–9. V.
Falun	1794	20. XII.–5. IV.
Stockholm	1617	90 days
Göteborg	1860	60 days
Växjö	1405	75 days

the greatest amount of precipitation are located in western Sweden, where, in Småland, the westward slopes of the Uplands can expect up to 1000 mm (39 inches) per year. The precipitation on the Scandian range, of course, exposed as it is to the Atlantic winds, exceeds 1000 mm, sometimes attaining almost 2000 mm (40 and 80 inches) annually.

The long-term unpredictable deviations of precipitation and temperature invest the weather patterns with a measure of unreliability which often has considerable economic consequences. Too much rain at an unsuitable time interferes mainly with tourism. Too little rain only very rarely results in crop failure, considering that the fields are almost exclusively on clay soils with good water retention. The forest, for its part, is not too sensitive to short-lived periods of drought. The volume of water in the rivers likewise reacts only moderately to major fluctuations in precipitation because the numerous lakes and marshes even out the outflow. Matters are more critical for the water supply of wells when the water-table drops (insofar as these draw their water from small isolated morains or parts of eskers), particularly if the drought continues for several consecutive years.

By comparison fluctuations of temperature around freezing point produce far more serious effects—and not only for transport due to icy roads, iced-up rails or, in the event of persistent heavy frost, the freezing up of the coasts. Protection of road surfaces against frost damage has essentially been accomplished over the past two decades at considerable construction expenditure. The winter frost period lasts for roughly six months in the North. Yet it is there that the largest hydro-electric plants are situated which supply more than 80% of Sweden's electric power needs. At the very time of year when a particularly large amount of energy is required a major part of the water power freezes to ice. Worse still, the precipitation falls in the form of snow which cannot benefit the hydro-electric power plants until it melts in the spring. That is why the rivers in northern Sweden which supply hydro-electric power have been equipped with huge dams to provide water reservoirs for collecting the summer and autumn rainfalls. This has entailed great expense, but there has been no other choice as Sweden would otherwise have been without the necessary energy sources for industrial development: the country is totally lacking in coal, for example.

Apart from the period of winter frosts, the northern Swedish rivers in particular are ideally suited for the utilization of their gradient power. Over their courses, mostly between 300

and 600 km (186 and 372 miles), they have to cover a vertical distance of roughly 500 m (1,600 ft) from the mountain lakes in their upper courses down to the Baltic. The few millenia which have elapsed since the disappearance of the Ice Age glaciers have not been enough to produce valley chains with an even gradient. The natural stairway between the individual lakes which even out the flow and the intermediate stretches with their numerous rapids favour their utilization both in mechanical water mills and in the generators of modern power stations. One disadvantage of the Norrland rivers, however, is their relative distance from the consumers. In consequence the rivers in central and southern Norrland have been developed to the fullest extent. In upper Norrland the capacities of 'the large Lule, Skellefte and Ume Rivers have been almost completely utilized, while the Torne, Kalix, and Pite Rivers, along with the Vindel, have been spared—partly from financial considerations, but primarily, due to recent pressures, out of consideration for the environment. In upper Norrland approximately one-half of the available potential of a good 10 million kilowatts is already harnessed. In southern Sweden nearly all the rivers have now been developed for energy generation. The turbine capacity installed in certain Swedish rivers today already exceeds the potential of the waterway at average flow. All in all, the available potential of the Swedish waterways is estimated at 20 million kilowatts, of which approximately 13 million kilowatts have so far been exploited. The latter figure represents an average annual energy of approximately 60 billion kilowatt-hours.

The greater understanding shown by industry and the authorities for the protection and care of the environment has come only just in time to benefit certain ecologically threatened inland lakes. The acidification caused by considerable sulphuric fallout from industries—not only Swedish but to an even greater extent industries on the Continent—is a serious threat to lake waters. Attempts have lately been made to raise the pH value of the water of a few especially jeopardized lakes by the addition of lime—but to make this a general practice would cost a great deal of money.

The total number of Swedish lakes runs into thousands. The biggest of them are located within two areas: central Sweden with Vänern, Vättern, Mälaren, and Hjalmaren, and the large lakes of Norrland.

Rivers

	Length in km
Klarälv-Götaälv	720
Muonioälv-Torneälv	570
Dalälv	520
Umeälv	460
Luleälv	450
Ångermanälv	450
Kalixälv	430
Ljusnan	430
Järpströmmen-Indalsälv	420
Skellefteälv	410
Piteälv	370
Ljungan	350

Lakes Lakes in a landscape are a sign of youth; the world's most ancient lakes are barely a million years old. Sweden's oldest lakes have an age of only about 10,000–12,000 years. They are all post-glacial and, ever since their emergence, have been rapidly filled up with sediment or deprived by erosion of the thresholds which dam them up. The transportation of sediment by the Swedish rivers still reaches astonishing proportions in spite of the numerous valley lakes and the dense forest cover. The Klarälv enlarges its delta in Lake Väner by 40,000 m³ (1.4 million cu.ft.) annually at an average water transportation of 165 m³/sec (5,830 cu.ft./ sec). The Ångermanälv with an average water transportation of 490 m³/sec (17,300 cu.ft./sec) carries some 200,000 m³ (7 million cu.ft.) of sediment into the Baltic each year. It accomplishes these massive transportation performances mainly with the spate at the time of the snow melt in the Kalfjäll, the mountains above the tree line. At that time the rate of flow of the northern Swedish rivers from the Klarälv to the Torneälv increases to five to ten times the normal amount. At present Sweden still has approximately 96,000 lakes. This count, of course, includes even the smallest of them—all those, in fact, shown on the old 1:100,000 General Staff map. Their combined area is a good 38,000 km² (15,000 square miles) or 8.5% of the area of Sweden. The four largest lakes together account for nearly a quarter of the total area of the inland lakes.

The principal Swedish lakes

Names	Area km²	Level m a.s.l.	Greatest depth m
Vänern	5585	43–45	89
Vättern	1912	89	119
Mälaren	1140	–	64
Hjälmaren	484	22	22
Storsjön	456	292	–
Siljan	354	161	120
Torneträsk	322	342	168
Hornavan	230–280	423–426	221
Uddjaure	190–250	419	–
Bolmen	184	142	–
Strömsvattudal	154–183	286	–
Stora Lulevatten	165	370–375	–
Storavan	150–175	419	–
Kallsjön	155	380–383	132
Åsnen	150	139	–
Delleusjöarna	132	42	–
Sommen	132	146–147	53
Skagern	131	67–69	72
Stora Le och Foxen	131	102	102
Storuman	120–165	349	135
Suorvajaure (Akkajaure)	32–210	420–439	92
Flåsjön	105–114	264–267	–
Virihaure	108	580	138
Frykensjöarna	102	62	120
Glafsfjorden	102	45	–

24

The persistent uplift of the land sustains the activity of the running water by progressively raising the threshold of erosion. This, together with abundant precipitation and the seasonal outflow rhythm, characterizes the dynamics of the landscape, its transformation. The same forces also play their part in the transformation of the coasts. Silting up proceeds rapidly. The Vikings' harbours of a thousand years ago are today located far inland, and their ancient boat channels are now shallow valleys where tractors plough furrows in the meadows. Not only in Norrland, but also far to the south in Småland, where uplift has been relatively slight, the medieval towns were obliged to move to new sites or to build ports away from the city in order to maintain contact with the sea. A fringe of skerries rising gradually from the sea characterizes the Scandinavian coastal landscape of the ancient rock shield. A third of Sweden's coast consists of skerries. In the west, apart from the large islands of Orust and Tjörn, it is distinguished largely by bare cliffs. This belt of rock reaches its most complex articulation off Södermanland and Uppland—the Stockholm archipelago stretching from Landsort to Arholma with a width of 80 km (50 miles) and consisting of 24,000 islands, islets, and skerries. Those closest to the mainland are scarcely different in nature from the inland scenery. Separated by wide fjords, the still forest-clad islands of the middle archipelago are spread out; further to seaward lie the myriads of islands and hundreds of islets and rocky skerries.

Until recently agriculture had been as important as fishing on the larger islands of the Baltic archipelago. In recent years, however, the population has decreased markedly. On the Skagerrak the fishing industry has been, and still is, the main source of livelihood for the inhabitants of the archipelago, partly because of the windier climate, but also because an earlier destruction of the forests on the islands left them considerably more barren. Every protected cove and island shelters a fishing-village, a unique form of settlement due to the homogeneous occupation of the inhabitants.

The skerries, especially in Bohuslän and outside Stockholm, are an extraordinarily important area for leisure. Summer homes are now numbered there by tens of thousands and Stockholmers alone own more than 20,000 sports craft, both sail and motor-powered.

The rocky beaches of the archipelago are interspersed with small sand-beaches in the inlets, where waves and currents have washed up the fine-grained material, but just as often the edge of the shore itself has been formed into round-humped

The Coasts

Land uplift

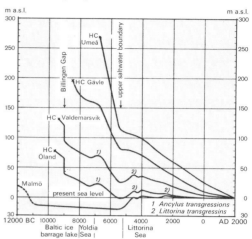

The diagram shows the changes since 2000 BC in the level of the highest coastline (HC) at five selected points on the Swedish coast in relation to the present sea level (acc. to Atlas över Sverige). See sequence of maps on p. 53

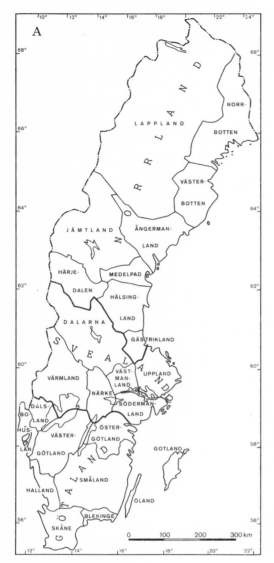

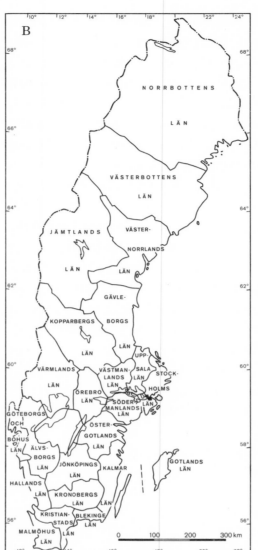

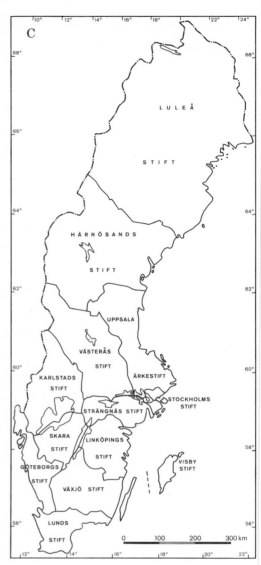

rubble-stones, called *malar*. One has to go as far south as Halland and around the coasts of Skåne, or to Öland and Gotland, to find long sandy beaches. The coasts have at all times played a fundamental role in ensuring Sweden's communications with the outside world. International transport predominantly originates from the southern half of the country and is directed thence towards the West, the South and the East. Direct contact with the Continent is provided by only one land bridge far to the North, one which moreover is difficult to cross during the winter half of the year.

The roads between Sweden and Norway have become, in recent years, more numerous. The oldest ones over to Trondheim and Röros have played an important part in business trips by the inhabitants of Jämtland and Härjedalen, and the railway to Narvik, for the transport of iron ore, opened in 1903, is of vital importance to Swedish iron ore exports. These exits, however, do not meet the needs of the central and southern

26

Swedish economic regions. In consequence, Sweden, in respect of most of its foreign contacts, and the most important of them, has the clear character of an island. The struggle for the coasts, for access to the sea in the South-West, therefore characterizes half a century of bitter war-like conflict with neighbouring Denmark. It was a long drawn-out conflict that was eventually settled at Roskilde in 1658. By comparison the Swedish colonization of the Finnish Baltic provinces was a more peaceful undertaking under the banner of Christian missionization. Although rather harsh at times, it was nevertheless a more or less organized settling of farming families. In the sixteenth century Sweden extended its dominions in continuous wars with the Russians until they included the Baltic States. And in the seventeenth century, following the Thirty Years' War, Sweden expanded southwards and was to control important regions around the estuaries of the German rivers for nearly a century. But all this came to an abrupt end in 1718 when Charles XII was killed at Fredrikshald and in 1809, when Finland, regarded since the Middle Ages as part of the Kingdom of Sweden, became a Grand Duchy under Russian domination.

Bloody though Sweden's history was for a long period, its territory and foreign policy today seems uncontroversial and consolidated—and, since the Napoleonic era, certainly free from war-like conflicts. That is unparalleled anywhere in the world.

Territorial Subdivision

In line with ancient tradition, surviving since Viking times, when Sweden consisted of several small kingdoms, Sweden is divided into 25 provinces (24, to be exact, as Norrbotten, formerly a part of Västerbotten, only came to be viewed as a province in its own right at the turn of this century). These provinces today have no administrative function whatever, but they are nevertheless deeply rooted in Swedish consciousness. A Swede feels a greater identity with his province than with his *län*, the administrative unit, and the borders of the traditional provinces are still a living entity, observed in many connections, such as maps and statistics.

Only in a few instances do the traditional borders coincide with those of the 24 official administrative units. This division derives from the seventeenth-century central administration of the state. The *län*, as a statistical unit, is most relevant when dealing with agriculture and population. Sweden, in fact, has been keeping official population statistics ever since 1749, the first country in the world to do so. Prior to the

second world war the provinces *(län)* were subdivided into districts *(härad)* and these in turn into municipalities of different types, such as towns, market centres and rural municipalities. A comprehensive reform of administrative areas a few years ago has greatly simplified that territorial hierarchy functionally. As a result, the number of municipalities has been reduced to 281 by the amalgamation of 2,524 (in 1939); of these the three big cities, Stockholm, Göteborg and Malmö are already administered directly. Gotland, which formerly consisted of 92 communes or parishes, as a result of this reform is now just one commune. This districts *(härad)* have disappeared completely. The distinction between towns, market centres and rural municipalities has been abolished. They are now simply called communes, each one with an average population of 15–30,000, and an administrative centre (usually a former town). These new communes generally contain a number of major or lesser compact settlements *(tätort)* with which the less densely inhabited farming country is associated. The term "town" is no longer an official concept. Today the overwhelming part of the population, 83%, lives an urban kind of life, but this is a relatively recent development in the social structure. Until the mid-thirties more people lived in the rural areas than in densely-populated communities, and a hundred years ago three-quarters of the population lived on remote isolated homesteads. Only for statistical—not for administrative—purposes is a distinction still made between remote isolated homesteads *(glesbygd)*, above all in Norrland, and "compact settlements" *(tätort)* which must have at least 200 inhabitants within earshot or sight of one another to qualify for this category. Independent of the territorial subdivision of the state administration the ancient ecclesiastical division of the country into bishoprics *(stift)* survives. Familiarity with these greatly helps the historical understanding of the country and its people.

Sweden's northernmost point is the three-country corner *(Treriksröset)* with Norway and Finland: 69°4'N.

Sweden's southernmost point is Cape Smygehuk on the Baltic coast of Skåne: 55°20'N.

Sweden's westernmost point is the skerry Stora Drammen of the Koster Island group: 10°58'E.

Sweden's easternmost point is the island of Kataja off the mouth of the Torneälv into the Bottenvik: 20°10'E.

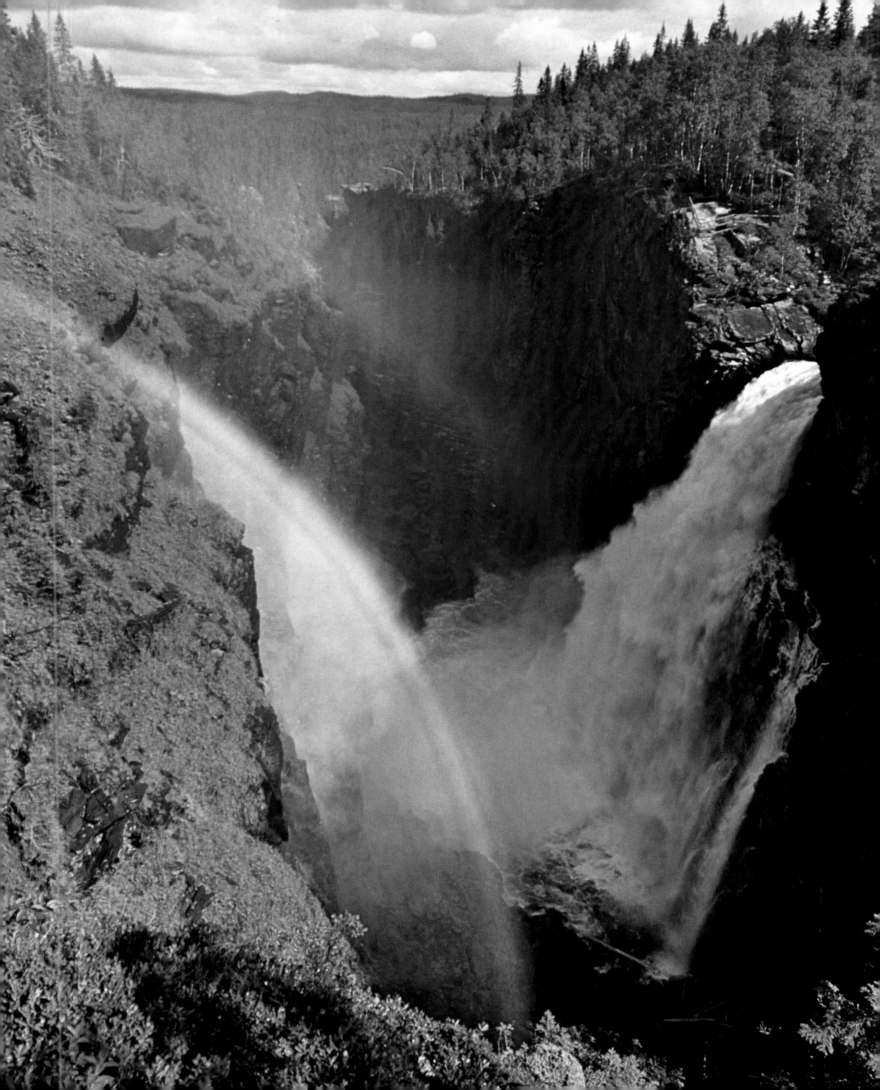

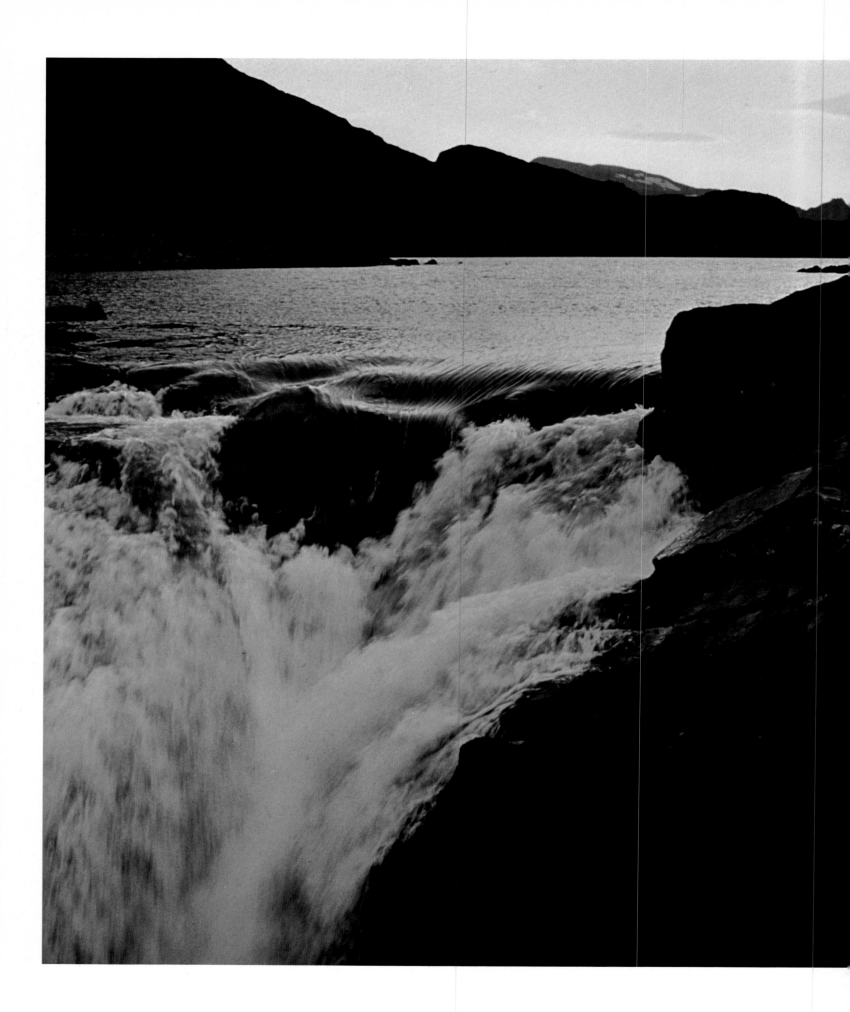

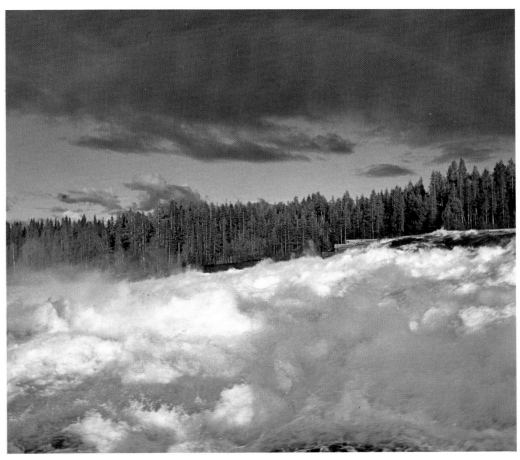

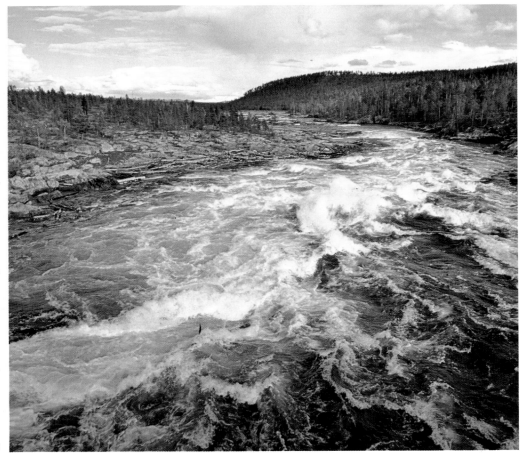

7

8

9

10 ▷

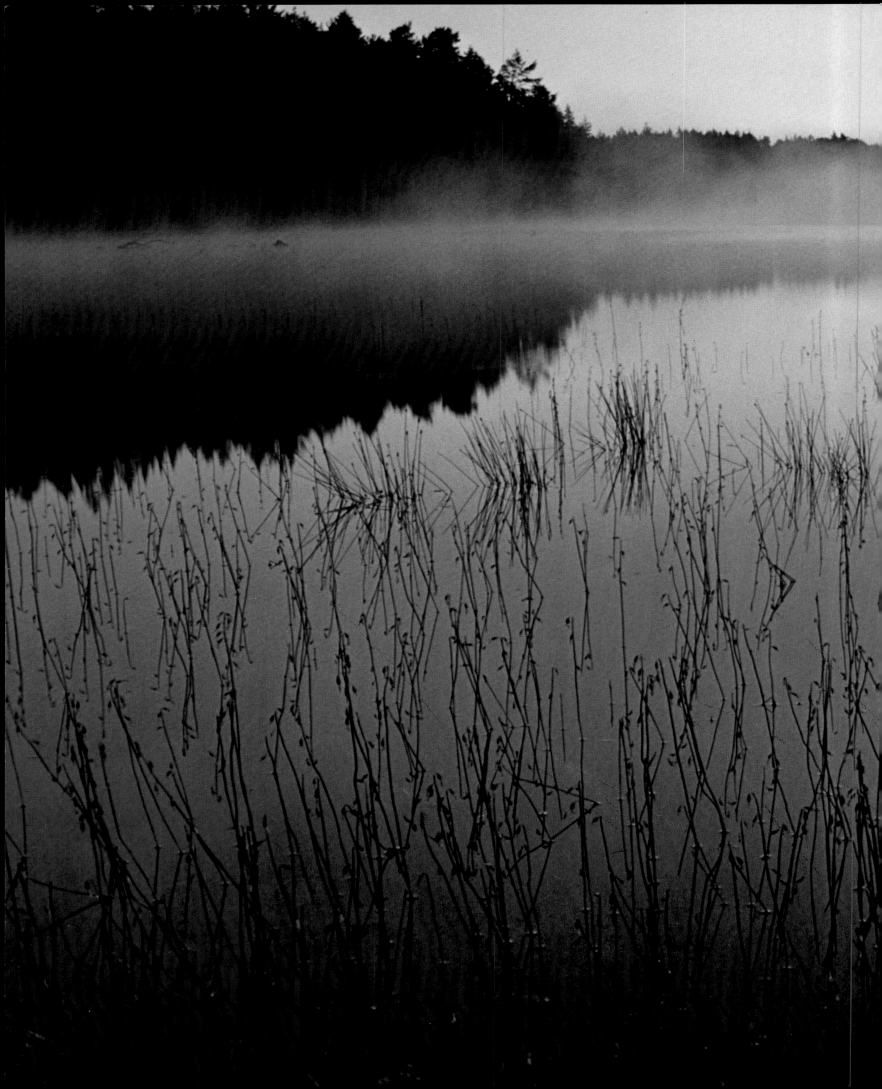

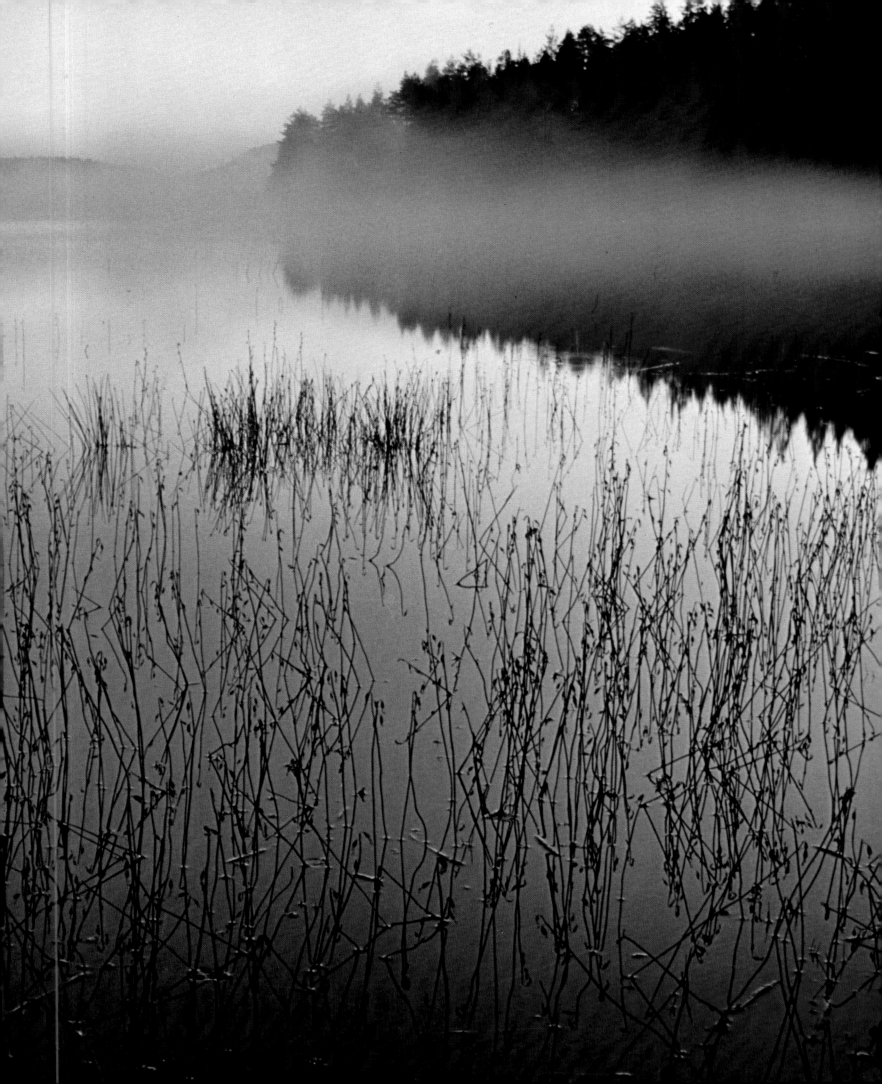

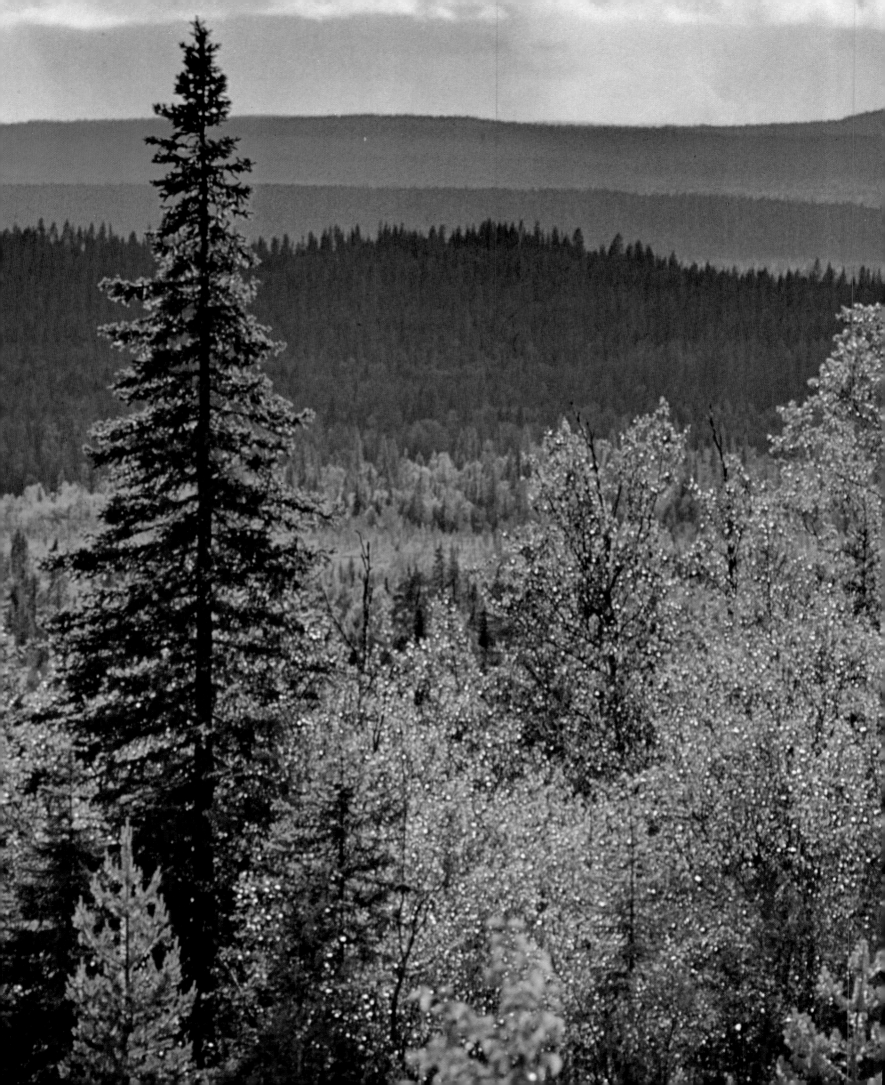

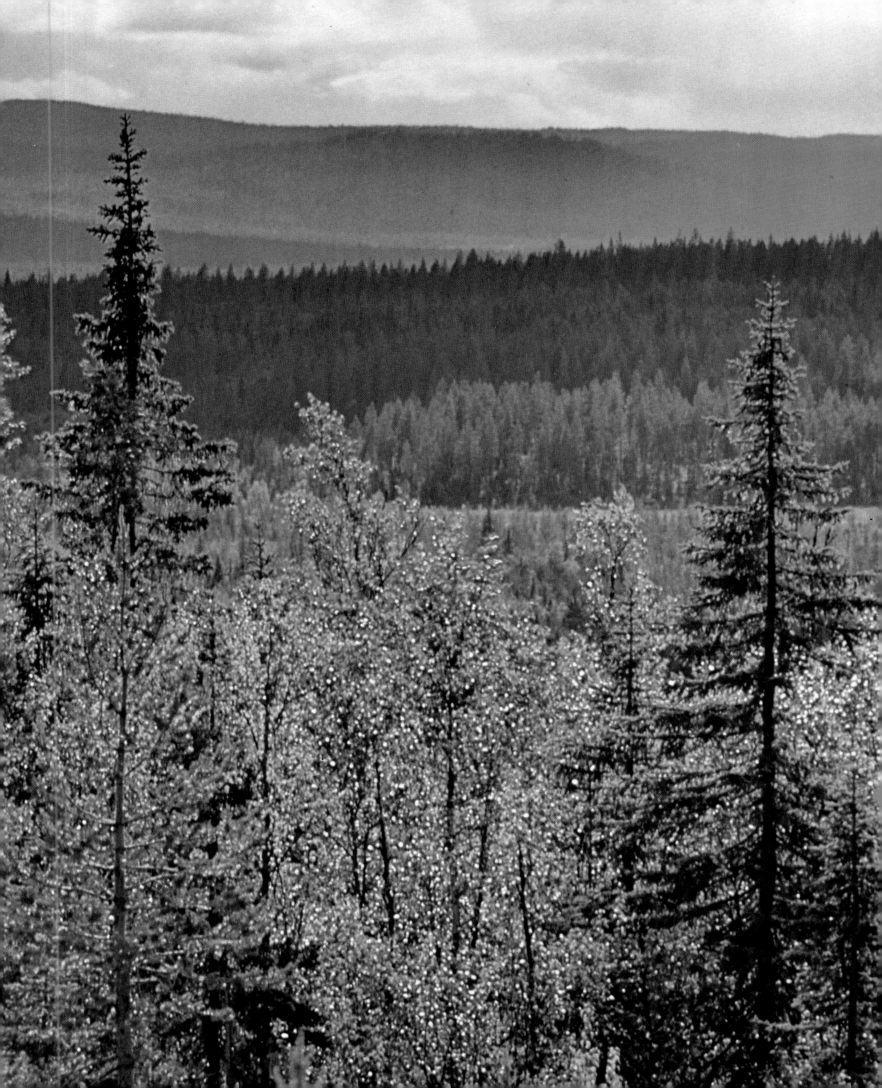

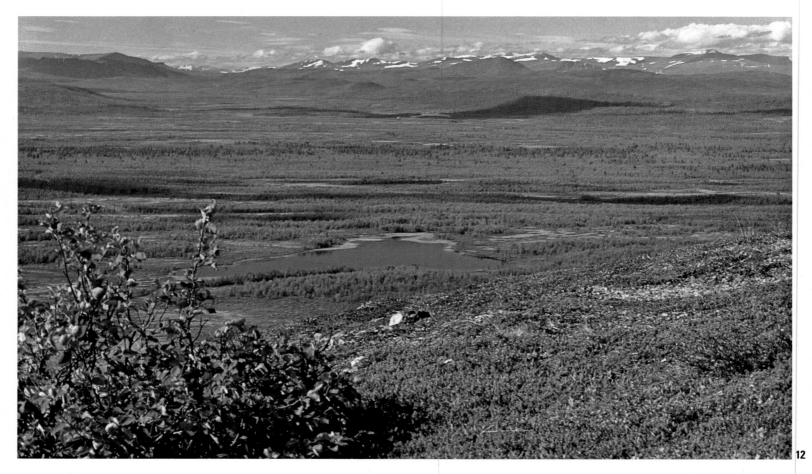

12

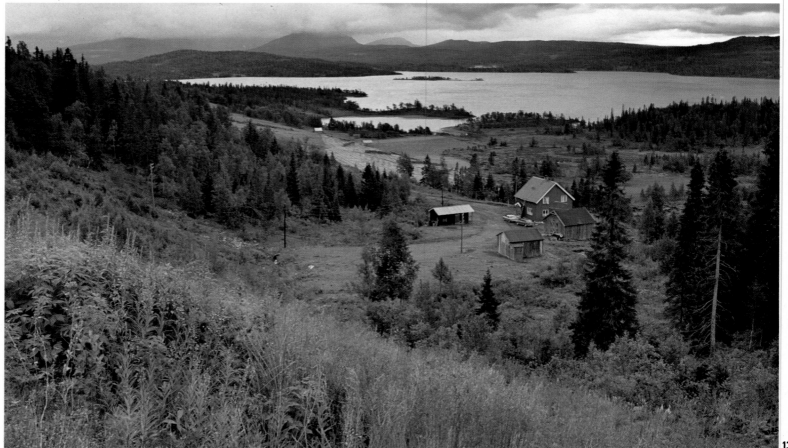

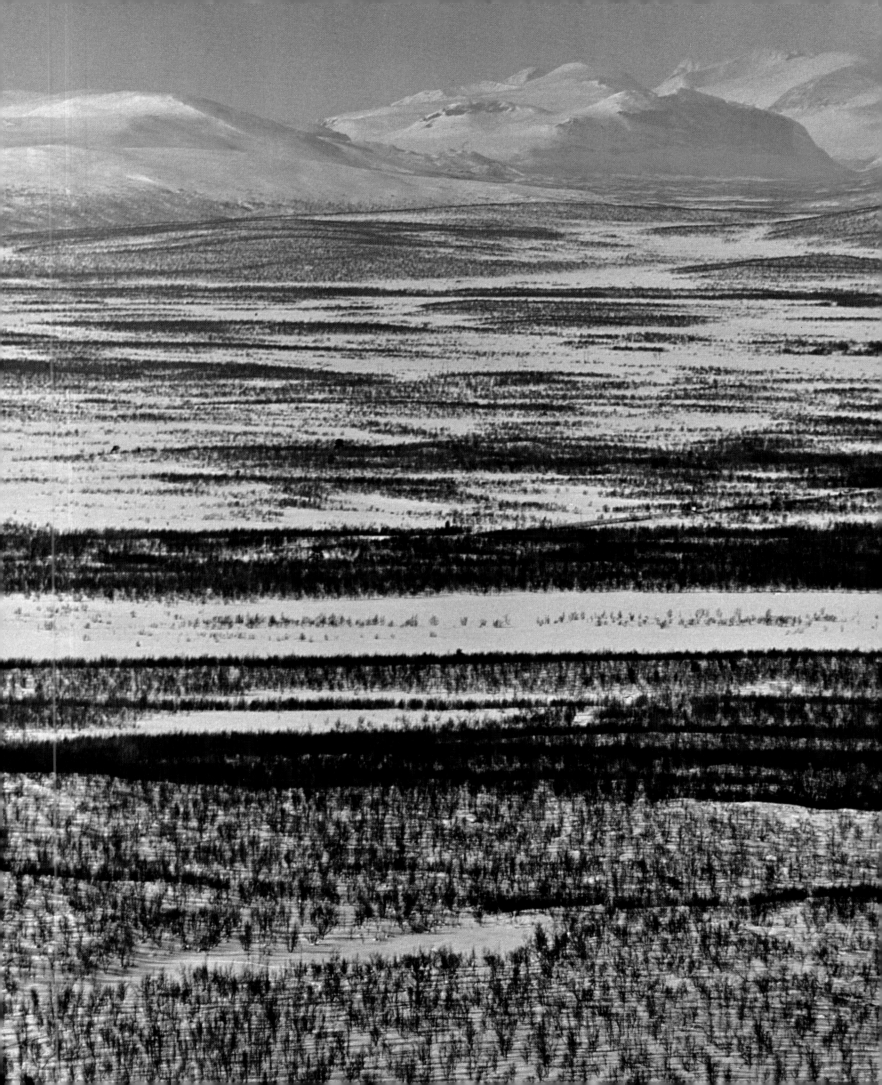

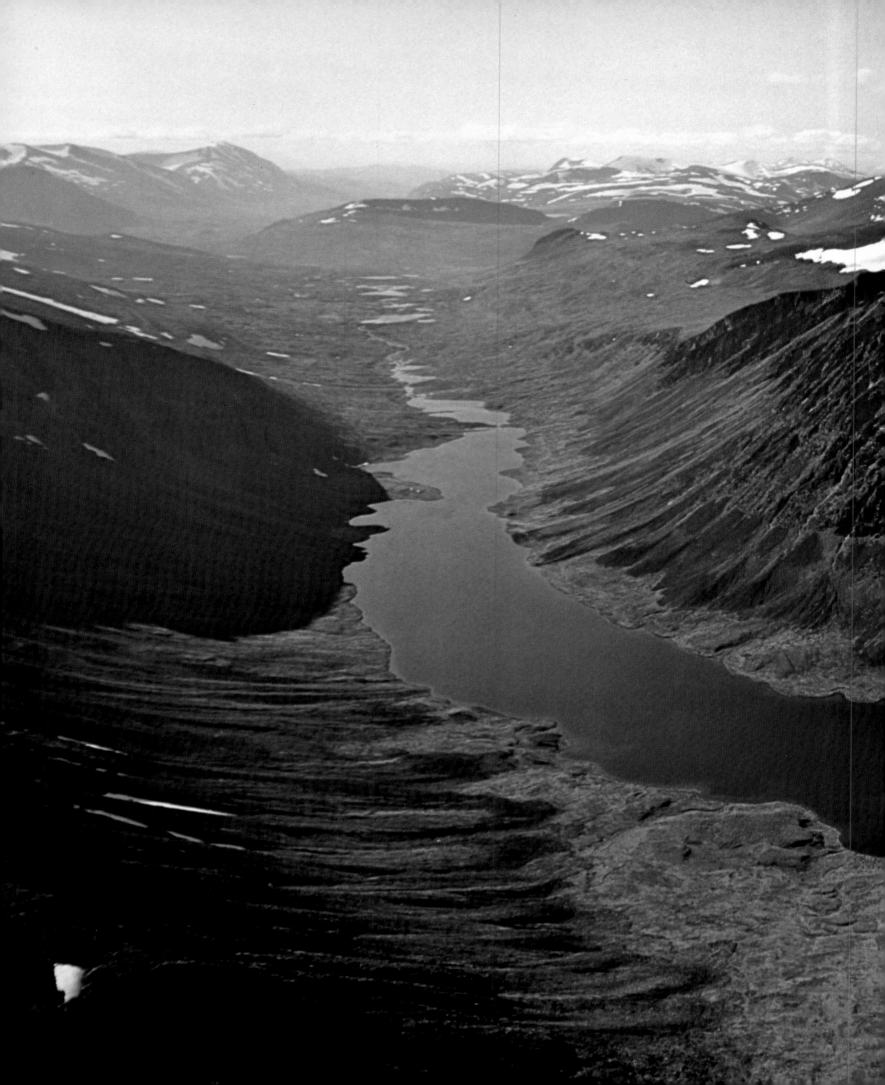

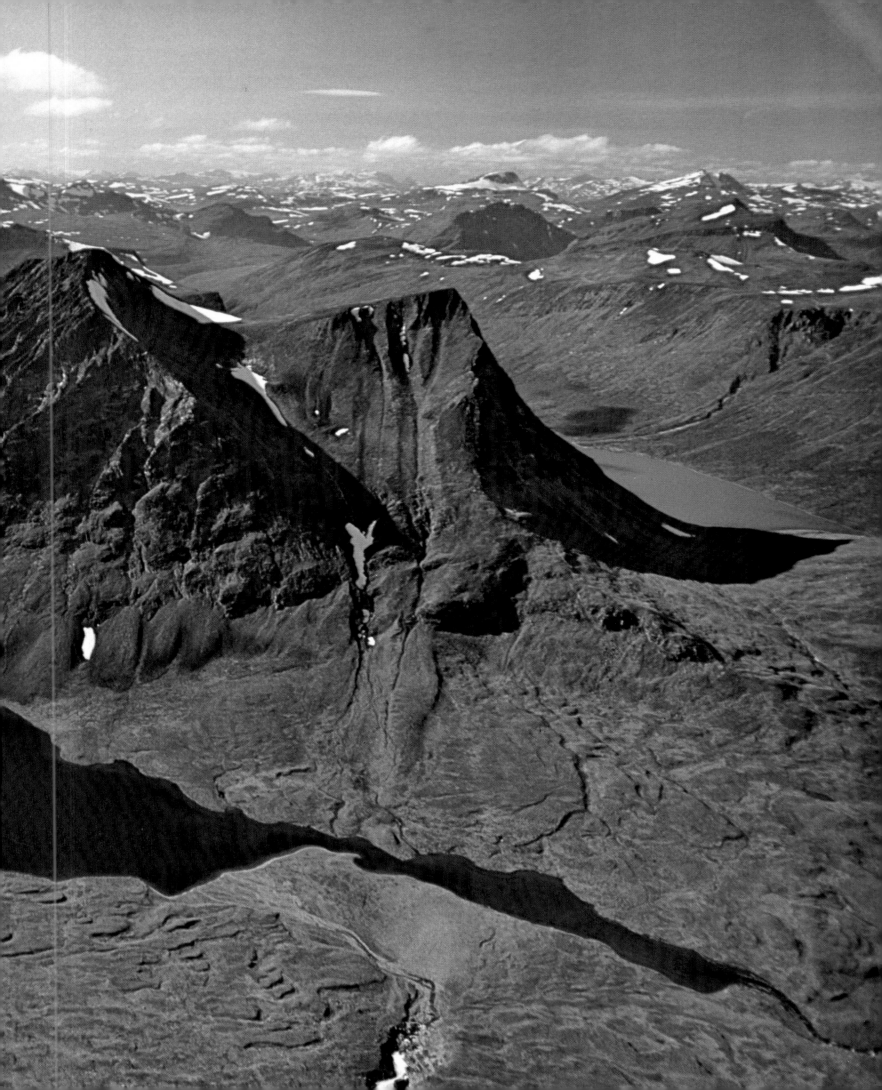

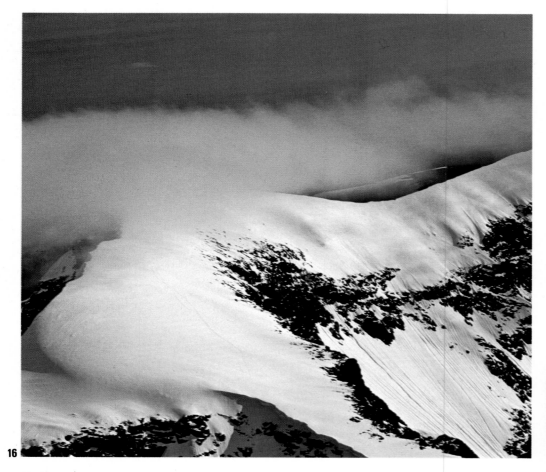

16

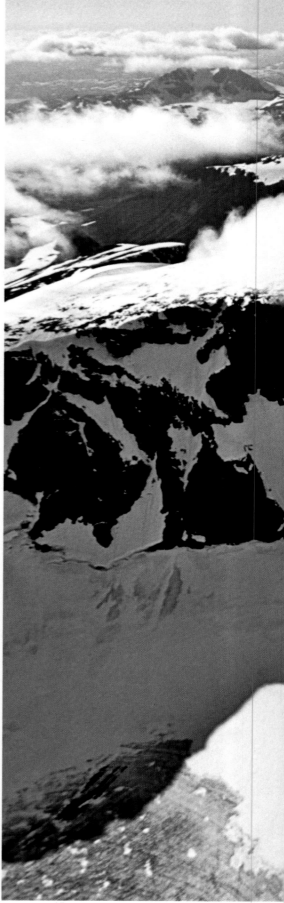

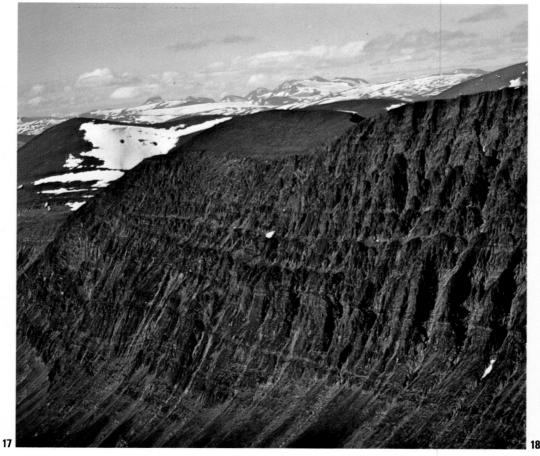

◁ **15** **17** **18**

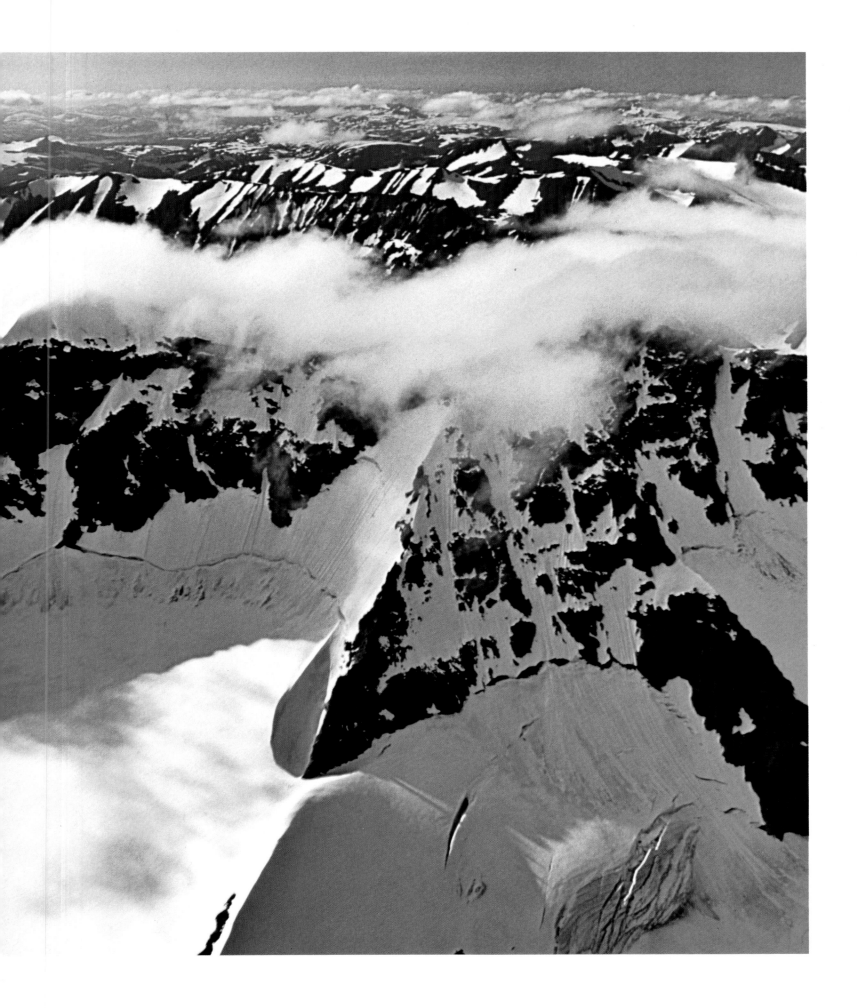

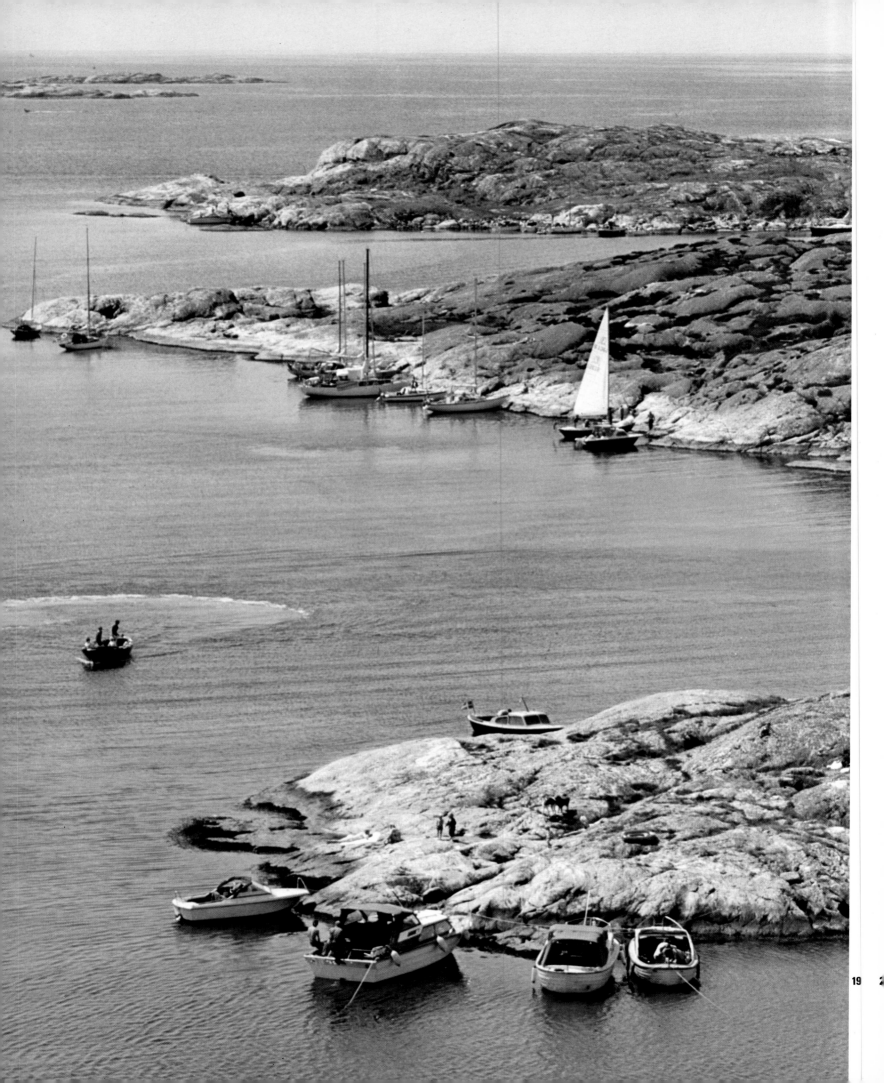

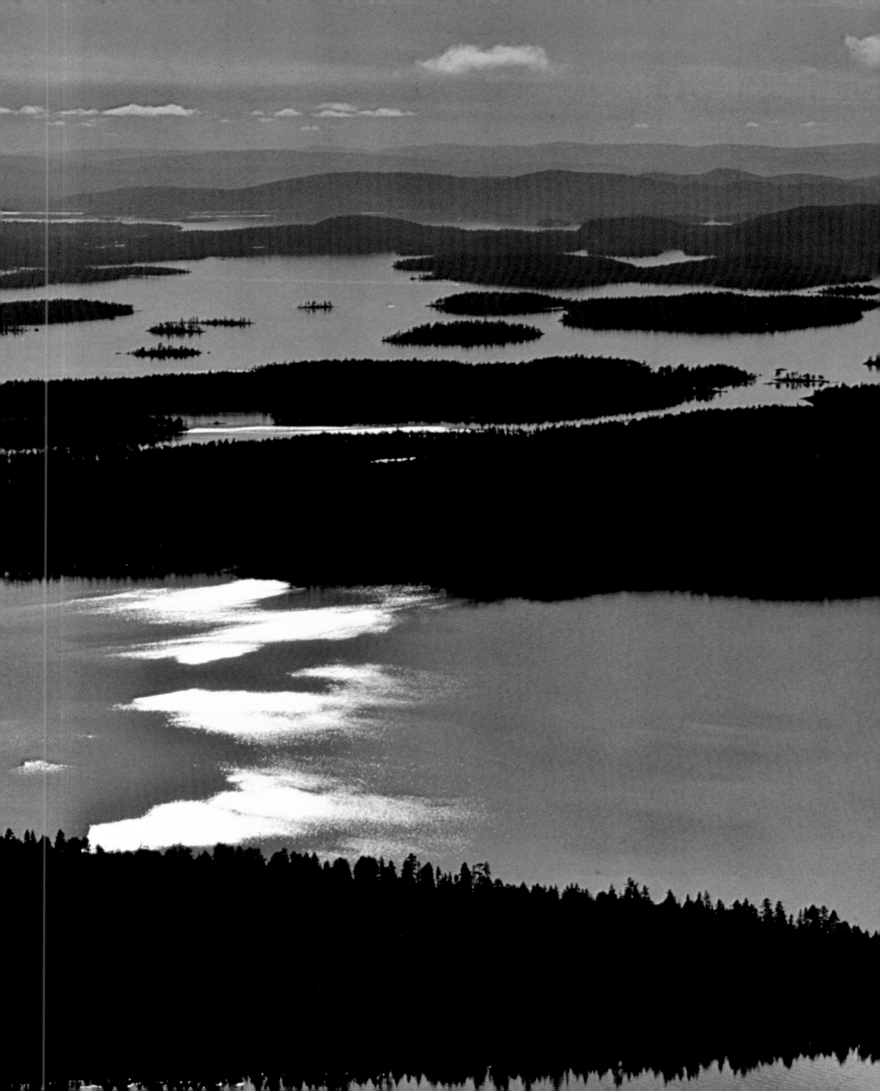

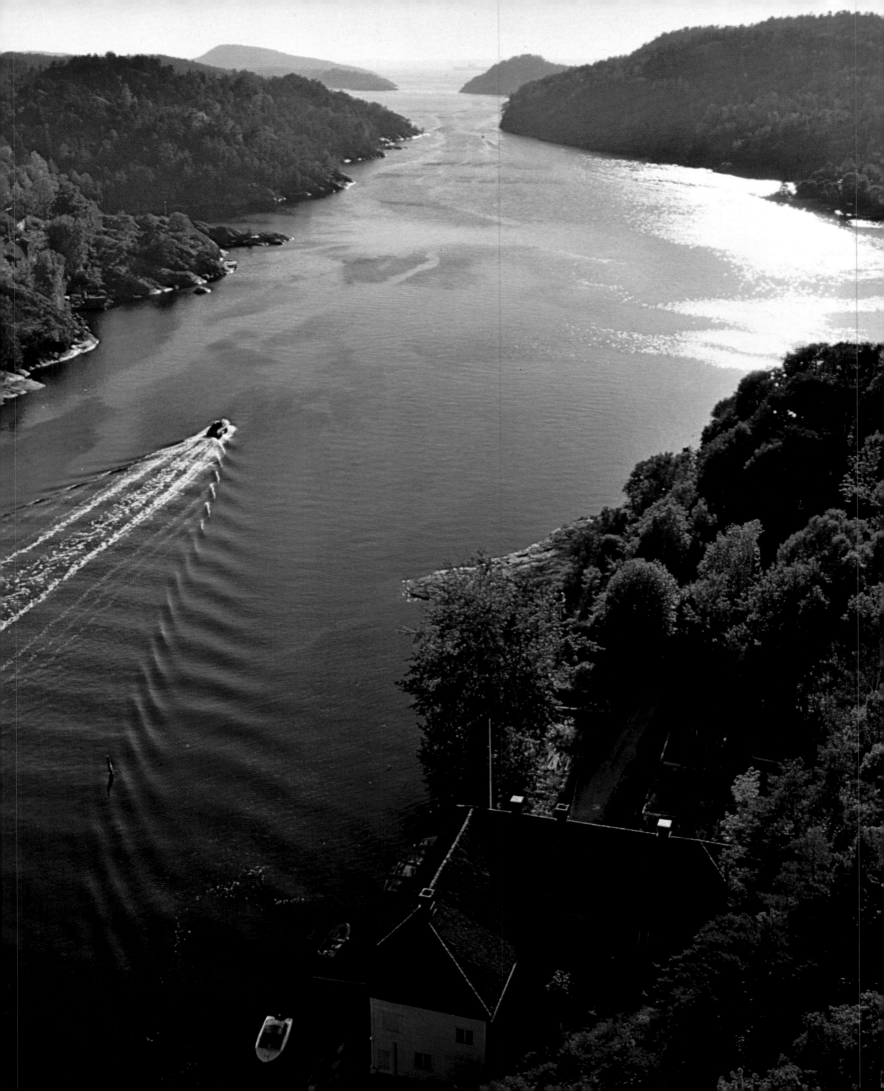

6 When the snow melts in the mountains the waterfalls are at their peak potential. The reservoirs at the hydro-electric power stations are filled and the turbines turn at full speed. There are still some untamed cascades left—those which are too remote to be profitable at the present time. The picture shows Hällingså Fall in the Ström valley in northern Jämtland. It is 35 m (115 ft) high and since the Ice Age has carved out a 600 m (2,000 ft) long gorge with vertical walls.

7 A water network as young geologically as Sweden's has no even gradient. Calm lake-like stretches of river alternate abruptly with drops through three, five, ten or twenty metres (up to 65 ft). Most of these are utilized for power generation. The picture shows what is left of Stora Sjö Falls, deep in the interior of the mountain world in the Stora Luleälv glen in Lapland. This was once Sweden's largest and most majestic waterfall. Now nearly all the water runs through the turbines of the Vieta power plant.

8/9 Piteälv is one of the four big Norrland rivers which are supposed to be left in their untamed state. Here, at the Storfors, the "Great Rapids" near Bredsel in Norrbotten, it is still 150 m (430 ft) above sea level and 90 km (56 miles) from its estuary in the tranquil Svensbyfjärden near Piteå. It is to the pulp factories of Lövholmen and Munksund that it carries individual logs at a rapid pace. The lakes from which the Piteälv originates, Peskehaure (578 m = 1,897 ft) and Mavasjaure (542 m = 1,779 ft), are situated among peaks rising to between 1,500 and 1,700 m (4,900 and 5,600 ft). There are no roads leading there: the Lapps can let their reindeer graze undisturbed.

10 One of Sweden's 96,000 lakes. The mist that gathers at dusk and the dark curtain of forest reflected in the water, a silence reinforced by bird song and the rustle of an animal moving at the edge of the lake—this is the nature that the Swedes value so dearly.

11 Sweden clearly is a country of forests. More than 56% of the land area is covered by woods, and from every lookout point in Norrland one horizon of forest meets the next in endless shimmering blue lines in the distant haze. Spruce is the predominant species, followed by pine, but the birches crowd in between and contribute light touches to the monotonous green of the conifers. Distances here between cultivated land and homes are great. From the height of an aircraft they appear like pinpricks on a dark green surface.

12 View of the Kebnekaise massif with Sweden's highest peak (2,111 m = 6,924 ft), nearly 50 km (30 miles) to the west of the camera. This distant view was taken from the 724 m (2,376 ft) high Luossavaara panoramic mountain on the edge of the mining town of Kiruna which can be reached in comfort by the *Nordpilen,* the Stockholm–Narvik express or by air. At the foot of the hill, overgrown with tundra heather, lies Lake Luossavaara (altitude 499 m = 1,638 ft—see also Plate 14).

13 In northern Jämtland the slates, only slightly transformed by orogeny, have weathered into fairly fertile soils. Moreover, the Kjölen—as the high mountain range is called here—intercepts the wet and cold Arctic maritime air masses which, in consequence, arrive from the Atlantic in these easterly foothills with an altitude of slightly over 300 m (1,000 ft) as warmed up Föhn-type winds. Small wonder that peasants settled here as long as 1,000 years ago. Economically, and at times also politically, they looked towards nearby Trondheim, the medieval capital of Norway. Nowadays the greater part of the land is no longer under the plough but at best serves hay production.

14 The Kebnekaise massif in winter, seen from the Luossavaara panorama hill near Kiruna (see Plate 12).

15 Surrekaise (1,560 m = 5,120 ft) is located in the Kårsatjåkka range in the high mountains south of Kebnekaise, between the Kaitumjaures and Teusajaures valleys. These have been deepened by glacier flows during and after the Ice Age. The small lake on the southern flank is Livamjaure. Its level is almost 200 m (650 ft) higher than that of the Padje-Kaitum, the lake in the background (775 m = 2,544 ft and 582 m = 1,910 ft). The summits on the skyline reach between 1,300 and 1,600 m (4,250 and 5,250 ft) and mark the present watershed against the Norwegian coast. This mountain landscape, covered only by sparse vegetation, permits an unobstructed observation of the vigorous processes shaping the relief. Gravity and frost weathering are the principal morphological forces, with wind and water being only the available means of transportation for the sharp-edged detritus. Remnants of cirques are a reminder of very recent glaciation.

16 Kebnekaise is Sweden's highest mountain. The southern peak (2,111 m = 6,294 ft) has a small glacier on top, covered with a snowdrift whose shape and thickness vary with the wind and weather. In 1883 Charles Rabot, a French geographer, made the first ascent of Kebnekaise.

17/18 The Kebnekaise massif is one of the most heavily glaciated areas of the Swedish *fjäll.* During the last fifty years, however, the glaciers have diminished markedly as a result of climatic changes. Scientists at the University of Stockholm, which has a research station in the Tarfala valley below the glaciers shown on this plate, are studying this development.

19 The Swedish Skagerrak coast is hemmed by a band of bare skerries. They virtually lack soil cover and in consequence are almost totally treeless. Occasional small fishing settlements huddle on their leeward sides. In fine summer weather this fringe of skerries is a favourite pleasure ground of weekend sailors.

20 A total contrast is the cluster of skerries on the Baltic coast, of which the 20,000 islands and peninsulas of the Stockholm archipelago with its width of, at times, 80 km (50 miles) is the finest manifestation. The large islands of the inner fringe of the skerries, as well as those of the middle skerries, are wooded, while those on the outer fringe facing the ocean consist of bare cliffs. This is the favourite recreational area for the inhabitants of Stockholm, with thousands of cabins along the beaches and even more pleasure boats crowding the bays and anchorages. Further north on the coast of Ångermanland, the rolling Norrland landscape of large hills extends out into the ocean to form Sweden's most dramatic coast and island world. Mjält Island north of Nordingrå is Sweden's highest island, 236 m (774 ft) above sea level.

21 Along Sweden's Skagerrak coast the relief almost approaches the character of a fjord landscape, as on the Svinesund which forms the frontier with Norway.

Flora and Fauna

Sweden's settlement by vegetation and animals only slightly preceded that by humans. It became possible only after the Ice Age glaciers had once more released their hold on the country. The melting process took several thousand years. It began approximately 14,000 years ago in Skåne, and stopped about 8,000 years ago far in the north. The new countryside revealed by the melting of the ice shield contained numerous lakes, many of them covering large areas, their waters dammed up by the receding edge of the ice. This was the case, among others, with the so-called Bolmen ice-lake in Småland and the Jämtlandian ice-lake. The weight of the ice had depressed the level of the land to such a degree that the coastline was considerably further inland. When the pressure diminished the land began to rise from the sea—as indeed it still is— thereby enlarging the living space of plants and animals. In terms of area, density or variety of species, the post-glacial resettlement is by no means at an end yet. Of the flora and fauna existing in Sweden prior to the last glaciation scarcely any traces survive, with the exception of the remains of mammoths from the interglacial period, found in Jämtland. A study of this resettlement, especially by vegetation, is particularly instructive for an understanding of present-day conditions along the Arctic frontier. An important aid in these investigations is pollen analysis. This is based on the fact that pollen (as well as spores) has been well preserved for thousands of years in bogs, natural humus and marine deposits, and that the age of the strata in which the pollen has been conserved can be fairly accurately determined. By painstaking counts it is possible in theory to obtain for each region and every year a fairly precise picture of the composition and spread of the vegetation. That laborious work has been done, on a sample basis, over extensive parts of Sweden. The results of the counts are presented in the form of pollen diagrams. They make it possible to compare various areas with one another and to trace developments over prolonged periods of time. In summary the late glacial and post-glacial history of Sweden's forests presents roughly this picture (see also page 53):

1. *Early sub-Arctic phase; until 13,800 BC*
 The more immediate neighbourhood of the ice shield was characterized by tree-less plant associations. Sweden was still totally covered by ice.
2. *Sub-Arctic period; until 10,300 BC*
 The small mountain anemone *Dryas octopetala* became the

characteristic plant in the tree-less lichen and bog flora (tundra). The Dwarf birch *(Betula nana)*, which had survived the Ice Age on small ice-free locations in Scandinavia, spread over major areas. This was joined by certain varieties of small willows, *Salix herbacea*, the dwarf willow, and *Salix reticulata* along with, possibly, the Arctic willow *(Salix polaris)*. Central and north-western Skåne were the first parts of present-day Sweden to be free from ice.

3. *Wasteland period; 10,000–9,000 BC*

A temporary warming of the climate favoured first the Dwarf birch but presently increasingly the Birch *(Betula pubescens)*.

4. *Late sub-Arctic period; until 8,000 BC*

The temperature evidently dropped again. The birches disappeared; the diagrams are dominated by non-tree pollen. The ice-shield, after being stationary for a few hundred years, once more advanced a short way over a broad front, piling up the most magnificent ridge of moraines in northern Europe. This ridge extended from southern Norway (Raa moraine) through central Sweden to eastern Finland (Salpausselkä). The Baltic Ice Barrage Lake was formed as the first predecessor of the Baltic.

5. *Pre-Boreal (pre-warmth period); until 7,000 BC*

Birch and pine pollen predominate. After a halt of at least 800 years the ice once more began to melt. In the region of Uppsala it has been possible, for example, on the basis of the distance between the moraines and the evidence of the stratified clay to measure an annual retreat of about 250 m (800 ft). The southern and central Baltic basin filled with saltwater from the Yoldia Sea.

6. *Boreal; until 6,000 BC*

The warming of the climate now enabled not only pine but also a number of broadleaved trees, notably alder *(Alnus)* and hazel *(Corylus)* to spread generously through southern Sweden. The "hazel period" was succeeded by the "pine period". Birch and pine closely approached the glaciers which were still present as remnants of the vast inland ice shield in the mountains and in northern Sweden. As a result of the land rise the broad channel between the Yoldia Sea and the Western Ocean (Atlantic) ceased to exist. The Baltic turned into freshwater, forming the Ancylus Lake.

7. *Atlantic; until 3,000 BC*

Central and northern Europe were enjoying a climatic optimum never equalled since, characterized by a warm,

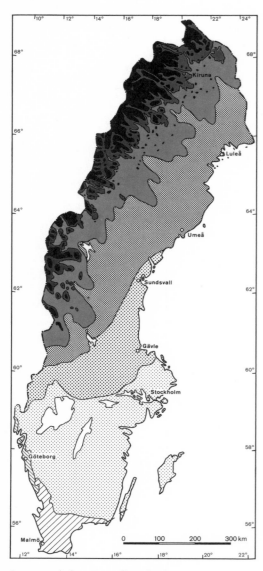

(acc. to Atlas över Sverige)

Beech forest region
Oceanic oak forest region
Mixed oak-spruce forest
(on SE coast without spruce)
Southern taiga
Central taiga
Mountain taiga
Fjäll birch forest
High mountain region (Kalfjäll)

maritime climate. Southern Sweden at the height of this warm period was covered with forests of oak, lime, elm, hazel, ash, and maple. In Norrland these were replaced for the most part by birch. In the mountains the tree line lay higher; for both birch and pine it was about 200 m (650 ft) higher than at present. Spruce pollen is also found in central and northern Sweden for that period.

8. *Sub-Boreal; until 500 BC*

The climate was for the most part a continental one, with high summer temperatures and increased snow and cold in winter. The beech *(Fagus silvatica)* advanced in Sweden at the expense of the mixed oak forests. The pine spread from the north and east towards the south, and reached a line extending from Öland to northern Småland and to Dalsland. (Today the natural southern and western boundaries go through Blekinge, northern Skåne, and up through Halland.)

9. *Sub-Atlantic; until the present*

A further deterioration of the climate, with colder and more humid summers, had a very negative effect on the development of settlements at the end of the Bronze Age. The high moors increased in extent. The broad-leaved trees retreated southwards towards their present lines of distribution. The mountain birch *(Betula tortuosa),* a small form of the birch *(Betula pubescens)* now forms the Arctic tree line in northern Europe. It is best adapted to cold dry conditions. At present the vegetation pattern is decisively determined by man.

An understanding of northern Europe's post-glacial history of vegetation requires more than an analysis of climatic changes. An important part is played also by the distances of glacial retreat locations, the refuges, and the speed with which a plant species overcame these distances during post-glacial spread. Added to this there are various other factors such as the emergence of new suitable soils, germination capacity, the composition of competing species, etc.

Information on these processes is provided by pollen diagrams. Among the trees the first to appear are the photophilic ones (pine and birch) which were able to spread rapidly even on humus-poor soils. Species with a lesser light requirement and higher demands on soil did not follow until later. The present-day distribution and composition of timbers is the result of the interplay of all those factors. Sweden is still covered by forest to 56%. By far the major part is used for the timber economy. Apart from distance from the markets

and accessibility it is, of course, the natural increase, i.e. the natural stock quality, that determines the intensity of utilization. That quality declines progressively to zero value at the tree line in the mountains. The tree line for coniferous forests maintains itself at about 800 m (2,600 ft) above sea level in Dalarna and in northern Lapland at about 500 m (1,650 ft). Above that line begins the region of the dwarf birch, interspersed with grey alder, aspen, mountain-ash, and bird-cherry, along with a number of varieties of willow. In the south it reaches 950 m (3,100 ft), in the north 200 m (650 ft) less, but with major local variations.

Only sporadically does the pine *(Pinus silvestris)* reach the tree line. It needs two vegetative periods to develop seeds capable of germination, but frequently two successive good summers do not occur for decades. In consequence, many age groups of pine can be lacking along the tree line, while a particular year can be represented by a great many trees. This explains why the trees forming the tree line need not necessarily be deformed through stunted growth. The time span between pines of equal age amounts to as much as 100 years at certain points in northern Europe. However, there are other factors also. Thus, sturdy pines may have standing by their sides young trees which have lost all their needles. For them wintering under the snow proved not a protection but a disaster. The reason is that the snow cover also favours the snow fungus *(Lophodermium pinastri).* This destroys the needles and only those pines which have grown tall enough to show above the snow cover have a hope of survival against that parasite. The snow fungus does not attack the birch. For this species the snow is the more effective limiting factor. It frequently forces it into strange shapes.

The Forest Regions

The further north one goes in that elongated country of Sweden, the harsher the climate becomes—a fact very clearly reflected in the changing composition of the forests. Farthest to the south is the *southern Swedish area of deciduous forests* encompassing those parts of the country south and west of the region where spruces propagate spontaneously. Here beech and oak are the predominating species. In addition, there are broad-leaved trees like elm, ash, lime, and maple, along with hazel. Pines are to be found in peripheral parts of the region. Such spruce forests as exist have been planted, to replace the less profitable beech woods.

The *southern region of coniferous forests* includes the remaining southern parts of the country, Götaland and Svealand, and

indeed all the way north to the southern border of Norrland—
i.e. a line running from the central Swedish lowlands of small
humps to a large, rolling countryside. This borderline also
closely coincides with the northern boundary of the oak
region. It traverses Värmland, continues down through
Bergslagen, and runs up again through Gästrikland towards
the Baltic. Here conifers predominate, especially spruce, but
these are heavily interspersed with southern deciduous trees,
except the beech.

"Oaks and noblemen do not go north of the Dal River"
claims an old saying. To the north, in the rest of Svealand
and in Norrland, lie the *northern regions of coniferous forest.*
That is part of the immense boreal area of forest that
occupies the northern parts of Russia, Siberia, and Canada.
The coniferous trees predominate: spruce on moist ground,
pine on drier, sandy soil. The deciduous species are primarily
birch and aspen, as well as grey alder. On southern slopes,
in climatically favourable locations, however, true broad-
leaved trees and hazel are to be found all the way north to
Ångermanland.

Within the areas farthest to the north the period of vegetation
is only three to five months. The summers are short and warm,
the winters cold and snowy. The mountainous region and the
northernmost areas of the country come close to the tundra,
where the ground never completely thaws out, even in summer.
Here, towards the mountains, there are many areas with very
flat ground. In such places the soil is exceedingly waterlogged,
bogs are common, and the coniferous forest is uniform. The
undergrowth consists primarily of low-growing bushes and
shrubs belonging to the family of heathers (Ericaceae), in-
cluding bilberry and bog whortleberry, as well as many varie-
ties with perennial evergreen leaves, such as lingonberry
(red whortleberry), bearberry, *ripbär* (Arctostaphylos alpina),
rosling (Andromeda polifolia), and others. The latter have
leathery leaves, or leaves resembling pine-needles cover-
ed with wax and equipped with recessed slits to reduce eva-
poration. Assimilation operates even during the cold spring
and autumn. In the coniferous forests of the *Fjäll* and on the
bogs, the spruces become smaller, the branches press tightly
against the trunk. In this fashion the trees take less sun
away from each other, and this type of growth also prevents
the weight of the snow from breaking the branches.

Marshes and peat bogs are common throughout the country.
The increase of the upland moors is dependent upon two
factors: precipitation and evaporation. In the Malar valley

peat bogs occupy only 1% of the land, whereas in the border region between Halland and Småland over half the area consists of moor, a result of the abundant precipitation in these parts. The cold climate in northern Sweden keeps the amount of evaporation relatively slight. Bogs account for 20 to 35% of this area; in upper Dalarna they cover more than 40%. The layer of peat, which consists primarily of peat-mosses (vitmossor) can reach a thickness of 10 m (33 ft). This is also the habitat of various species of scrub plants, including heather, crowberry, cranberry and cloudberry.

The vegetation zones provide the habitats of a definitive, well-adapted fauna which, however, owing to massive human intervention, differs greatly from its natural composition, at least in respect of certain species. Characteristic vertebrates include the reindeer (Rangifer tarandus), the Mountain hare (Lepus timidus), the musk ox (Ovibus moschatus)—at one time extinct in Scandinavia, but now reintroduced—as well as the lemming (Lemmus lemmus) and the Forest lemming (Myopus schisticolor).

The lemming is a small rodent, approximately 15 cm (6 inches) in length. It makes its den by burrowing under stones and under the roots of trees. It does not hibernate. This lively, pugnacious little rodent is to be found in the *Fjäll* area and the adjacent forest regions. It represents an important basic food for various birds of prey. The lemming's mode of life has not so far been well researched, any more than that of its cognate species, the Forest lemming, isolated from racially identical stocks in Finland and Russia. Both kinds of lemming migrate between the mountainous areas and the forests according to season. Their population totals reveal strange fluctuations. Every four or five years there is a mass increase which causes great damage to vegetation through root destruction. One then speaks of a "year of the lemming". Their mass migrations have become a legend. No obstacle, not even waterways, can stop their march; they plunge into the current and are carried away by it. Many are drowned. Others sometimes reach the coast, but they usually perish before getting that far. Food shortage, snow and cold, and, above all, birds of prey soon decimate the survivors of the "emigration".

In Sweden the reindeer is by now completely domesticated, and has for a long time provided the basis for the nomadic pasture economy of the Lapps. Stocks of domesticated reindeer

Animals

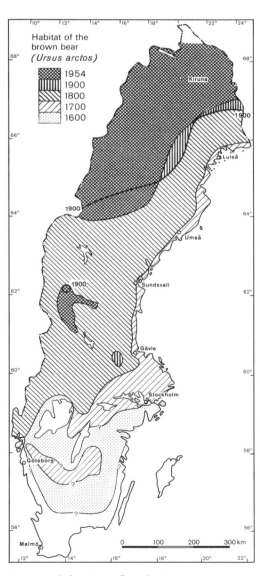

(acc. to Atlas över Sverige)

are estimated at about 275,000, of which 60,000 are slaughtered annually. There are mountain and forest reindeer, the latter being the larger and sturdier. The mountain reindeer spend the winter in the woods, where they feed on lichen scraped up from under the snow, as well as on tree lichens. In the spring they move to the mountain areas in the west, where the females give birth to their young within the low-lying *Fjäll* areas. The herds spend their summers in the valleys of the high mountains, grazing on all sorts of herbs, grasses, and leaves. During the Ice Age the reindeer was widespread throughout central Europe; it migrated into Scandinavia as the ice shield retreated. There are no wild reindeer left in Sweden now, the last having been shot in the 1880s. In Norway about 40,000 wild reindeer survive, as well as a few hundred in Karelia. At the beginning of this century the bear was extinct throughout southern Sweden and in the greater part of Norrland. Only in the very far north, in the *Fjäll* regions of northern Jämtland and Lapland and in the adjacent forest areas were there a few bears left. In addition, a few survived around Sånfjället in Harjedalen, a fact which caused that area to be declared a national park in 1909. There were possibly also some bears in the border regions between Gästrikland and Southern Dalarna. After a period as a protected species, from 1925 to 1942, their number increased again; today their estimated total is 400–600, with concentrations in northern Jämtland and in the forest and low-mountain regions of central Norrbotten.

The lynx, which had been driven back into the forests of Norrland, was considered so rare in the 1920s that in 1927 it came under total protection. As a result, the species increased rapidly. By the 1940s isolated specimens were encountered as far south as Bergslagen and Småland. At present lynx have been sighted in most of the provinces, the majority in Värmland, Dalsland, Närke, and southern Norrland. In 1942 they were no longer viewed as a threatened species, and today 40–60 animals are shot annually. It is assumed that there are 500–1,200 lynx in Sweden.

There are no wolves left in Sweden except for occasional arrivals across the Finnish-Swedish frontier. The disappearance of the wolf has made it easier to tend the reindeer. Its absence has also been a major reason for the exceptional increase in the number of deer during the last fifty years. Whereas at the end of the nineteenth century there were only a few left in southern Sweden, today they are to be found as far north as Norrland.

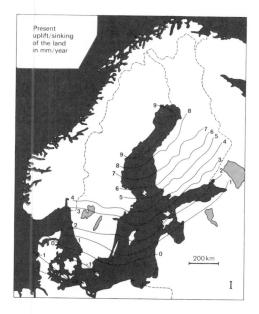

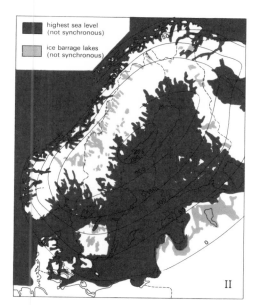

The genesis of the Baltic

The process of the genesis of the Baltic Sea is of fundamental importance to the re-emergence of life in northern Europe following the disappearance of the Ice Age glaciers.

The present rate of land uplift, which is seen as a consequence of the removal of the weight of the ice and which has been proceeding at an uneven rate at least since the melting of the inland ice, permits reliable conclusions to be drawn concerning the changes in level in the Baltic region. This compensatory movement is called isostasy. It reaches its at present highest value of 1 m (40 inches) per century at the centre of the former inland ice at Umeå (Map I).

At times this land uplift was overtaken by a rise in the sea level, the eustatic movement (see diagram p. 00). Maps III/IV show the uplift of the land up to the stage of development in question. The rise in sea level is a consequence of the inflow of melt water into the sea. The interplay of land rise and sea level rise has left behind an enormous number of shore lines. Moreover, large melt water lakes (ice barrage lakes) formed inland for a time. The greatest extent of this water cover, which, however, did not exist everywhere at the same time, is shown by Map II. Among the highest coastlines (HC, see diagram p. 00) it has been possible to identify shore lines which were unmistakably formed by a salt water sea. In this way laborious studies of the terrain have led to a very accurate understanding of the history of the Baltic.

Map III shows the virtually lifeless cold Baltic ice barrage lake. This existed until 10,000 years ago and had its main outflow through the Billingen Gap, but also drained through the Öresund and at times from north-eastern Finland to the White Sea.

A few centuries later the ice had retreated from the Billingen Gap. Since the level of the world ocean had rapidly risen its salt water burst into the Baltic area in a broad front across central Sweden. The Yoldia Sea (Map IV) came into being. This produced a milder climate in landlocked southern Sweden, to such an extent that alder and hazel joined the birch and pine (see page 00, pre-Boreal).

Although the melting of the ice sheet progressed very rapidly during the next 1,000 years the land rise during that period again overtook the rise of the sea level. In consequence, the broad sea link between the Yoldia Sea and the Skagerrak by way of central Sweden was closed and the water remaining in the Baltic basin gradually became fresh. About 9,000 years ago the Ancylus Lake came into being. It drained through the primeval river valleys of the Svea, Göta and Dana (Map V).

By then the uplift of the land in the North had reached such an extent that the Ancylus Lake was virtually tipped out towards the South. This flushed the Danish Straits clear to such an extent that salt water was once more able to advance through them. After about 2,000 years of the Ancylus period the Baltic basin was once more salted up by the Littorina Sea.

At present the trend is again in the opposite direction.

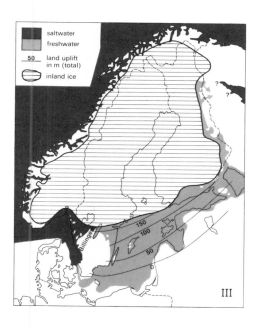

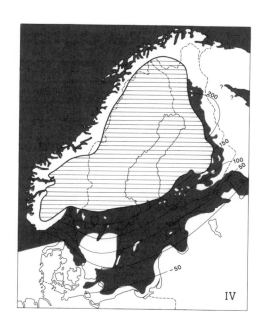

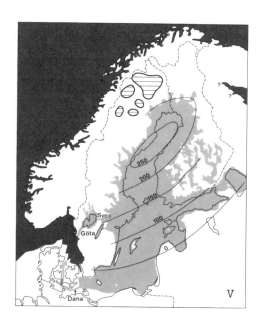

The most important large game of the Swedish forest is the European elk *(Alces alces)*. This species was also threatened with complete extinction at the beginning of the nineteenth century. It was saved by a total hunting prohibition from 1808 to 1817 and again from 1826 to 1835. At present the elk population in Sweden is roughly 300,000 in winter in spite of a larger shooting quota every year. In 1977 no fewer than 70,000 elks were shot, and the annual quota for 1978 is thought to come close to 90,000. It is calculated that an annual shooting quota of 100,000 elks would be necessary to keep the number of animals at an acceptable level. The elk is optimally adapted to living conditions in forests and bogs; it can swim, wade through deep swamps, and stamp through snow several feet deep, provided that there is no hard crust. The extermination of the wolf in Sweden—for all practical purposes its only enemy except for man—is a factor in the increased elk population. The elk is not particularly shy and merely walks away serenely if it is disturbed. It has been known to make an entirely unflustered appearance in densely populated areas and to take a walk along the streets of garden suburbs. Elks are a great hazard to traffic, because they often cross roads in order to pass from one section of a forest to another. The number of elks killed in traffic accidents increases every year: 2,515 in 1976 and 3,277 in 1977. As these figures represent only the reported accidents, the actual totals must be higher.

Among the predatory animals of the forest areas are several species of stoat, such as the marten, the badger, the otter, the polecat, and the ermine. The largest type of stoat is the wolverine, nowadays forced back to the *Fjäll* environment in Norrbotten. Its prey consists mainly of reindeer, hare, fox, and, in rare cases, elk. The number of fully-grown specimens is estimated at between 50 and 80. Its territory can extend over as much as 2,000 km² (772 square miles) and it makes daily journeys of up to 70 km (43 miles). In the winter it often prefers long migrations down to the coastal region and southwards in which case it may range as far as central Sweden.

Birds The world of minute creatures makes itself painfully noticed by billions and billions of midges, horseflies, gnats and mosquitoes. The countless inland waters and, above all, the bogs and other damp areas provide ideal breeding grounds. The vast insect world supports a rich bird life. Their great radius of action and their speed of locomotion has led to a relatively

plentiful range of bird species; predominantly these are birds of passage. Thus a great deal of life invades even the brief summer of the far north. There the waders *(Limicolae)* predominate; they feed on the small creatures living in pools and mud. Among them are dotterels, sandpipers like the wood sandpiper, and snipes, which spend only a relatively short breeding period in the far north and migrate to their southern winter quarters as early as the end of August. Of duck and goose species only a few breed this far north, such as the bean goose and the lesser white-fronted goose, the wigeon, the scaup, the goldeneye, and the long-tailed duck. The whooper swan breeds, though rarely, on the vast bogs of northernmost Lapland.

Reptiles (lizards and snakes) have greater difficulties in adapting to living conditions in the tundra than mammals and birds (warm-blooded creatures) since their body temperature depends on the ambient temperature. To ensure that their eggs have the necessary warmth for maturing they are not, as elsewhere, deposited on the ground but kept within the maternal body until hatching. Thus the Common lizard *(Lacerta vivipara),* for instance, a lizard widespread from the Alps to the North Cape, has managed to fool the zoologists: it is not "vivipara" at all, i.e. it does not give birth to live young since the eggs which it hatches inside its body are not connected to the maternal blood circulation. This is true also of the slow-worm *(Anguis fragilis)*. The adder, too, bears fully-developed young in eggs, which hatch as soon as they leave the body of the mother.

Lizards and Snakes

The change in the water fill of the Baltic between salt, brackish and fresh water—a change over an extraordinarily short period in geological terms—during the recent, postglacial, genesis of the Baltic and its predecessors made exceptional demands on the flora and fauna of these waters. The initial Baltic Ice Barrage Lake was extremely poor in species and individuals. Very soon it found a direct link to the North Atlantic by way of central Sweden and the Skagerrak. From there, together with the saltwater, the saltwater fauna made a rapid advance. The snail *Yoldia arctica* (nowadays called *Portlandia arctica)* was well adapted to life in cold saltwater. It is regarded as the guide fossil for that stage of development (8,000–7,000 BC) and consequently gave its name to the Baltic for that period. The Yoldia deposits cover large parts of what is now dry land in the Baltic region.

Wet Habitats

About 7,000 BC the progressive uplift of the land again severed the broad link to the open sea across central Sweden. The water masses in the Baltic basin became freshwater. Characteristic of the changed marine fauna was the snail *Ancylus fluviatilis* which still inhabits the unpolluted mountain streams of central Europe. The outflow of the Ancylus Lake was by way of the Svea and Göta rivers, and subsequently by way of the Dana river and the Danish Straits. The further vigorous rising of the land surface in the northern Baltic area, due to the removal of the weight of the melted ice shield, virtually tipped the Ancylus Lake out towards the South. The massive outflow volume flushed out the Danish Straits to such an extent that, in a countercurrent along the bottom, saltwater was again able to advance. Soon—about 5,000 BC—the present Baltic basin up to the Gulf of Bothnia was filled with mixed brackish water. This phase received its name from a snail, the Common periwinkle *(Littorina littorea)*. About 4,500 BC the Littorina sea was most clearly defined. After that date a slight loss of salinity once more took place. Characteristic of that phase was the freshwater snail *Radix peregera* (formerly *Lymnaea ovata baltica*). During the Littorina period the northern part of the Bottenvik still had a salt content of 0.8%. Nowadays the boundary of this salinity extends as far south as a line from Trelleborg (southern Sweden) to Rügen in the southern Baltic.

The rapid change in the salinity of the predecessors of the present Baltic was a result of changes of level following the Ice Age. Thus many an inland lake was also cut off from its former saltwater links. Part of the fauna succeeded in adapting to such changes in their environment and continues to exist— often in stunted forms—as a particularly interesting object of ecological research. The small crab *Mysis relicta,* not unlike a shrimp, is regarded as a survivor from the Yoldia period. The Greenland seal *Phoca groenlandica,* still lived off the Atlantic coast and in isolated places in the Baltic towards the region of Sundsvall during the Littorina period. A large part of the fauna of the Swedish inland lakes in the region of the Baltic clearly goes back to a former marine environment. Thus the Ringed seal *(Phoca hispida),* still surviving in Ladoga, among other places, the fish *Myoxocephalus quadricornis,* the crabs *Pontoporeia affinis* and *Msidotea entomon* are found on Arctic coasts, in the Baltic, as well as in such Russian, Finnish and Swedish lakes which, at the end of the Ice Age, were linked with the Baltic or one of its predecessors (the Yoldia or Littorina Seas).

The author wishes to thank Lilla Zadory for her indispensable help with this chapter.

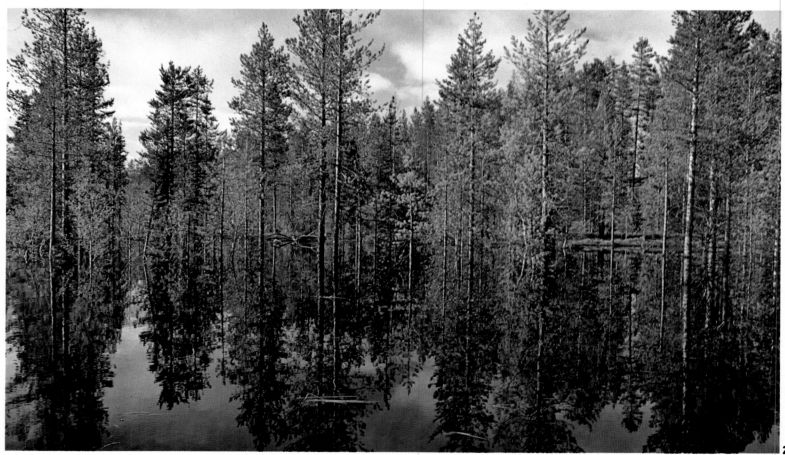

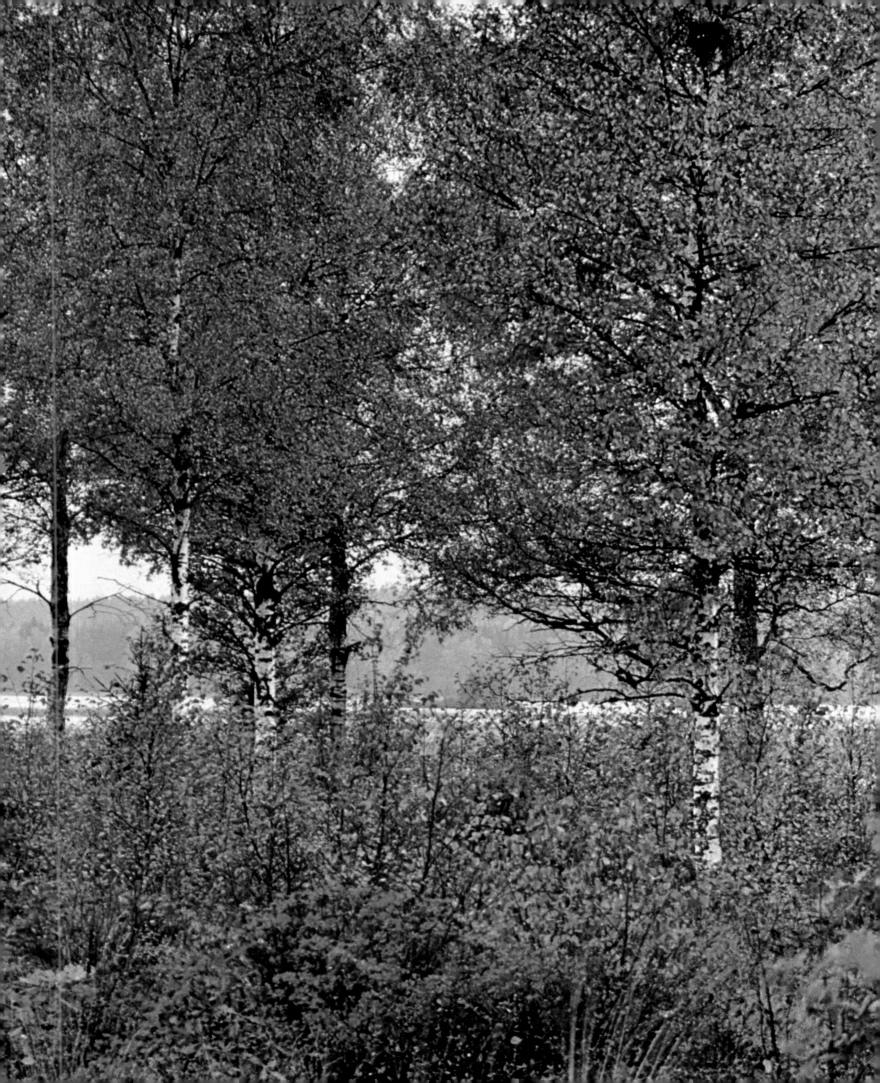

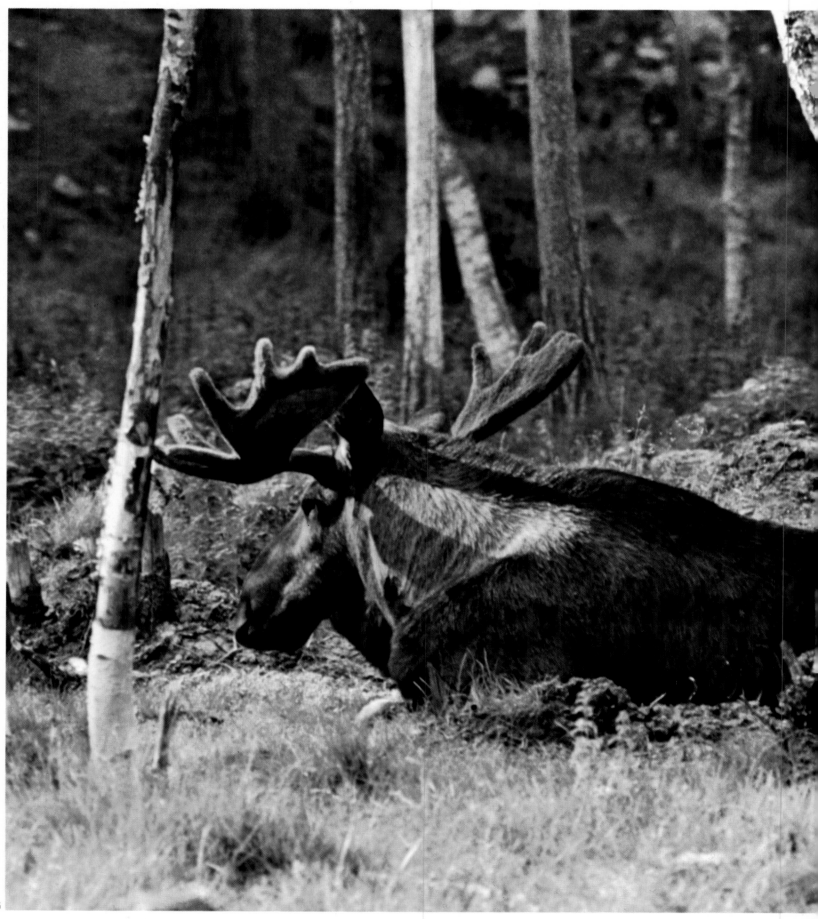

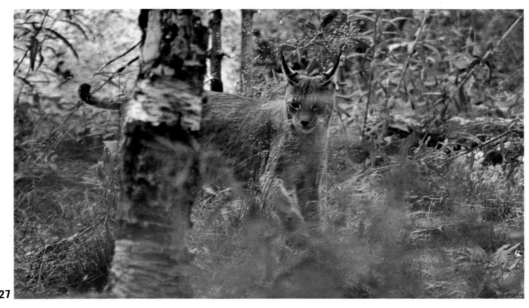

27

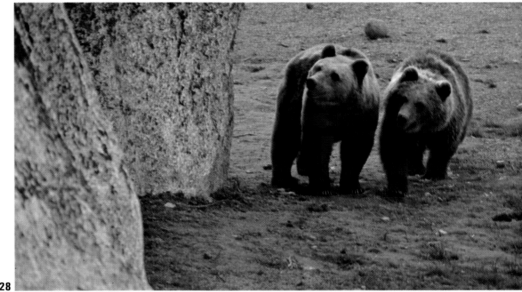

28

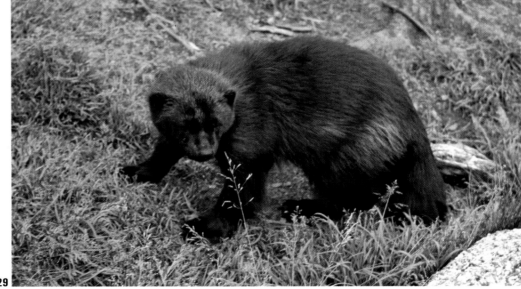

29

30

31

32

33

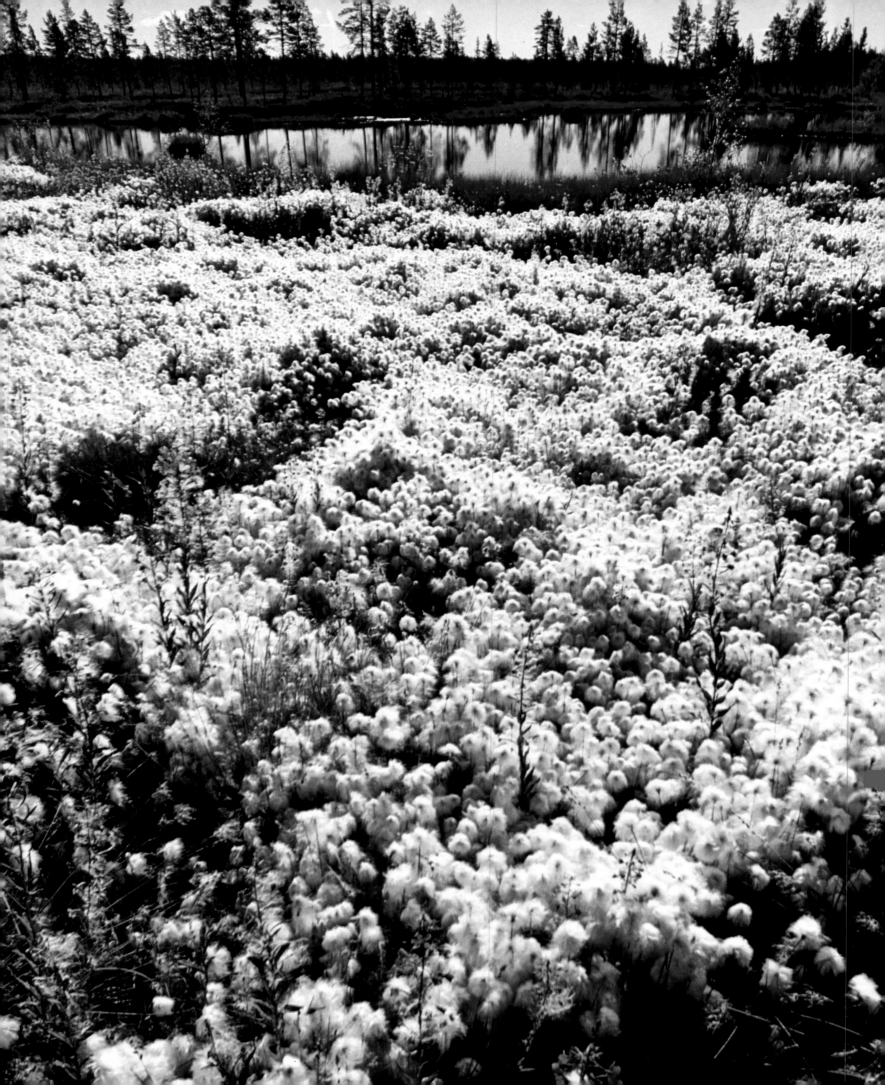

22 Rosebay Willow-herb (formerly *Epilobium*, now *Chamaenerion angustifolium*) is found all over Sweden. It prefers the edges of woods and ditches, or forest clearings, and thrives plentifully on the gravel along railway embankments. It is, therefore, also called the "trolley-rose".

23 The mixture of pine and birch is typical of the taiga, the northern coniferous belt. In southern Sweden the deciduous species are more numerous, fringing the woods with lime, ash and wild cherry trees with their clouds of white blossom in springtime.

24 On the young, still uneven, terrain of the Swedish forest regions there are frequent water blockages in the spring, sometimes on still frozen ground, as well as flooding and swamp formation—and by no means only after the thaw—and, in consequence, numerous clearings among the stands.

25 In spring the birch enlivens the gloomy taiga with its light green and in autumn with the golden hues of its foliage. The autumnally tinted small leaves of the lush bilberry plants on the ground are a magnificent brilliant purple, especially under the oblique rays of the sun.

26 A fully grown bull elk *(Alces alces)*, with fourteen tines. The antlers become bigger and grow more tines every year; they are biggest on a 10–12 year-old bull elk. The elk sheds his antlers in the autumn after the mating season. There are two types of elk antlers: the "palmate" with shovel-shaped horns is seen in the picture. The "cervine" type has no scoop, or only a very small one, but long antler points. There are about 300,000 elks in Sweden. In 1977 70,000 elks were shot.

27 The lynx *(Lynx lynx)* is the only wild cat of the Nordic forest. Fifty years ago it was so rare that it was declared a protected animal. It has now increased again in number and, from time to time, can be observed as far south as Småland. The number of lynx in Sweden is uncertain. Statistics vary between 500 and 1,200. The hare is its most common prey.

28 The Brown Bear *(Ursus arctos)* was native to large parts of Europe only a few centuries ago. The arrival of fire-arms has exterminated it except for a few survivors—this was true also of Sweden at the end of the last century. Since then, however, the species has increased in numbers thanks to far-reaching protective measures. A comprehensive census in 1975–1976 indicated the existence of 400–600 bears in Sweden.

29 The wolverine *(Gulo gulo)* is a large stoat and a much feared beast of prey (1 m = 40 inches long, 45 cm = 18 inches tall). In Sweden it lives primarily in the mountains of Lapland, but it often travels great distances. On such occasions it can be seen in central Sweden. Its prey are hares and foxes, but it also attacks reindeer, and in more unusual cases, elks. In the spring of 1974 the estimated number of fully grown wolverines was 50 to 60 animals.

30 The Common Butterwort *(Pinguicula vulgaris)* thrives as a land or water plant alongside or in lakes and bogs. If feeds on insects which it traps with a viscous slime secreted by the leaves—insects being exceedingly plentiful here. The Common Butterwort is used for making "long milk". One rubs the milk bowl with the plant and when the milk is allowed to turn sour the result is not normal soured milk but one that makes long, gluey threads. But it tastes good.

31 The Common Sundew *(Drosera rotundifolia)*, although not related to the Common Butterwort, likewise feeds on insects which are trapped by its glandular secretions. The drops of viscous slime on the ends of the glandular hairs are clearly visible in the picture. This flower, too, thrives on damp ground, often together with peat-moss.

32 The Yellow Mountain Saxifrage *(Saxifraga aizoides)* grows in the mountainous regions between Härjedalen and Lapland. It likes damp ground and grows readily in the gullies of streams. The flower can vary in colour from lemon-yellow (as in the picture) to brick-red.

33 The Creeping Azalea *(Loiseleuria procumbens)* is an Ericacea with leathery evergreen leaves. It is frequently found in the dwarf shrub tundra. Because of its frost resistance it can survive in windy and generally exposed locations. In summer it contributes to lending colour to the tundra, together with bilberry, cranberry and crowberry. It is found from Dalarna to Lapland.

34 The association of lichens (and mosses) with dwarf shrubs is characteristic of the tundra. The plate shows the whitish Reindeer Moss *(Cladonia alpestris)*, well known in central Europe for its use in wreaths, as well as the yet unripe red fruit of the broad-leaved Cloudberry *(Rubus chamaemorus)*, top left the Bilberry (Blueberry) *(Vaccinium myrtillis)* as well as—dotted among the reindeer moss—the needle-leaved Crowberry *(Empetrum)* with its black fruit. Stabilized patches of mountain bog can be completely covered by reindeer moss.

35 Cotton Grass *(Eriophorum scheuchzeri)*—seen here together with Rosebay Willow-herb—is a ubiquitous feature of Nordic swamps and bogs. This Cotton Grass has only one tuft of wool, as opposed to its relative in the lowlands and southern Sweden, the Common Cotton Grass which has three or more seed spikes.

65

The Swedish State

The origins of history

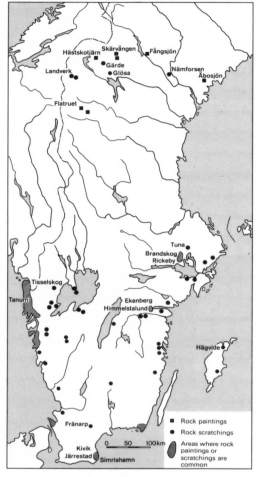

Sites of Bronze Age rock paintings (acc. to Sternberger 1977; see Plate 36)

Until the Swedes emerged from their inaccessible forest the rest of Europe took little notice of them. Early contacts with other countries were characterized in every respect by Sweden's insular isolation. Man had undoubtedly come into the country from central Europe in pursuit of his prey—into a country which for roughly 12,000 years had been freed from its Ice Age glaciers and been covered first by tundra and subsequently by birch and coniferous forest. During the last 7,000 years such an immigration may also have taken place from the East, across the Ancylus Lake and the Littorina Sea, the precursors of the Baltic. Traces of Stone Age settlements are widespread all the way up to the far North. They can be used both for determining the age of ancient beachlines and also for the dating of prehistoric finds. From the New Stone Age artefacts of North-Eurasian cultures have been found along the entire Swedish coast from Gästrikland to Skåne and thence north again along the west coast to the Oslo Fjord and, further on, sporadically along the southern Norwegian Skagerrak coast. Southern Finland and the entire Baltic region must also have been inhabited by hunters and fishers of approximately similar culture at that time. The sea was no obstacle to them. The Baltic islands of Åland, Dagö, Ösel, Gotland, Öland, what are now the Danish islands, and northern Jutland were part of their living space. Towards the end of the New Stone Age (1,400 BC) came the appearance on the scene of the "Nordic funnel beaker folk", thus called after the peculiar form of their pottery. They so conspicuously chose the relatively most favourable arable soil for settlement, and nowhere else, that they can hardly have depended on hunting and fishing alone for their food supplies. While in exactly the same settlement areas the huge megalithic tombs made their appearance during the next few centuries, East European "corded pottery people" took possession of the whole of southern Sweden and spread northwards along the Baltic coast; on the Finnish side to almost as far as the Arctic Circle. Evidently they flourished for only a few centuries because at the peak of the Bronze Age, from the 11th to the 8th century BC, the permanent settlement of Sweden was again predominantly confined to the southern and western coasts as well as the fertile Silurian region near Falköping between Lakes Väner and Vätter. This is an area which has been conspicuous as an inland settlement region ever since the New Stone Age.

66

At the beginning of the Iron Age in Scandinavia, at about 400 BC, a fairly uniform culture began to emerge, embracing the whole of the southern Norwegian coast, southern Sweden with the islands of Öland and Gotland, and south-western Finland, as well as the whole of Denmark and the central north German plain between the Weser and the lower Vistula. This was the cradle of the Germanic peoples who, through their contact with the Roman Empire at the beginning of our era, entered the spotlight of recorded history. In these most ancient written records we already encounter the subsequent name of the Swedish state in the form of the tribal name of the *Suionen (Svionen)* and in the 7th and 8th centuries as *Sweonen*—in Swedish; *Svear*—in Svealand, i.e. central Sweden, whereas the inhabitants of the area along the Götaälv and around Lake Vätter are called *Göten* or *Gauten*. It is to them that the name of Götaland goes back (see Map A, page); the extreme South of Sweden, i.e. Skåne, was settled by the *Dani.* The subsequent name of the state of Denmark goes back to them.

Nothing of importance is known about the *Svear* for centuries while a great deal more is known about the *Göten,* though not necessarily under that name. We are not sure when the *Göten* began to cross the Baltic. Presumably this had been done "ever since the beginning of human memory". At any rate, immigrants from southern Sweden with the tribal name of *Goten* (Goths) were settled on the lower Vistula about the beginning of our era, and Goths were quite certainly represented in Russia in the 4th century. There their country of origin, i.e. Sweden, was known as *Rus,* just as the Finns call Sweden *Ruotsi* to this day. The origin of the name can be traced to Roden, i.e. the Swedish Baltic coast, the starting point of the Viking expeditions. In Uppland it survives as Roslagen. *Roden, rus* also gave Russia its name. The Goths had well-established (no doubt changing but as a rule permanently inhabited) settlements from which they conducted a far-reaching trade. They were capable of rowing or sailing their ships, or taking them overland on rollers from one waterway to the next. They frequently appear to have sailed the Volkhov, Dvina, Volga and other East European rivers. The fact that they appeared at Constantinople to engage in barter trade, and indeed also to serve as mercenaries, does not seem to have surprised anyone there; people were familiar with these Nordic elements.

These distant connections had significant effects on Sweden itself. Not only did the trade bring in profits and new know-

67

ledge, but the Goths also made very early contact with Christianity through Constantinople. Ulfilas, the son of a captive Christian couple from Cappadocia, a region in the interior of Anatolia, in the 4th century became bishop among the (later) Western Goths. He translated the Bible into Gothic. A copy of that translation found its way from Italy to the monastery of Werden on the Ruhr in the 6th century, and thence to Prague, where it was seized as booty by Swedish troops in the Thirty Years' War. Since 1669 this unique linguistic document, known as the "Codex argenteus" (thus called because it was written with silver Gothic letters upon purple parchment), has been kept at the University Library in Uppsala. The treasure is best known under the name of the "Ulfilas Bible". Portions of a second copy of that Gothic Bible were found in 1758 in the library of Wolfenbüttel. Parts of a third copy were discovered in Italy in 1817. A few further finds of fragments followed, for instance in Turin, including an explanatory paraphrase of the Gospel according to St. John in Gothic, dating back to the 6th century. This work was reprinted in Munich in 1834: "Skeireins aivaggeljons thairch Johannen". With the aid of this ancient linguistic document it has been possible to understand the entire Gothic language and to reconstruct its grammar.

The Goth's early contacts with Mediterranean civilization are probably to be credited, long before the creation of the Ulfilas Bible, with the development of the Germanic runic script which was used with astonishing uniformity among all the Germanic tribes and peoples throughout Europe. Such cultural uniformity across these kinds of distances must have been due to lively contacts. Shipping offered the only conceivable prerequisite at that time. Even at an early date the people of Scandinavia had developed the art of ship-building to an amazing degree of skill. They built stable boats, boats capable of being transported overland, resilient and easily manoeuvrable. The method of bolting the ribs firmly to the keel made it possible, more so than with any previous method, to enclose a large space along the full length of a side.

Of even greater importance was the invention of a rigging which, for the first time in history, made it possible to tack against the wind, and—with a small crew, i.e. without oarsmen—to venture out on to the high seas and to undertake distant voyages. None of this had been known to Phoenicians, Romans, Persians, Arabs, Malays or Chinese, all of whom were otherwise great seafarers. With these fast sailing craft

the inhabitants of northern Europe were able to travel to Scotland, Iceland, Greenland, and North America. They reached every corner of the Mediterranean and penetrated into the Black Sea.

The ships, moreover, were the largest transport containers which had ever been built. The rest of Europe knew these seafarers as Norsemen, Normans or Vikings. But such collective names reveal nothing about their tribal origin or homeland. The Goths' seamanship supplemented their earlier skills in covering very great distances overland along the natural waterways, and in winter on their ice cover, even though they never were a nation of horsemen. In consequence, they met the limits of their mobility wherever their kind of route, i.e. suitable rivers or lakes, did not exist. Such limits they often encountered in the Mediterranean region. And that was where, in the end, they perished. It is no coincidence that they also invariably avoided the great mountain ranges of Europe.

Due to their location on the Baltic the voyages of the *Svear* were less far ranging. They travelled primarily towards the east, along the Russian rivers. In time their area of settlement extended from their heartland in the Mälar countryside northwards as far as Dalarna and Gästrikland and then all along the coast to Västerbotten. By way of the archipelago they reached Åland and the Finnish coastal area. The inhabitants of the various provinces elected their own Kings and had different laws, but from time to time they came together, *Svear* as well as *Göten,* for consultation and cultic worship in Old Uppsala, the political and religious centre of the day. The trading centres of the *Svear* were on the Mälar; the most important were Helgö, Birka and later Sigtuna which is nearer to Uppsala. The corresponding centres outside the Swedish mainland were Visby on the west coast of the island of Gotland, Haithabu on the Schlei, and Rerik near present-day Wismar, Jumne or Veneta on the island of Wollin in the Oder estuary, Truso near present-day Elblag, Wisikauten on the Amber coast of Samland, and Seeburg, the later Grobin near Libau (Liepaja), and finally Ladoga on the estuary of the Volkhov into Lake Ladoga—certainly from the 9th century onwards. Before that date Holmgard had existed for many centuries—the subsequent Naugard or Novgorod on the outflow of the Volkhov from Lake Ilmen. This was a collecting point of the traffic to the Orient via the Dnieper and the Volga. In this way the *Svear* began to enjoy the benefits of long-distance trade at an early date.

Beginnings of a State About the year 1000 the first political unity was accomplished between the two Swedish tribes, the *Svear* having achieved a dominant role for the past few centuries. Chronologically the political unification coincided with the Christianization of north-eastern Europe. It was in the year 1000 that Olof Skötkonung, the king of the *Svear* allowed himself to be baptized in the spring at Husaby in Västergötland. The early contact of the Goths with Mediterranean Christianity did not produce any lasting consequences in the North. Christianization now spread from Bremen and Hamburg via Dalby and, later, the neighbouring Lund to Denmark, south-western Sweden and the area of the Oslo Fjord, in some parts as early as the 9th century. Among the Scandinavians the missionaries encountered vigorous opposition. The inhabitants of Svealand, in particular, succeeded in keeping aloof from the new

The Viking Period (800–1050) acc. to Helge Ingstad in: Norden i text och kart, 1976.

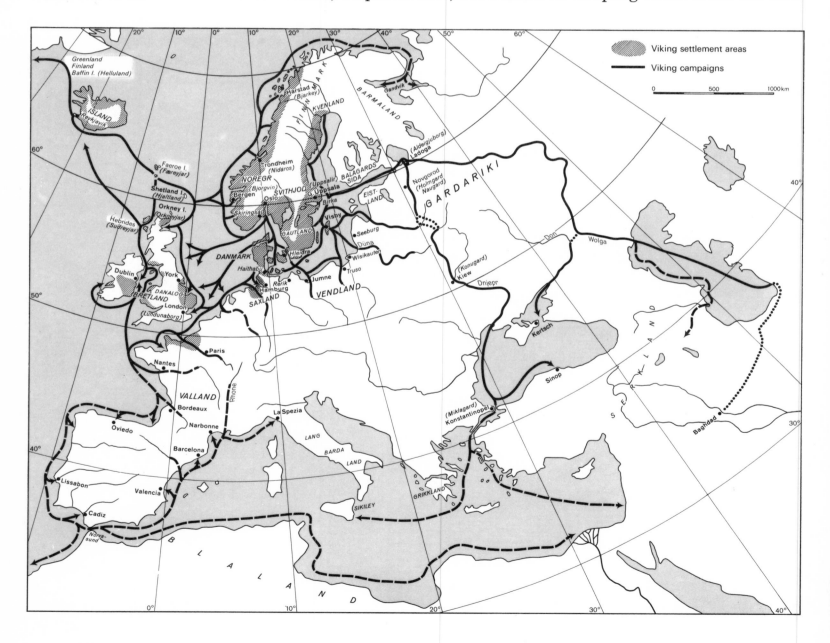

faith for a considerable period. One reason for the stubborn resistance was possibly to be found in the social innovations rather than in the religious message. Militant monks and priests, as well as Knights of the Teutonic Order, believed that they might dispose of the local peasantry in the way that was possible in the Levant or in southern Europe. The population, however, would not tolerate an aristocracy with inherited privileges or a privileged clergy as its governing class. In addition to savage resistance there was also emigration—from Norway, for instance, to Iceland, from Svealand up along the coast of Västerbotten and to Österbotten on the other side of the Gulf of Bothnia. These clashes at times also caused a split between the *Svear* and the *Göten*. This was the case, for example, when Blott-Sven took power after Olof Skötkonung, who was baptized at Husaby in Västergötland in 1000 A.D. It was a reversion to heathendom which led to dissension and a temporary dissolution of the unified kingdom. It was not until the 13th century that Birger, "Jarl of the Swedes and Goths", succeeded in once more establishing some measure of central power and in pacifying the country. (Jarl, meaning something like "stout fellow", is cognate with English "earl".) In 1255 he founded Stockholm—as a lock across Lake Mälar—and granted the Hanseatic League the rights of free trade there. The ancient pagan centre of Uppsala had meanwhile become the see of an archbishop; building of the cathedral had started in 1260. However, Swedish history was to be dominated for nearly three more centuries by exceedingly savage disputes and intrigues of the nobility and the clergy. These classes did not succeed in properly establishing themselves whereas, by contrast, a marked rise was taking place in the small towns of a middle class represented by merchants and guilds.

The great intellectual currents of the Late Middle Ages, which —originating mainly in Italy—engulfed large parts of western and central Europe, only left some very modest traces in Sweden. The opportunities which a flourishing trade might have offered the country suffered a severe setback when the Hanseatic city of Visby on Gotland was destroyed in 1361 by the Danes led by Valdemar Atterdag. The ruins of sixteen churches, in addition to the surviving cathedral church (built between 1190 and 1225), testify to the lifestyle of the 20,000 inhabitants at that time. The town has never since had so many inhabitants.

The fall of Visby marked the beginning of a prolonged period of Danish supremacy in northern Europe. It was sealed by

the Kalmar Union of 1397, by which the brilliant Queen Margarete of Denmark, having already acquired the Norwegian crown, gained that of Sweden as well. As far as Sweden's development is concerned, that period brought no improvements. Even in the 15th century nobility and clergy remained a great economic burden upon the peasantry.

In the Mälar region and in the central Swedish ore region of Bergslagen, in particular, the most vital areas of Sweden, most of the grievances were blamed on Danish rule since the Danes protected the Church and collected the taxes. The severe tax burden resulted in the 1430's in a peasant uprising led by the mining homesteader Engelbrekt and in the overthrow of the Danish king, Eric of Pomerania. The union was re-established soon after Engelbrekt's death, and a period of civil strife between the unionists and the nationalists began, with power alternating between Swedish kings or regents and Danish supremacy. These tensions culminated in the Stockholm Massacre of 8th November 1520, when the Danish King Christian II, crowned with the assistance of the Archbishop of Uppsala, Gustav Trolle, had all opponents of Danish rule within reach arrested and, a few days later, beheaded in the market place of Stockholm—roughly 600 burghers and noblemen.

Sweden's Rise to Great Power Status

This dreadful event was a turning point in Swedish history. That same winter Gustav Vasa prepared a counterstroke from Dalarna and in February 1521 occupied the famous copper mines of Falun. Supported by the miners he moved on to Gävle, where he was welcomed by the citizens. At Whitsun he succeeded in capturing Uppsala, the residence of the hated archbishop. Gustav, who had lost his father and brother-in-law in the Stockholm Massacre and who had been held imprisoned by the Danes as a hostage at Kalö in 1518/19, until, with the support of Lübeck, he succeeded in escaping, continued the struggle. In June 1521 Gustav Vasa, again with Hanseatic support in the shape of troops and ships, succeeded in capturing Stockholm. His triumphal advance rapidly developed into a Swedish war of liberation against Denmark. In 1523 Gustav Vasa, then 27, was elected King of Sweden at Strängnäs on the southern shore of the Mälar.

His realm was in a pitiful state. It needed peace. The formal dissolution of the Kalmar Union by the Malmö Recess in 1524 meant that Sweden's most powerful opponent, Denmark, was being held at bay for the moment. At home the next task was breaking of the power of the Catholic Church. This

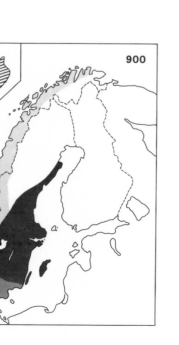

900

was achieved by the enactment of the Reformation by decision of the Riksdag—the Diet—at Västerås in 1527. By one fell stroke the Crown, and hence the state administration, thereby acquired money through the sequestration of the monasteries and Church domains. Admittedly this led to some local unrest among the population, especially in Dalarna, and Småland, where there was resistance to the removal of the church bells. Gustav could not avoid granting the nobility a few hereditary privileges, as a result of which a number of big farmers established a genuine feudal position for themselves. Their hereditary privileges were fully institutionalized in 1569. As a result of the successful war against Lübeck, the "Feud of the Counts" *(Grevefejden)* (1534–36) carried on together with the Danes, the economic grip of the Hanseatic League on the Swedish mercantile cities was loosened, even though Sweden's foreign trade as late as towards the end of the sixteenth century was, in the final analysis, to pass into the hands of Lübeck. The fact that Gustav succeeded in retrieving some of its extraordinary privileges even from the Hansa again testifies to his skill as a negotiator. His successes led him to feel secure in his position: in 1544 he got the Riksdag of Västerås to endorse the hereditary nature of the Crown. That was the formal end of the ancient Germanic elective kingship.

When Gustav I Vasa died in 1560, after a reign of 39 years, he left behind a state consolidated in every respect. His sons and later successors lost a good deal of that by pointless wars and mismanagement. When Sigismund—simultaneously King of Poland—tried to re-introduce Catholicism he was overthrown (1599). He was succeeded by his uncle Charles IX (1599–1611), and by his son, Gustav II Adolf (1611–1632). As rulers they pursued Gustav Vasa's endeavours to establish a centralized government. They organized public administration by the far-sighted and consistent establishment of an effective civil service. Parliament took on more definite outlines. The country was divided into *län* (administrative districts) administered by governors loyal to the King. The educational system was developed and the foundations laid of what was later to become universal compulsory education. The school ordinance of 1649 provided for the organization of higher education. Grammar schools *(gymnasier)* were established and Uppsala University was enlarged. The army and the navy were also raised to an unprecedented level.

To begin with, the Swedes were not particularly successful. The war of Kalmar (1611–1613) against Denmark ended with

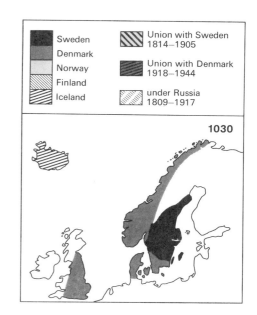

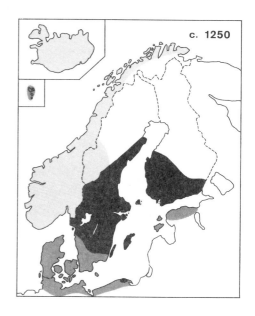

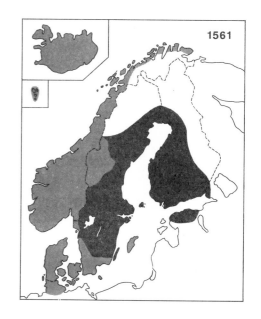

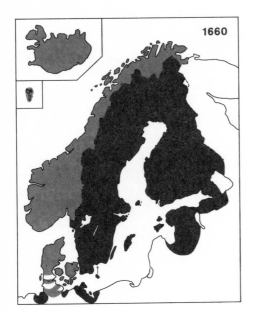

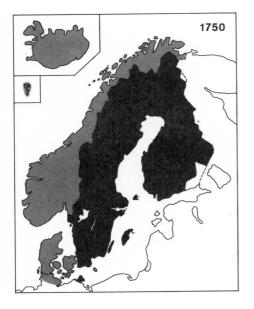

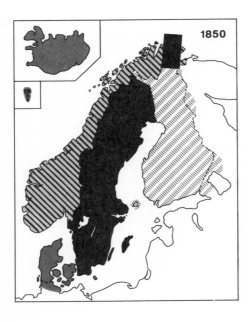

the Peace of Knäred: the Danes, having taken Älvsborg, the fortress protecting Sweden's only harbour in the west, demanded a sum of a million "rix-dollars" to be paid over a period of six years. Until that time they held on to the fortress of Älvsborg and six districts *(härader)* in Västergötland. The ransom for Älvsborg—its present equivalent would be at least ten billion Kronor—was paid by levying a surtax in excess of customary taxation. In 1621 Gustav II Adolf was able to grant privileges to the new city of Göteborg whose location at the mouth of the Göta River he had personally helped to choose.

The Swedes also waged war in the east, against the Russians and the Poles, and with greater success. In the Peace of Stolbova (1617) Sweden received Ingermanland and eastern Karelia, which meant that Russia lost her access to the Baltic. And in 1629 at Altmark, the Poles had to hand over parts of Estonia and Latvia to the Swedes. Continually repeated attempts by the Poles as much as by others to set a Counter-Reformation in motion in Sweden also induced the Riksdag in 1629 to instruct the King to intervene in the Thirty Years' War against the Catholic House of Habsburg. In 1630 Gustav II Adolf landed with his Swedish armies on German soil and within a short time inspired great respect for Swedish military power. After his death on the battle-field of Lützen, on 6th November 1632, the war continued with varying fortune for the Swedes. The final success was crowned by the Peace of Westphalia (1648) by which Sweden received the greater part of Pomerania, along with Wismar Bremen, and Verden. Just before this the Swedes had defeated the Danes, who, in the Peace of Brömsebro (1645), were forced to relinquish Gotland, Jämtland and Härjedalen, Särna in Dalarna, Ösel, as well as Halland for a period of 30 years. In addition, Swedish ships were exempted from the Sound Toll. The following decades were marked by continual conflict with Denmark, a struggle that after Charles X Gustav's surprising expedition across the frozen Danish Straits, the Great and Little Belts, was brought to an end with the harsh Peace of Roskilde (1658). This confirmed the conquests acknowledged by the Peace of Brömsebro (1645); in addition, Sweden received Skåne, Blekinge, Bohuslän and Halland in perpetuity. After a few years, however, because a Dutch intervention, Sweden was obliged to return Bornholm and the Trondheim *län* to Denmark although these had been assigned to Sweden under the terms of the Peace Treaty. With the conclusion of this Peace Sweden reached the zenith of its power in northern

Europe with its greatest territorial extension and control of the Baltic Sea area including important harbours at the mouths of the German rivers. These external successes and territorial gains demanded internal consolidation, especially in the economic field. Charles X Gustav had already taken action against the nobility's increasing acquisition of former crown lands by his *Fjärdepartsräfsten* decree which reduced these holdings by a quarter, and Charles XI, who was by then an absolute monarch in practice—a fact confirmed in theory by parliament in 1693—continued to execute a radical diminution, to the point of a virtually total revocation of the fiefs received by the nobility in earlier times.

At a very early date, 1632, a university had been established at Dorpat for the Baltic parts of the realm. Eight years later Abo Academy was founded. In 1668, ten years after the Peace of Roskilde, Lund University was inaugurated, a measure designed to link the conquered provinces more closely with the Swedish Kingdom.

Absolute monarchy worked out badly for Charles XII, the son of Charles XI, crowned at the age of 15. Sweden's neighbours, Denmark, Poland and Russia, humiliated by Swedish victories, formed an alliance and in 1700 simultaneously attacked on three fronts. This was the curtain-raiser for the great Nordic war. At first the Swedes were victorious: they won a crushing victory over the Russian armies at Narva and fought with great success in Poland and Saxony. While the young king with his army was wasting his strength in the depths of the continent—as Napoleon and Hitler after him—and eventually suffered defeat at Poltava in the Ukraine (1709), the Russians succeeded, undisturbed, in setting up their new capital, St. Petersburg, on the Gulf of Finland (1703). With the remnants of his army Charles XII remained in Turkey as a refugee and a petitioner for five years. He did not succeed in persuading the Sultan to attack Russia—the Sultan was himself too hard pressed by the Habsburg attacks in the Danube region. After his legendary ride across Europe to Stralsund he tried without success to organize the defence of Swedish Pomerania. Upon his arrival in Sweden he raised a new army for an attack on Norway, where he was killed outside the fortress of Fredrikshald in 1718.

Charles XII's sister, Ulrika Eleonora, was chosen to rule, and was succeeded only a year later by her husband Fredrik I. Absolute monarchy was abolished, and parliament and the Council of the Realm took command with one goal in mind:

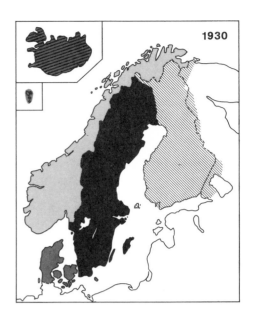

Decline

acc. to Staffan Helmfrid in: Norden i text och kart, 1976

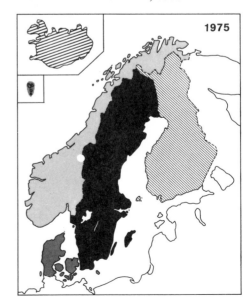

to obtain peace for the country at any price. Hanover received the Bishopric of Bremen in return for one million *Thaler*. Prussia took possession of Outer Pomerania as far as the Peene in exchange for an indemnification of two million *Thaler*. Sweden was also obliged to relinquish its toll exemption in the Öresund as part of the peace with Denmark. Russia achieved the biggest territorial gains through the final peace of Nysad (1721). Sweden was forced to abandon Livonia, Estonia, Ingermanland, and eastern Karelia, including Viborg. Sweden's hegemony was at an end.

The succeeding great power in the Baltic was Russia with its new capital of St. Petersburg, which by the end of the 18th century had 200,000 inhabitants. It has remained the biggest city on the Baltic ever since.

During the 18th century, until the reign of Gustav III, political life was marked by the emergence of the party system. Parliament and the Council made the decisions. The king's power was weak, at times non-existent, until Gustav III, by his coup d'état in 1772, reintroduced a strong monarchy, which, a few years later, was to result in a new absolutism. He was assassinated at the celebrated masked opera ball in 1792.

Industry was supported by customs duties and loans. Mining was of great importance. Swedish iron dominated the world market. In 1770 Sweden provided 40% of the world's production of pig-iron. The thought of revenge, especially against Russia, lived on. Sweden started several Russian wars (1771, 1788, and 1808), but all of these ended more or less unsuccessfully. The last was a disaster, as Sweden lost the whole of Finland.

While political reverses were paralleled by continuous economic set-backs, a remarkable spiritual renewal began in the 18th century which later, throughout the 19th and 20th centuries, raised Sweden to a respected position in science and the arts. Her cultural level and the prolonged period of peace—ever since 1814—have since opened roads for Sweden in economic and social policy, both in theory and in practice, which may be regarded as not unrealistic models for reforms in other countries. For decades now the Swedish economy has ensured a socially balanced standard of living at a level not achieved anywhere else. This extraordinary success was accomplished without detriment to the remarkable health of the natural environment which, because of its special conditions on the edge of the Arctic region, is susceptible and vulnerable to any ill-considered overtaxing.

The foundations of Sweden's present-day legislation, the *Swedish Ideas of Law* "Sveriges Rikets Lag" which governs civil and criminal law *and Justice* (1734) and the Basic Law determining the form of government (1809) go back to the 17th century. The latter was supplanted in 1975 by a new Constitutional Law concerning the form of government. In spite of frequent amendments the old law no longer matched the reality of Swedish democracy since important fundamental features of Swedish parliamentary practice had continued to develop outside the written Constitution. The fact that this was possible is probably typical of the pragmatically tolerant way of life in Sweden. It is a manifestation of a surviving tradition of the Germanic concept of law. In civil law, similarly, there is nothing like the comprehensive codification of the French *Code Civil* or the German *Bürgerliches Gesetzbuch*. Ever since the end of the 19th century that flexibility has made it easier to achieve a large measure of harmonization of civil law among all the Nordic countries. The countries of the European Community will have to dream for a long time yet of any similar integration.

The Swedish legal system is so flexible that it is a downright pacemaker of domestic reforms rather than a system adhering to principles in order to preserve existing states of affairs and thereby acting as an obstacle to progress and hence, as is happening in many countries, becoming the nutritive soil of political radicalism. In consequence, there is internal peace in Sweden. Is that not also a prerequisite of the external peace so often envied by others? It is accepted here as a matter of course that life should rewrite the laws of the judiciary. It has long been understood in Sweden that the orderly administration of a big country inevitably results in a big bureaucratic machine and that such a machine can all too easily, with entirely unintentional insensitivity, steamroll the interest of the individual. To prevent this, the institution of Ombudsmen has been established. The office of the Judicial Ombudsman has existed since 1809. The Judicial Ombudsman, abbreviated to JO, is appointed by Parliament. His task is to ensure that the judges and officials observe the laws and ordinances. They can be prosecuted for neglect on their part, in which case it is the primary duty of the JO to denounce mistakes deriving from "self-interest, evil-doing, partiality, or flagrant negligence, or which create a general uncertainty about the citizens' rights". Not even members of the Supreme Court or the government are exempt from the JO's control. In 1915 the office of Military Ombudsman (MO) with comparable duties concerning national defence was

created. Later an Ombudsman dealing with the liberty to pursue a trade (NO, 1954) and a Consumer Ombudsman (KO, 1971), with similar supervisory duties, were appointed.

The influence of this institution of the Ombudsman on the public awareness of the law and hence flexibility in law-making and case law is extremely great. Foreign observers have not always paid sufficient attention to its existence and function. The often daringly progressive decisions of the Swedish Riksdag, for instance in the field of labour and social law over the past forty years of Social Democratic government, are more easily understood if one reflects that any unpremeditated or undesirable results of the legislators' actions will be spotted and examined by the Ombudsmen. They thus provide an excellent prerequisite of adapting the state apparatus to the continually changing requirement of the nation. In this way the bureaucracy, which is there to serve the citizen, is so controlled that scarcely any scope is provided for dissatisfaction with the state.

It is because Sweden possesses a well-tried system for correcting grievances that whatever social problems, emancipation problems, or calls for protective measures—either for human concerns or the natural environment—may arise are always new and topical but never explosive. One just lives with them. Problems and their solution represent a normal part of Swedish everyday life, just as making mistakes is not regarded as anything bad. Mistakes are occasions for reflection, for doing better in the future. There is always a next time. That "next time" must be tolerable for all concerned, and it should be better than the "last time". This kind of consideration underlies Sweden's penal system.

A state of this kind, of course, costs money. Consequently Swedes have to pay heavy taxes. The taxation system has a levelling effect and, in this respect, is controversial even among the Swedish public although, by comparison with other nations, it is highly homogeneous. Criticism comes chiefly from those who are convinced that they are giving more to the state than they receive from it.

Present Form of Government Sweden has always had a Riksdag and in that respect has always been a democracy. At the same time it has always been a kingdom. The division of powers between the Riksdag and the King or, in his place, a Regent, Crown Council or Protector, naturally varied over the course of history. The Constitution of 1809 has been subjected to a thorough reform since the fifties of the present century. The present Consti-

tution consists of three Basic Laws: the Law on the Form of Government of 1974, the Law on the Succession of 1810, most recently amended in the autumn of 1977, and the Press Law of 1949. Added to this is the Riksdag Law of 1974. The Constitution of 1809 had granted the King rather extensive powers; however, in line with 20th century practice, these have become primarily formal in character. Quite recently, in 1974, Parliament ratified a new form of government according to which the King, while still the Head of State, exercises strictly representative duties. He is not permitted, even to the slightest extent, to become involved in politics. The influence of the Royal House, of course, is still considerable in cultural and social matters. This is an understandable consequence of the esteem which the most recent royal generations have enjoyed with the public.

Political power is in the hands of the Government. This consists of the Premier and a varying number of Ministers— up to 20. Fourteen of them are heads of departments, the rest are without portfolio. Most of the Ministers belong to the ruling party, or the ruling parties, and are members of the Riksdag. Their parliamentary duties, however, are performed, during their tenure of Ministerial office, by deputies. Ministers are entitled to speak in the Riksdag but not to vote. They are appointed by the Premier but may be dismissed either by him or by the President of the Riksdag. The Cabinet is collectively responsible for all its decisions. No minutes are kept of the one to three weekly Cabinet meetings. The staff of the 14 departmental Ministries comprises only about 100 persons each, including cleaning women and drivers. Numerous routine decisions are taken quite informally over the daily joint lunch of the Ministers in a dining room of the Government building not open to the public. As a rule only the top official of a Ministry, the Secretary of State, is appointed on a political basis. Appointment of Ministerial officials is exclusively within the competence of the Government. The Riksdag is not entitled to comment on this. For the implementation of Government decisions the Ministries have, subordinated to them, central administrative authorities headed in each case by a Director General.

Since 1971 the Riksdag has consisted of one Chamber only, which at first had 350 members, and since 1976 has had 349. The life-time of a Parliament is three years. Every Swedish citizen, from the age of 18, has the vote and the right to be elected. Sweden is divided into 29 electoral districts. Seats in the Riksdag are assigned by proportional representation

on the basis of the votes in the country as a whole, supplemented by 39 listed seats. Small parties must collect at least 4% of all valid votes cast in the country in order to get a seat in the Riksdag. For each individual constituency, independently of the above, the 12% rule applies. The Riksdag can overthrow the Government or unseat individual Ministers by a simple majority, while on the other hand the Government can at any time dissolve the Riksdag and hold new elections. Their result is valid only for the remainder of the current parliamentary period. The normal session of the Riksdag is eight months, from October—when it is ceremoniously opened by the King—until May. Parliamentary work is largely done in 16 specialized committees and once a week in plenary session. The elections for the members of the county councils and the municipal authorities take place at the same time as those for Parliament. The 24 county councils, each one responsible for a *län,* are primarily concerned with health care. Since 1976 even foreigners have been eligible to the municipal assemblies provided they have been locally resident for not less than three years.

The political picture is determined by five parties among which the Social Democrats over the past forty years have invariably gained between just over 40% and just over 50% of the vote, and have, with the support of the Communists, been able to acquire a majority in Parliament. In the 1976 elections the bourgeois parties—the Centre Party, the Liberals, and the Conservatives—gained a majority, and formed a coalition government led by the Centre Party, with Torvald Fälldin as Prime Minister. In the autumn of 1978 this coalition broke up over conflicting views on nuclear power, and Fälldin resigned. Ola Ullsten became Prime Minister when the Liberals formed a minority government. The Swedish press (which of course enjoys unrestricted freedom) with approximately half its circulation inclines towards Liberal attitudes. About one quarter supports the Conservatives and one quarter the Social Democrats.

Sweden's foreign policy pursues a strict neutrality in all warlike conflicts and since 1814 Sweden has not been involved in any war. Since 1946 the country has vigorously co-operated within the United Nations and many of its sub-organizations. Sweden is also a member of OECD and of the Coucil of Europe. The Nordic Council, a consultative parliamentary body serving co-operation between the Nordic countries (Denmark, Finland, Iceland, Norway, and Sweden), provides Sweden with an important organ for co-ordinating its foreign policy.

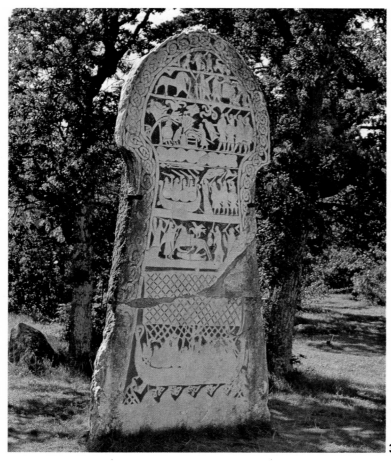

37

38

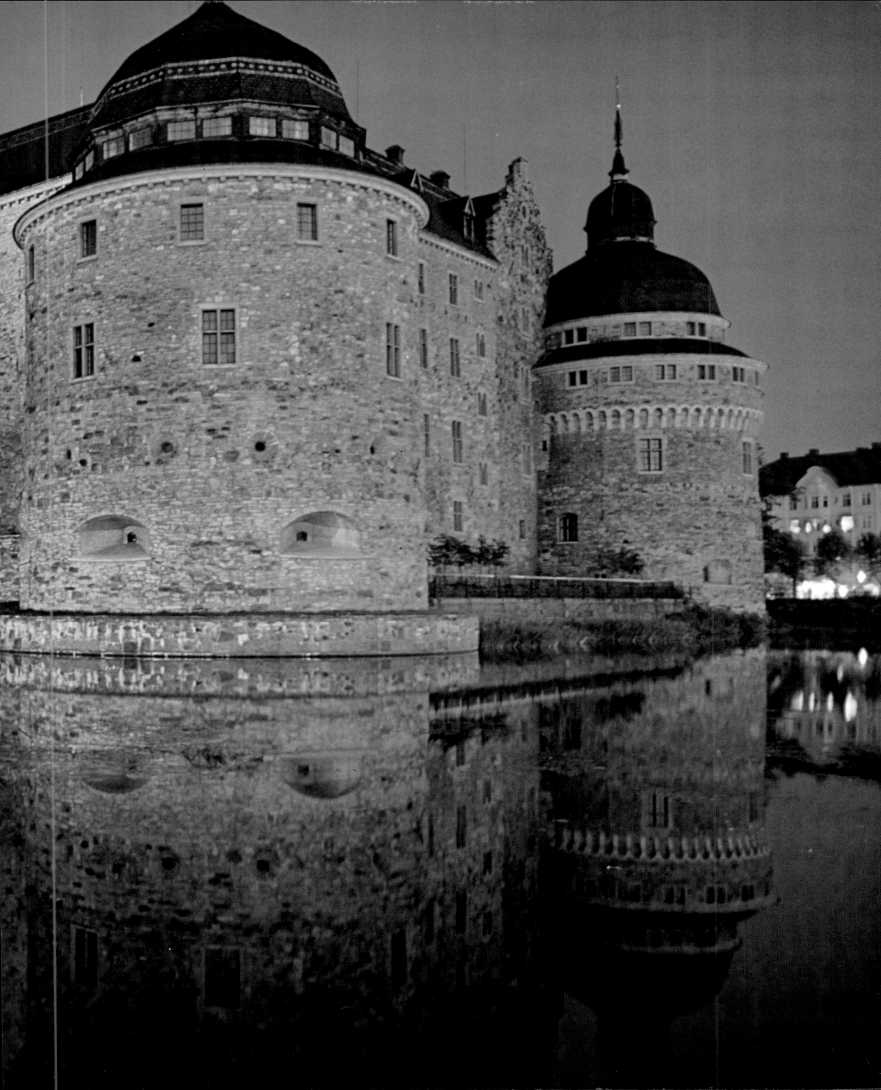

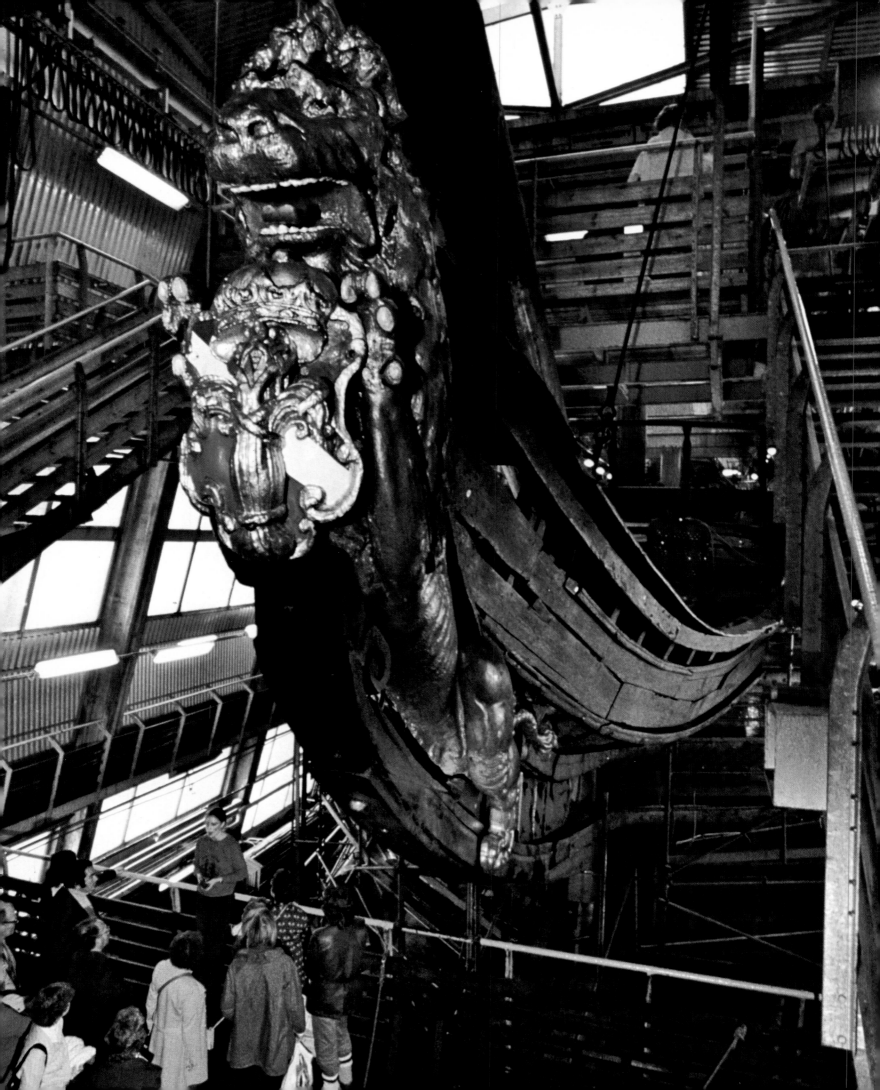

36 Important traces of settlement dating back to the middle of the second millenium BC, the Bronze Age (18th–5th century BC) are known mainly on Sweden's west and south coasts. In Bohuslän, in particular, revealing rock carvings have been found. Most of these show hunting scenes and ships (still without sails) and symbols of the sun and of the god's presence (see the footprints in the upper right-hand corner). They were scratched into the rock during magical-religious rites, and the pictures were to induce the gods to grant the believers good crops and fertile live-stock. The lime regions between Lakes Väner and Vätter were settled a few centuries earlier. It is thought that agri-culture played an important part even then (see map on page 66).

37 Only on Gotland are there picture stones from the Iron Age of the type shown here. They are covered with a symbolic picture language, about which we know very little. They were possibly incised to honour the gods, or possibly they served the same purpose as the Bronze Age en-gravings on the rock shelves. We note Viking ships—at the same time the ship that was to carry the dead chief to Valhalla —we see Odin's eight-footed horse, battle scenes, stallion hunts and many other events of symbolic significance to the Nordic inhabitants.

Other standing stones found in large num-bers are the runic stones, of which there are 3,000 in Sweden, most of them in Upp-land. They were set up as memorials to a dead father, mother or son. The text in runic letters is short, consisting mostly of only a few words about the person honou-red and naming the person who raised the memorial and the engraver.

38 Towards the end of the neolithic period —in Sweden about 1,500 BC—or even later, when the Bronze Age had already begun in the south of the country, a num-ber of remains testifies to settlement on the then coast of northern Sweden ap-proaching the Arctic Circle, 40 to 50 m (130 to 165 ft) above the present level of the Bottenvik. The finds are generally confined to tumuli of unhewn stone without any metal objects as grave furnishings. Pos-sibly they testify only to seasonal (summer) settlement, since it is only in the South, above all in Småland, that such tumuli are found in large numbers, grouped to-gether in dozens; these are clearly Bronze Age and partially show a transition to cremation burial (Iron Age, 500 BC to AD 400). The plate shows a prehistoric tumulus near Kåge, north of Skellefteå. Since 1827, this area has been a rich source of archeological finds, yielding so far well over 100 stone weapons and implements, many of them of south Swedish type. Some of the stone piles, however, are not tombs but refuse dumps of stones burst through heat, evidently used for bringing water to the boil in wooden vessels. Near Bjurselet, a little further to the North, it has been possible to confirm the cultivation of barley, the keeping of sheep and cattle (2,000 BC), and—at Norrböle/Ångerman-land—also the cultivation of wheat.

39 The exceptional significance of the ship even in early Germanic times—in southern Sweden since the transition from the Bronze Age to the Iron Age, i.e. from about 500 BC—is reflected by its symbolical inclusion in cultic performances. Impor-tant individuals were honoured by a tomb in the shape of a ship. The stones are usually planted immediately above the then shoreline, with the keel axis perpen-dicular to it. The stem and stern stones are especially tall, while the rib stones very regularly decrease in size towards the middle of the hull. Ship stone tombs are particularly common on Gotland, where there are over 300 of them. Only one-tenth of them has so far been more closely investigated. Similar tombs have also been found along the south-eastern coast of the Swedish mainland, on Åland, Bornholm and on the western coast of the Gulf of Riga. The biggest of them (near Gnisvärd/Tofta on Gotland) is 45 m (148 ft) long. As a rule their length varies from 6 to 20 m (20 to 65 ft).

40 The fortified church of Hossmo, south of Kalmar, dates from the late 12th cen-tury and, like many other churches in the neighbourhood, was fortified during the 13th century to support the castle of Kal-mar. Its interior was elaborately furnished in the rococo style in the 18th century.

41 Visby, the "city of ruins and roses", is one of the most remarkable and most ancient cities in Sweden. Visby is situated below a high cliff of Silurian limestone on the western coast of Gotland. Its harbour, protected by some limestone cliffs, served the Vikings as a base for their voyages between Birka, Haithabu and Novgorod (Naugard). Finds of thousands of silver coins of Arab, German and Anglo-Saxon origin testify to the range of their trade relations. A trade treaty with Henry the Lion, Duke of Saxony, in 1161 was followed by the foundation of German merchant guilds in Visby and, in the 13th century, by its accession to the Hanseatic League. The approximately 20,000 inhabitants of those days equipped their city with several hospitals, monasteries and 17 churches, as well as a massive town wall 3.5 km (over 2 miles) in circumference. In 1361, however, Visby was taken and sacked by the Danes. During the next few centuries it remained a notorious hiding place of pirates until, in 1525, the forces of Lübeck put a bloody end to their activities, sparing only the German Church, since then the Cathedral Church. In the 18th century Visby experienced a feeble second flo-wering. Nowadays the city, though the see of a bishop and the administrative centre of Gotland, only has about 17,500 inhabitants—plus, in the summer, thou-sands of tourists.

42 In the centre of the town of Örebro (118,000 inhabitants) on an island in the Svartån stands the massive castle which received its present shape in the 16th cen-tury, when it was reconstructed in the Renaissance style under the Vasa kings. The castle has repeatedly been the scene of important events in Swedish history. It was captured by Engelbrekt in 1434 and by Gustav Vasa in 1521, on both occasions during a war of liberation against Danish hegemony. The castle was last besieged in 1568, when Duke Carl occupied it during the war of sedition against his brother Eric XIV. The Parliament of 1810 in Örebro chose the French marshal Jean Jacques Bernadotte as heir to the Swedish throne—to become King Carl XIV Johan. In 1812 Parliament accepted the new decree on the freedom of the press and signed a peace with Britain—although no war had in fact taken place.

43 The *Wasa* is the oldest warship that has been salvaged and provided with its own museum. She had sunk in Stockholm harbour on her maiden voyage on 10th August 1628 for reasons never quite ex-plained, "with sails hoisted, flags and all", entirely undamaged. In August 1956 the wreck was rediscovered after a systematic search. It was salvaged between 1959 and 1961. The brackish water of the Baltic offers no habitat to the shipworm *Teredo navalis*. The seabed silt, which is low in oxygen, has likewise contributed to the excellent preservation of the vessel.

Sweden's Population

Regular Swedish population statistics have been kept since 1749. Since that date the population total has increased nearly every year: from 1,780,678 (1750) to 8,236,179 (1976). The increase was never steady and, in the present century in particular, shows a number of significant irregularities in spite of a general decline and an increased balance between births and deaths. After the first world war a clear drop in births was recorded for the first time, an average of 90,000 per year in the 1930's. It was at that time that Gunnar Myrdal's book *The Population Crisis* appeared. These low figures for the thirties rose rapidly during the second world war, and remained at a rather high level during the 1950's and 1960's, with annual births in the 1970's averaging between 107,000 and 114,000. During the 1970's there has been a downward trend. In 1976 the number fell below 100,000 for the first time since the thirties.

On the basis of the low level of the birth rate in the mid-seventies the probable population total for the year 2000 has been calculated at 8,343,500. This projection does not, of course, make allowance for fluctuations in the birth rate—which are evidently determined only by attitudes—and therefore is rather unreliable. It is nevertheless certain that the number of people over 80 is dramatically increasing.

The change in the age structure of the population is no less important to the national economy than a change in the population total. If official predictions prove correct, there will be—in spite of an appreciable decline in the birth rate—155,300 more people of working age (16 to 64 years) in the year 2000 than in 1980. And that in a phase of technological progress which allows more and more to be achieved by fewer and fewer people.

This trend in the age structure makes important demands on the state in respect of the provision of the necessary infrastructure—capacity of schools, hospitals and old people's homes—as well as with regard to the labour market and consumption.

Guest Workers It does not justify speculation, for the rest of the century, of a rosy future, for instance, for Mediterranean guest workers of whom Sweden in 1976 had roughly 31,000 Yugoslavs, 14,350 Greeks, 5,100 (1975) Turks and 4,600 Italians. In any case, the fluctuation in manpower requirements with the upward and downward movement of the economic cycle is largely met by the immigration and re-emigration of Finns (in 1976 some 118,000 were employed in Sweden) who benefit from the open Nordic labour market for the nationals of all

five Nordic countries. In 1976 there were in Sweden 266,677 employed foreigners and, all told, 418,000 foreign citizens— more than ever before. Naturally, in such a modern country as Sweden there has been a change in occupation structure since the advent of industrialization (from the middle of the 19th century) as against a pattern that until then had been uniform over the centuries: then the increase in manpower resulting from an increase in the population total was absorbed almost exclusively—and indeed had to be absorbed—by agriculture, forestry and fisheries. This problem was partially solved by emigration, always a symptom of economic (and hence social) upheaval, of uncertainty, and of restlessness.

Emigration from Sweden gathered momentum in the latter half of the 19th century, reaching its height between 1881 and 1890 when there were 376,400 emigrants, nearly all to North America. Industry was not yet sufficiently developed to be able to absorb the overpopulation of the rural areas. The number of emigrants varied greatly from year to year, depending on the economic situation on the American continent as well as in Sweden, but remained more or less constant around 250,000 per decade until the first world war. A new peak occurred in the 1920's, which were difficult years in Sweden.

Emigration

It has been estimated that as a result of emigration Sweden has lost 1,200,000 citizens. Not all provinces were affected in equal measure. During the peak of the 1880's more than 1% of the population in the Jönköping and Kronoberg *län,* in Öland, Halland and Värmland, and in the Älvsborg *län* emigrated. Emigration was lowest in the Mälar valley, where industry was already in a position to provide numerous opportunities for employment. The Norrland *län* also showed relatively low emigration figures because there was still space for colonization in the interior of the province, along with a rapidly developing saw-mill industry in the coastal regions. These attracted the unemployed not only from Norrland but also from those typical emigration provinces Värmland and Dalsland.

Swedish emigration has been richly documented at the "Utvandrarnas hus" (The House of the Emigrants) in Växjö.

The number of persons engaged in agriculture, forestry and fishing reached its peak about 1880 with a total of 3.1 million, the equivalent of one third of the entire population. Ninety years later (1970) that figure had declined to one-tenth of the 1880 figure, down to 276,000 or 8% of the total population, and it continues to decline. Agriculture alone, which at the

91

end of the 1930's was still providing a livelihood for approximately 35% of the population now employs only about 6%, although this number produces more than ever before. The total of persons employed in industry which showed massive growth rates during the first half of the 20th century, at present stagnates between 1.1 and 1.2 million, which is 34% of the total of persons employed. Administration, both the public and private sectors, the health service, teaching and technology, have absorbed a very large part of the country's manpower. In percentage terms this category is approximately on a level with industry; it continues to increase all the time, with annual increments of up to 100,000 in the 1970's. Only a few of these jobs offer opportunities to guest workers.

The changes in the age structure and the occupation structure is very clearly reflected in the changes of population distribution. This is the period when the population has become almost completely urbanized.

Officially no distinction is made in Sweden between town and countryside, since both are joined together administratively by the municipality. Seen geographically, a municipality consists of an urban centre—generally what one would formerly have called a "town"—a number of densely populated areas *(tätorter)* and, interspersed, the rural areas *(glesbygd)*. The term *tätort* designates a community of more than 200 living relatively close together.

Prior to 1950 the densely populated areas consisting of farming communities were not included in the statistics for the *tätorter*. Since 1950 all such agglomerations have been listed regardless of economic structure.

Allowing for this fact it is possible to compare the changes in population distribution since the end of the last century. In the 1880's approximately one-quarter of the population lived in towns and villages. This fraction increased rapidly during the first two decades of the 20th century, until in 1920 it reached 45%, in 1939 49%, in 1940 56%, in 1950 66%, in 1960 73% and in 1970 81%. The most rapid increase was between 1940 and 1950, and it is still continuing.

The "drift from the land" was first noted and discussed in the thirties. There was then no clear picture of the effect of the social transformation and industrialization that was taking place. Rather, there was a tendency to blame the "tediousness of life in the countryside", or similar generalities. And it was to become even more "boring" after the second world war, when new industries and the welfare community created a great number of employment opportunities in the

cities, while a restrictive agricultural policy was stifling the rural areas. It was obvious that public services in the country-side were rapidly becoming poorer as the population decreased. Shops were forced to close, public transport services were reduced, schools were shut, school buses instead carried the children to a central school in the nearest populated area. Certain railway lines were closed down and train stops at small stations were no longer scheduled. People living in the countryside today cannot manage without a car.

In the forest regions of Norrland depopulation was increased and hastened by the rationalization of the forest industry. Motor-saw and forest machines made it possible for forest work to become an all-year-round activity for full-time labourers. Small farmers, who had formerly depended on work in the woods during winter, to supplement their incomes, were now no longer able to live off their small farms. They were obliged to move to the built-up areas, where work opportunities were available. Farming was abandoned, and soon villages were empty.

When, during the 1950's, people began to speak of the "drift from the city" or the "green wave", this did not mean that people were abandoning their urban way of life. The opposite was the case: the "green wave" was the expression of a very urbanized life style in the sense that many elected to retain their employment in the cities but chose to live in the country or in less densely populated communities. They became commuters, primarily by car, covering up to 30 km (19 miles) or more per day. In 1965 approximately 600,000 people, or 18% of the working population, belonged to this category, and the figures are steadily rising.

The few city dwellers who move to the country and to a farming life are for the most part idealists. In contrast to this small group there are the numerous families with country homes as a second residence, whether simple summer cabins for sport and recreation or more substantially-built weekend homes for all-year-round use. Prices of abandoned farms as well as of vacation cabins in the mountains and on the coasts have doubled many times over during the past few years. In 1975 there were 590,000 such second residences in Sweden, an increase of 18,000 per year since 1970. This process is still accelerating. The west coast, the Stockholm archipelago and the mountain regions of Dalarna and southern Norrland are the most sought-after areas.

These country homes are symptomatic of Sweden's high standard of living, and also of the Swede's love of nature.

As a result there is a strong interest in environmental concerns which, unfortunately, has not prevented serious damage to nature even today. Hydro-electric power plants, timber-felling, and gravel pits are examples of such controversial assaults on the environment. The extent to which the inhabitants of the Nordic countries value nature and derive pleasure from contact with it is nevertheless always very striking to the foreign visitor.

Fellow humans are regarded as part of the natural environment. Their demands on life are considered a matter of course, and that applies equally to children, old people or handicaped persons. Without such a widespread endorsement of this fundamental attitude the social harmony at present existing in Sweden could never have been achieved. This basic attitude has also made it easier to meet the demands of religious, ethnic and political minorities, on condition that they accept the rules of the game as practised in the country.

The Role of Mining A few important industries within the Swedish economy still make it possible to live relatively close to nature in small settlements. This is true in particular of those sectors which are based on the utilization of natural resources such as ore and timber; in consequence they have influenced the geographical distribution of the population. The sectors concerned are mainly mining, timber and—to a much smaller extent—fishing. In Swedish mining the production and processing of iron and copper played a predominant part for many centuries. Ever since the 14th century they have demonstrably led to a remarkable integration of ore, water and timber utilization and to a resultant social legislation. Their sphere of validity is "Bergslagen", the area of the mining law. There used also to be a similar integrated economic and social legislation based on mining in Central Europe. Developments there and in Sweden frequently benefited each other through the centuries. The structuring of the cultural landscape due to the mining laws greatly affected both the distribution of the population and its composition.

The dense network of small semi-urban settlements in central Sweden could not have come into existence in any other way. The well known concentration processes which followed industrialization between 1860 and the second world war, and beyond, were bound to produce an appropriate population shift. The economically inescapable abandonment of small and unprofitable mines and smelting plants has by no means been offset everywhere or adequately by other, newly created

94

livelihood opportunities. This is the reason, at least in part, for the high emigration quota from Värmland in the late 19th century. Domestic transmigration was on an even larger scale, especially to the timber industry areas in Norrland.

A basically similar process, occurring over a much bigger area though affecting considerably fewer people, took place after the second world war as a result of the comprehensive mechanization of the timber industry, giving rise to a population drift towards the coastal towns of Norrland at the expense of the forestry settlements in the interior, many of which were completely abandoned. This has been accompanied by an infra-structure transformation of the entire Norrland settlement network, a change that has not been adequately noticed in its qualitative aspect.

The Role of the Timber Industry

Mining and timber, unlike agriculture, have traditionally employed an appreciable proportion of foreign labour. As early as the Middle Ages Swedish mining had contact with German ore mining—names of Swedish localities like Garpenberg and Garphyttan derive from the medieval term *garpar,* referring to the Germans working in the mining industry. Traditionally there was an exchange of experience in mining technology; until the middle of the 19th century there was a continuous supply of German miners and mining engineers. Many of these have become assimilated over the generations, as have the Walloons, experienced blacksmiths and iron workers, who were invited to Sweden in the 17th century, primarily from Belgium. The latter included not only workers but also entrepreneurs with capital. Families like the de Besches and the De Geers acquired, and have maintained, great importance in Sweden's economic life.

The Finns colonized certain areas of northern and central Sweden in the 16th and 17th centuries by creating new settlements in the crown forests. Charles IX, who wished to see these uninhabited areas settled, was particularly responsible for furthering the Finnish influx. The largest Finnish settlements were in Dalarna, Västmanland, and Värmland—Charles IX's former duchy—and also in the coastal countryside of southern Norrland. Names like "Orsa finnmark" and "Finnskoga" ("Finnish tract" and "forest" respectively) and pure Finnish names serve as reminders of this influence. The concentration processes—especially after the second world war—have been accompanied by active settlement planning, by a settlement policy aiming at the creation of (as far as possible) balanced urban centres all the way up to

the northern settlement boundary and at ensuring that in this rather remote and generally sparsely populated region— the four northern provinces have an average population density of 4 per square kilometre, or about 10 per square mile—as many people as possible were settled in the small towns, or at no more than an hour's drive from such small towns. Only if this objective was achieved did it seem feasible to approach the general Swedish standards—which tower head and shoulders above anything outside Scandinavia near the polar boundary of human settlement, no matter whether in the northern or in the southern hemisphere. This is true of schooling, cultural, medical and social facilities, of public and private long-distance transport facilities, as well as the range and quality of retail goods. There has been no hesitation about totally abandoning many settlements and disused communication routes (mainly railways, less often an occasional road) in favour of ensuring a high-grade infra-

Urbanization of Marginal Areas structure for what was left and what was being further developed. It proved cheaper, in terms of the national economy, to pull down certain forestry workers' settlements although they had been in use for only a few decades, and instead to transport the workers by company bus or even helicopter each day from a well established centre to their (anyway changing) place of work. This new urban mode of settlement, or rather mode of life, has provided the young people with vastly improved educational and vocational opportunities. And it has offered far greater opportunities for women to realize their emancipational aspirations, if only by providing a broad range of different and often part-time occupations. This trend has been supplemented by the institution of considerable subsidies to attract new industries and by moving numerous state authorities and institutions from the more southerly conurbations into the great centre of Norrland— sometimes in the face of considerable domestic opposition. In consequence it has been possible, in numerous instances, to loosen up the characteristic economic monostructure of the past, and this in turn has benefited young people and women and moreover relieved the labour market in the North generally. In actual fact, this kind of systematic structural change is not confined to Norrland. Basically the plan has also been practised in smaller unit areas, for instance in western central Sweden, in Småland and on a few islands— always with some degree of success. In every instance the goal was a socially secure multiplication of opportunities for the full development of the individual.

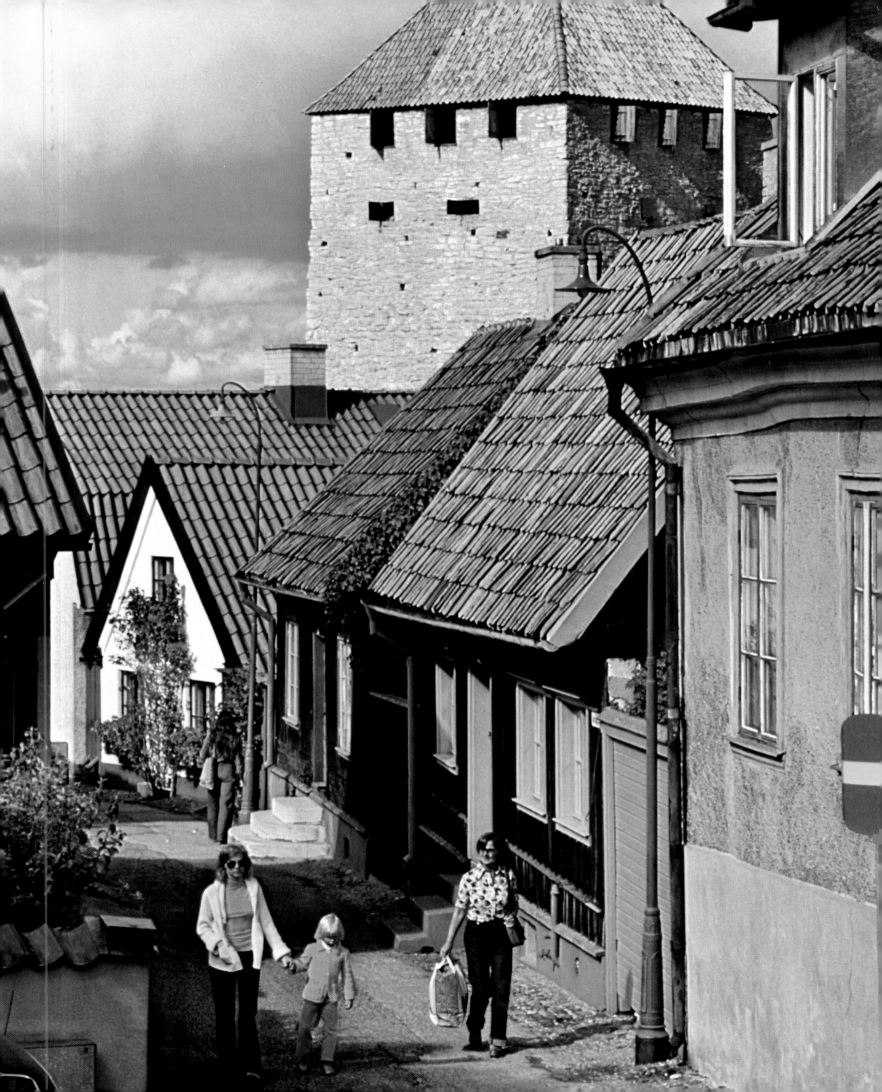

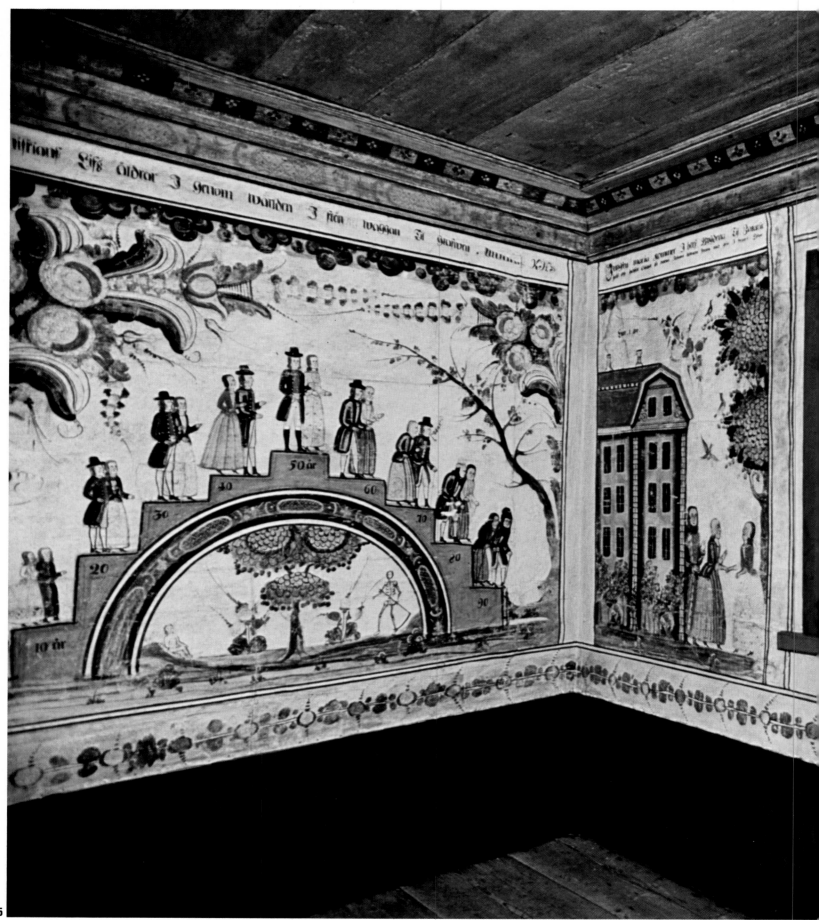

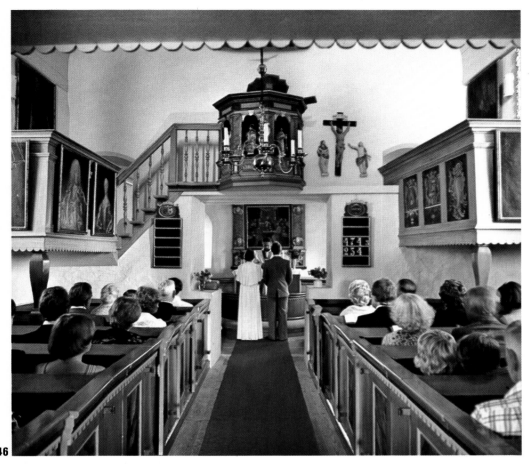

46

47

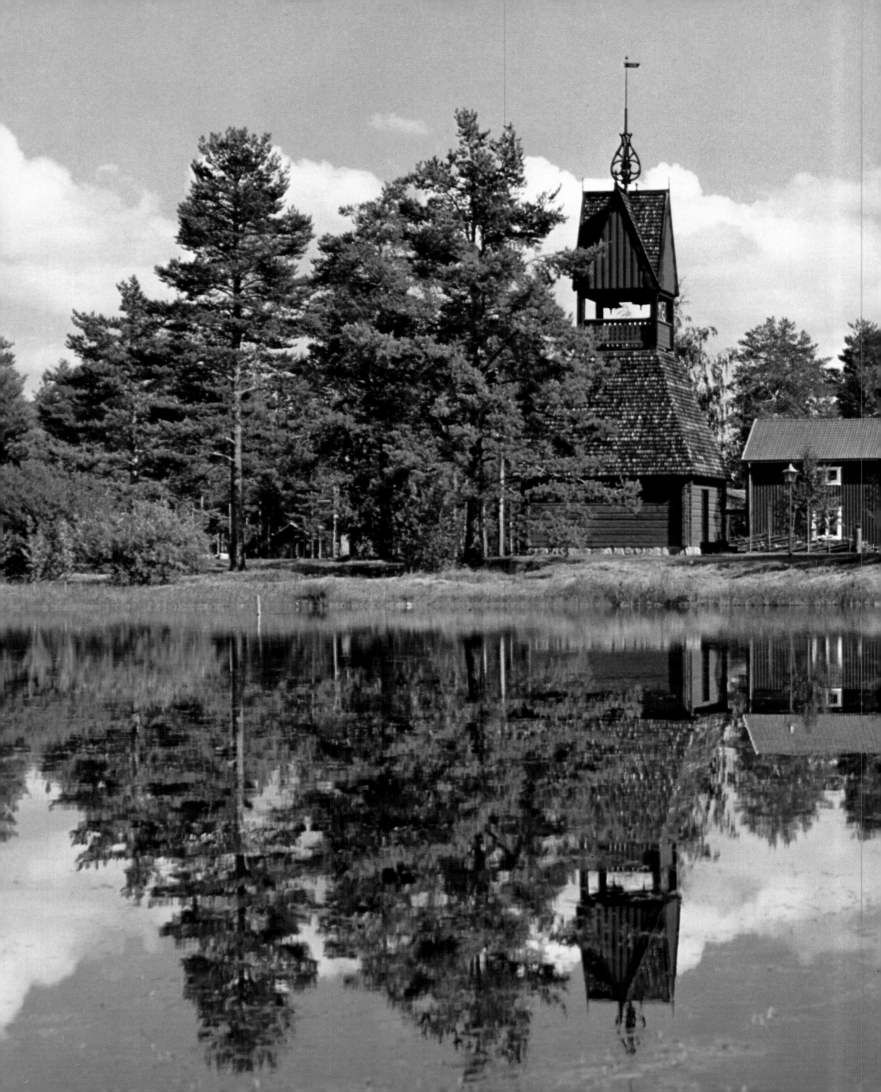

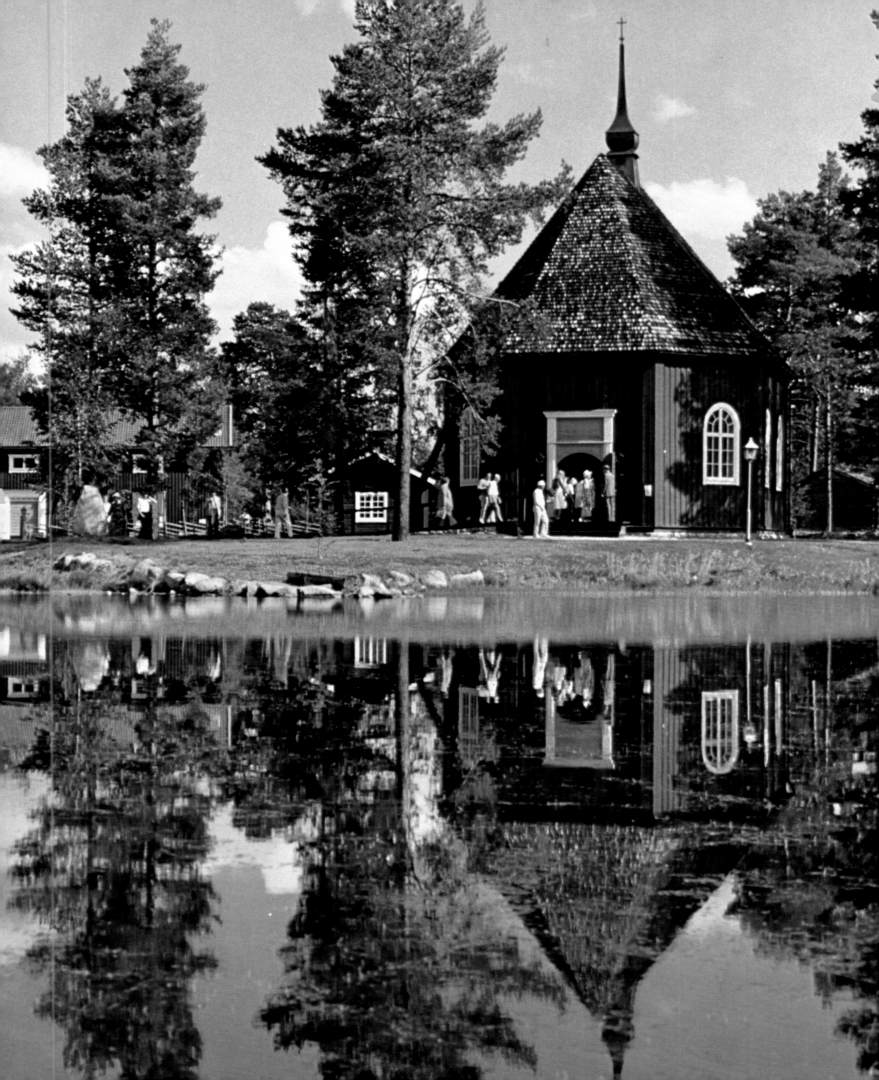

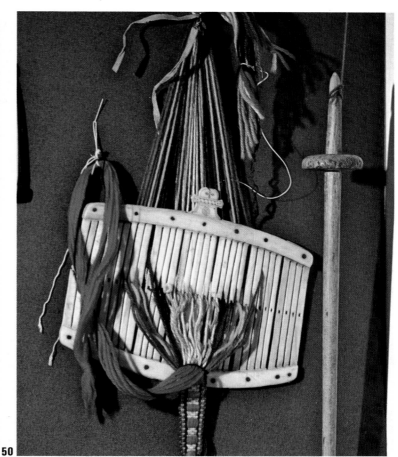

50

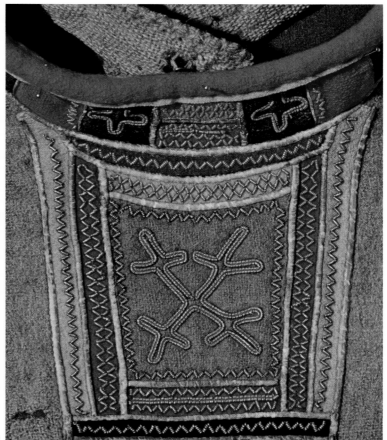

51

44 In Visby (see Plate 41), the capital of Gotland, the clock stopped with its destruction in 1361. The town never again regained its ancient mercantile importance for the whole Baltic region. Many of the little houses on the narrow streets date back to the 18th century, when there was once more a slight flowering whose traces have survived later fires. The houses are well cared for and trim, and cower as romantic idylls under the menacing towers of the medieval town wall. Silurian limestone—about 450-million-years-old seafloor mud—rich in fossils (more than 1,500 species), has been the local building material for generations. That, too, is rare in Sweden—even though the blessings of nature in the form of the limestone have remained. Without it there would not be such good soil and no cement industry— situated favourably from the shipping point of view at Slite on the north-east coast. Gotland owes its thousand-year-old peasantry to those limestone soils; these peasants managed for long periods to resist the capital of their own island, the city of Visby. The forest has been cleared and grazing (sheep and horses) prevent it from rejuvenation. In some areas the shallow limestone soils have become heath. Long dry and warm summers and mild autumns allow a breath of the Baltic climate to waft into Sweden. The idyllic setting, the tranquility and the mild climate attract many thousands of tourists to Gotland. The island is linked by ferries with Södertälje, Nynäshamn, Oxelösund, Västervik, Oskarshamn and Lübeck.

45 In Dalarna, near the border with Hälsingland, lies the little village of Bingsjö. Several *fäbodar,* the farmers' long huts used during the time of summer grazing, belonged to the village, and some of them —those which can be reached by motor roads built for forest exploitation, are still in use today. Dalarna peasant painting from the 18th and 19th centuries is widely known, but equally splendid examples by rustic artists can be found in other Swedish provinces—in Halland, Småland, and, above all, Häsingland. The subjects are often Bible stories. The Marriage in Cana, The Prodigal Son, The Wise and the Foolish Virgins, King Solomon (but also Carl XIV Johan) are common themes, as is also that of the stairs representing the ages of man from birth to death, as can be seen on the left in a room at the Daniel farm. The Leksand artist Winter Carl Hansson (1777–1805) was responsible for these paintings. He transformed the Renaissance flower vase into the decorative stylized "Kürbits" flower.
Dala paintings were often done on linen which was then fastened to the walls. There are very few peasant paintings left in the homes of the Dalecarlian farmers. Most of them have gone to museums and private collections. In Hälsingland, however, every other farmer has pictures in his house.

46 On the Kållandsö Peninsula on the south side of Lake Väner, by the road to Läckö Castle, stands Saint Mary's Chapel, belonging to the parish of Otterstad. In the Middle Ages it was a parish church in its own right, one of three on Kålland Island, but later fell into disrepair. Count Magnus Gabriel De La Gardie, the lord of Läckö Castle, had the little church restored and named it after his wife Maria Eufrosyna, at which time it was embellished with paintings, a triptych, and a pulpit. The location of the pulpit above the choir is unusual in Swedish churches. Nowadays these beautifully preserved little churches are favourite choices for the weddings of people from elsewhere.
Kållandsö is one of the oldest settled areas in Sweden.

47 Life goes on everywhere: heads bowed, the mourners follow the coffin of a departed. The woodland cemetery of Övertorneå in the Far North on the Finnish frontier has been a final resting place ever since the 17th century, when the first Swedish settlers—mainly fur trappers—made their permanent homes here.

48 In 1601 King Charles IX established Lycksele in the valley of Umeälv. It was intended to serve trade with the Lapps, and be a centre of their administration and missionization. Soon it became famous as one of the first centres on the Bothnian coast, it received its charter in 1588 and is known to have had a chapel as early as 1324. The ancient market and church square, Gammelplatsen, is one kilometer (⅔ of a mile) upstream from the present centre. It now serves as a leisure park and contains a large enclosure with taiga and tundra animals. In 1946 Lycksele was given town status. The nearly 15,000 inhabitants still derive their livelihood mainly from forestry and the timber economy. However, metal processing, engine manufacture and the foodstuffs industry are beginning to play a part. For science the Ionosphere Research Observatory is an important institution at Lycksele. Here research is conducted into the effects of the Northern Lights on radio communications.

49 The small village of Vilasund is situated on one of the lakes from which the Umeälv takes its origin, Lake Överuman. It is screened from cold north-westerly, northerly and north-easterly winds by the Brantfjäll (1,117 m = 3,718 ft). As in an amphitheatre the little village lies by the shore of the lake, whose level at 520 m (1,707 ft) comes rather close to the watershed. This coincides fairly closely in these parts with the Norwegian frontier. Across the lake, on the southern side of the Överuman, are the ruins of the Vila chapel below the bare tundra peaks of the Artfjäll, rising to over 1,500 m (4,900 ft). The chapel has long been derelict. The ancient Lapp Per M. Balls no longer accompanies the

reindeer to their summer pastures; this task is left to younger men. He stays behind in his timber house and keeps the accounts of his herds for the Revenue Department and the Statistical Office. He lives by himself in one room. His files hang on the wall above his bed. His desk is also his kitchen and dining table. He orders whatever he needs by telephone from a merchant at Tärnaby, a place nearly 70 km (44 miles) away. Every Tuesday, ever since the road to the new town of Mo i Rana on the Norwegian coast was built in the fifties, the merchant arrives with his van. In a sense, this road has made the land of the Lapps even more lonely. Many of the young people have left.

50/51 Almost precisely on the Arctic Circle, just off the Klint Lakes of the Luleälv lies Jokkmokk. Since ancient times it has been a cultic and trade centre of the Lapps. Many of them have their winter quarters here. In February they have their church fair and market here. Not surprisingly the Swedish state chose Jokkmokk to set up a nomad high-school, the Lapp People's College, and—since 1966—a magnificent Lapland Museum. Plates 50 and 51 were photographed in that museum. Plate 50 shows a small weaving frame. With such ingenious implements of birchwood the women were able to weave the brightly coloured woollen braids which are such an important part of the Lapp costume. Plate 51 shows a very particular Lapp tradition—tin embroidery. This used to adorn the back of a person's costume below the collar. Jokkmokk is served by the "inland railway" from Östersund to Gällivare. Although this railway is of no significance to communications nowadays it has nevertheless facilitated the planning and construction of the big hydro-electric power stations nearby—Porjus, Harsprånget, Ligga, Metsi, Porsi and Laxede. In consequence the Luleälv has become Sweden's most intensively used river for energy generation. Of a feasible potential of 3.31 million kW 2.643 million had been developed by 1975. That is 20.65% of the capacity of all Swedish hydro-electric power stations.

52 About 1110 km (694 miles) south of Jokkmokk as the crow files, on the shore of Lake Hornavan, 430 m (1,411 ft) above sea level is Arjeplog, a township of over 4,000 inhabitants with a territory of nearly 13,000 km² (5,000 square miles). Here, too, a big Lapp market is held in February. More recently Arjeplog has become famous through the books of its doctor, Dr. Einar Wallquist (see plate), who also founded Arjeplog's Silver Museum in 1965. The old silver mine in Nasafjäll, which was worked during the 17th and 18th centuries, was located far up in the mountains at the border with Norway, within the parish of Arjeplog.

The Lapps

A diminutive minority of the Swedish population, 0.22% (1973: 15,062), has always commanded particular interest. These people are different, they speak a different language, they lead a different life. They call themselves *sameh* or *samek* (singular: *sapme*). But they were so little known that they were at first—and to this day are—given quite different names. The oldest known record dates back to Tacitus in AD 98. He speaks of a savage nation of hunters, living beyond the Germans and chasing the deer on skis—a strange report. He called these mysterious people *Fenni,* Finns. The term was adopted by later historians. Skiing and hunting were always emphasized as a peculiarity. Not until the 13th century does the name of Lapps appear in Saxo Grammaticus. According to this report they inhabited Lapland, on both sides of the Bottenvik, the most northerly part of the Baltic, that is the taiga, not the tundra. "Lapps" *(Lappar)* was the name commonly used from then on until the 1950's, when, in their struggle to maintain their individuality and their language, they were able to bring their own designation for themselves, the name "Samer" into general use and acceptance. The word "Lapp" is now considered almost a pejorative. Only in northern Norway did the name *Finner* survive for the Lapps, or rather *sameh,* and Finnmark for the tundra province in northern Norway which is the summer grazing of the Lapps today. The Finns, on the other hand, are known here as *kväner,* although they call themselves *suomalaiset.* The present habitat of the Lapps extends over the whole tundra, or the Kalfjäll from the Norwegian-Swedish frontier region around Röros-Idre to the eastern coast of the Kola peninsula in the north-western Soviet Union. At the beginning of our era they also inhabited the adjoining taiga, on "both sides of the Bottenvik". At one time they virtually inhabited the whole of Finland and Karelia and only gradually pushed towards the North and away from the Baltic coasts.

The present day Lapp population is not accurately known. It is thought to be about 40,000. Half of them live in Norway, about 15,000 in Sweden, about 2,500 in Finland and an estimated 1,500 in the Soviet Union. Most of the Swedish Lapps live in Lapland, but in recent years many have gone to southern Sweden to work—in 1973 there were no less than 1,179 Lapps living in the Stockholm *län.* Many of the Lapps engage in fishing and agriculture on a very small scale; but in recent years they have increasingly sought employment in the communities of Norrland, especially in the mining industry. Those who today live a semi-nomadic life as reindeer herds-

men are relatively few; in Norway the figure is about 10%, in Sweden it was 2,270 in 1972, of whom 622 were women.

The language of the Lapps is closely related to the Finno-Ugric and possibly represents an older form of modern Finnish; presumably, however, this is not their original language but one which they accepted from Finnish tribes a long time ago. It is sub-divided into roughly 50 dialects which can be grouped together, around the central forms of Lule and Pite Lapp, into a southern, a northern (or Norwegian) and an eastern group.

Science is not quite clear on the racial position of the Lapps. They may be the descendants of the original race from which Europides and Mongolides developed at one time. Modern blood group research has even suggested that the Lapps might be two different races, a northeastern and a south-western one. Although of small stature—the men are 150–160 cm (59–63 inches) and the women 140–150 cm (54–59 inches) tall—they are nevertheless fairly strong. They have an alert intellect and a lively temperament. They have small round heads, black hair, brown eyes and a pale skin. Racial mixtures are frequent; the purest type is normally found in Lule-Lappmark in northern Sweden.

Just as the language and race of the Lapps still present riddles, so their early history poses a lot of unanswered questions. There are a vast quantity of finds in northern Scandinavia from the New Stone Age—weapons and implements of slate and quartzite. These used to be regarded exclusively as remote instances of the south Scandinavian neolithic cultures. And since Bronze Age finds are totally absent in Lapland it used to be believed that Lapland had not been settled at all at that period, especially as the Bronze Age there coincided with a certain deterioration of the climate. Other researchers doubt that things can have been so bad and tend to assume that the material civilization in Lapland made a direct transition from the Stone Age to the Iron Age. The Edda Sagas admittedly speak of the terrible *finbulwinter* which forced the ancient inhabitants of the Far North to emigrate, whereupon the Lapps are said to have moved in, on the trail of the reindeer. This then would have been about 500 BC—towards the end of the Bronze Age—according to legend, and it would tally quite well with the ideas of Gustav von Düben, the prehistorian who believed that the Lapps had emigrated from the interior of Asia at the time of the Scythian horsemen's raids into south-eastern Europe. And the linguist Wilund held the view that just about that time there must

107

Types of Lapp yurts

Type A

Type B

Type C

Type A: Forked-pole yurt for temporary or permanent erection
a: three forked poles form the basic skeleton; b: tent poles; c: pot rail; d: tent cover; e: smoke vent; f: entrance; g: ante-room (uksa); h: hearth (arran); i: kitchen (påssjo); j: side rooms (låito).

Type B: Hooped-pole yurt, the transportable nomad tent.
a: hooped poles, held together in paris, form the basic skeleton; b: pot rail; c: cross spar; d: door post; e: rear brace; f: tent poles; g: tent cover; h: smoke vent; i: entrance; j: ante-room; k: hearth; l: kitchen; m: side rooms.

Type C: Turf yurt, on the same structural principle as Type B but with a covering of turfs on a close layer of round timbers. The superimposed smoke vent marks a more advanced building method.

Acc. to Ernst Manker (Atlas över Sverige)

have been a link between Lapp and proto-Nordic. Admittedly he dated the immigration about the end of the Ice Age, i.e. several thousands of years earlier. The Lapps, according to him, together with the reindeer had followed the retreating edge of the ice or the advancing tundra all the way from the Urals. The discovery of the paleolithic Komsa culture on the Alta Fjord by the Norwegian Nummedal about 50 years ago gave rise to the assumption that humans must have survived the last glaciation on the Norwegian Arctic coast, just as the Eskimos on the coast of Greenland which, after all, is still full of inland ice. These people on the Norwegian Arctic coast could have been the ancestors of the Lapps who, with the ending of the Ice Age, had then spread across Lapland from the North. Their long glacial seclusion would also explain the peculiarity of the Lapp race. In the meantime, however, the Komsa culture has come to be regarded as much more recent, certainly as post-glacial.

The findings of research since the second world war are once again tending towards the old theories according to which the neolithic finds in Scandinavia, in the North and in the South, generally point to the Lapps as the first post-glacial inhabitants of northern Europe. About 500 BC their culture moved straight from the Stone Age into the Iron Age (through contact with the early Germanic people moving in via Denmark). A large number of exclusively seasonal camp sites have been confirmed for the period about 5000 BC. Skis and other implements—easily dated and of appropriate antiquity—have been recovered from bogs and these fit into the picture which we may put together from the oldest written historical records. It may be assumed that the Lapps immigrated from the region of Lake Ladoga and further east, in several waves and by different routes. That would also explain the existence of different branches in the present Lapp population. These differences manifest themselves not only in racial characteristics, mode of life and dialect, but also with regard to present-day religious allegiance and above all in the great variety of characteristic costumes. The Skolt Lapps in the Kola peninsula are Russian Orthodox Christians. Their territory extends westwards as far as Neiden in the extreme north-eastern corner of Norway. The rest of the Lapps are Lutherans. The most important feature of their costume is the kilt. Otherwise, however, the costume varies a great deal in cut, braid and colour, and above all in headgear which distinguishes them according to their traditional settlement areas.

Even though the second world war marked the end of thousands of years of nomadic reindeer keeping, and even though few Lapps nowadays keep reindeer—of the 15,000 Swedish Lapps only 2,000 are still reindeer breeders—a knowledge of this form of livestock breeding, so superbly suited to the natural conditions, is indispensable to an understanding of Lapp culture and hence also of the location, size and structure of their traditional settlement areas. There is no doubt that initially the Lapps followed the reindeer merely as hunters and trappers. This is proved by numerous finds of stone and iron arrow-heads and by the countless pitfalls, often of remarkable size and arranged in rows.

It is not quite clear yet when the Lapps switched from hunting to domestication. As the wild reindeer invariably respond to the change of the seasons by moving in entire herds up and down the same valleys, and since on the Kalfjäll they also always prefer the same areas, nothing could be more natural for a hunter than always to follow the same herd. The mutual forming of a habit was the first step towards domestication. Written testimony about this type of hunting dates back to the 9th century. At first they probably tamed a few reindeer as bait for the wild ones. At the same time, however, it was customary to trap the animals in pitfalls. From the 16th century onwards the nomadic pattern was evidently well established with all the special implements represented on the magic drums of the not-yet-Christianized Lapps.

This does not rule out the possibility that there may have been a large number of Lapps—perhaps even the majority—who in time became settled and engaged in agriculture, fishing the fjords, lakes and rivers, and keeping cattle and sheep, and that only a few members of each family (and possibly then only for a limited period in their lives) migrated with the herds. In any case, three degrees of nomadism have to be distinguished:

1. The Skolt Lapps, for example, always had a regular site of habitation for the winter. They would leave it in spring radiating in different directions, in search of good grazing areas (with tamed reindeer) and rewarding fishing grounds, to return in the autumn to these regular habitations— where the tax collectors of the kings or the Tsar, or sometimes both, would fleece them.
2. The forest Lapps, on the other hand, had several regular but only seasonally inhabited settlements along a migration circle. They went down to the coast in the winter time, and only had small herds of domesticated reindeer.

travelling sled
(pulka)

closed akja
for foodstuffs
and valuables

meat akja

flour akja

akja for
bedding, etc.

akja for
implements

tent akja

Winter rajd with sleds and draft animals

3. The big shuttle migrations of the mountain Lapps. In many cases these went from coast to coast (Atlantic in summer— Baltic in winter). They stuck strictly to the trails used by the wild reindeer, invariably along the same valleys.

Even though all three systems have now yielded to an almost completely stationary life for the Lapp families and although a noticeable reduction of herd migration has been observable since the turn of the century, the great reindeer migrations in northern Sweden nevertheless represented a unique European tradition well beyond the second world war. The herds would be accompanied by two to four families. Such a group was called a *sita*. One of the older men would be its leader. Each member of a *sita* had his own animals which bore an appropriate ear brand. Several *sitor* (that is the plural) formed a village community—or, more accurately, a valley community. These were grouped together in districts which jointly, under the name of Lapland, possessed a certain autonomous administration under a "Lapp Bailiff".

A Lapp village does not correspond in any way to a normal farming village, but is a community of one or more *sitor* which move around within a defined area.

The number of reindeer Laps in Sweden diminishes every year. In 1972 2,270 were recorded, of whom 426 were forest Lapps, whereas in 1958–1959 there had been 3,010 reindeer Lapps, 645 of them counting as forest Lapps. The migration routes of the mountain Lapps can range between 100 and 400 km (60 to 250 miles) in length. Since the 1919 reindeer pasture agreement with Norway reindeer from Sweden are no longer allowed to graze on the Norwegian Fjäll West of the frontier in the summer, except in the Troms area. There the reindeer continue to move all the way down to the shore of the fjords.

Another obstacle has arisen with the ore railway from Kiruna to Narvik. In the southern provinces, in Jämtland and Härjedalen frontier barriers have been errected—with mile after mile of wire netting, the *renstängsel*—with the result that herd migration has been curtailed by at least 100 km (60 miles) to 50–140 km (30–90 miles).

110

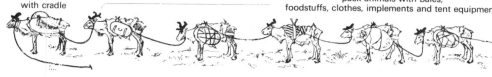

Summer rajd with pack animals
(drawing by O. Elgström)
(acc. to Atlas över Sverige)

The families are no longer constantly on the move. In the winter they most often nowadays live in normal one-family houses. The spring camp is in the low mountainous area close to the place where the calves are born. The summer camp, however, is located high up in the mountains. The autumn camp is often the same one as the spring camp. The Lapps then return to their winter habitation. In the past—in fact as recently as a few decades ago—when the Lapps moved along with their herds, they packed all their belongings, tents, and household equipment on specially tamed reindeer *(härkar),* which transported the goods or drew the *akja,* a boat-like sled. A long row of such roped-up pack reindeer with sleds and loads constituted a *rajd,* the migration caravan.

In the past the mountain Lapps used to live in *yurts* during the migration itself. In this century, however, this had already become the exception in the winter. Small farmhouses, rented or owned, were preferred. There the Lapps remained from December until April. Sometimes they moved off to their spring camp as early as March. The spring camp—as also the autumn camp, frequently consisted of peat tents and various storage sheds, the only fixed point during the annual migration. In May the calves were born there, which was the reason for the next move not being made until mid-summer. In the autumn they also stayed there for a month or two during the reindeer mating season. Formerly the summer camp used to be moved frequently. With an increasing quantity of domestic equipment nowadays an attempt is made to avoid such moves. An additional factor was the shortening of migratory routes owing to the closure of the frontier.

At the height of summer, during the midge plague, the reindeer are fond of escaping to the snow line. There it is also easier for the herdsmen to collect their animals before the autumn *rajd* in August and to sort them according to each *sita* in big corrals. This is necessary because different herds are bound to get mixed during the far-ranging summer grazing. Of itself this would be quite desirable but mating does not take place until September, at the autumn camp. This is also where slaughter begins, first of the weaker bulls, even before mating. Later, but while they still carry their summer fat, the

111

bullocks and the cows are slaughtered. At one time the reindeer was utilized almost completely—antlers and bones providing tools, the hide or the leather providing clothing. Nowadays both are purchased.

Modern reindeer breeding is quite different. The family, with all its belongings, no longer follows the reindeer. Only the breeders, generally the younger men, follow and supervise the herd and drive it from one grazing ground to the next. The snow scooter is today an indispensable mode of transportation for them during the winter. When the family moves to spring, summer and autumn camp—still the general practice—this is done by boat, car and, not uncommonly, by air. The herds have become bigger, but their numbers can vary from good to bad years. The entire Swedish stock of reindeer is estimated at 250–280,000 animals. Formerly there used to be relatively small herds, carefully tended, which were regularly driven together for the cows to be milked. Nowadays the milk is no longer used, and the large herds are kept solely for meat production.

In order to preserve their unique culture and to defend their rights the Lapps have an active organizational structure headed by a national Lapp organization. This, among other concerns, employs a jurist as *ombudsman*. The Lapps feel very much that they must fight to make themselves heard and to get their rights acknowledged. For many hundreds of years, even to this day, they have been bullied and treated like minors. The state has been obliged to abolish its earlier office of Lapp bailiffs and to establish a system of advisory officers. The Lapps issue their own newspaper, *Samefolket,* and in Jockmock there is a Lapp *Folkhögskola* (people's high-school). The map overleaf, by the Lapp researcher Ernst Manker, records the conclusion of an ancient fascinating chapter of European agricultural and cultural history. There can be no return. Lapp culture, still alive at the turn of the century, has finally become a museum exhibit.

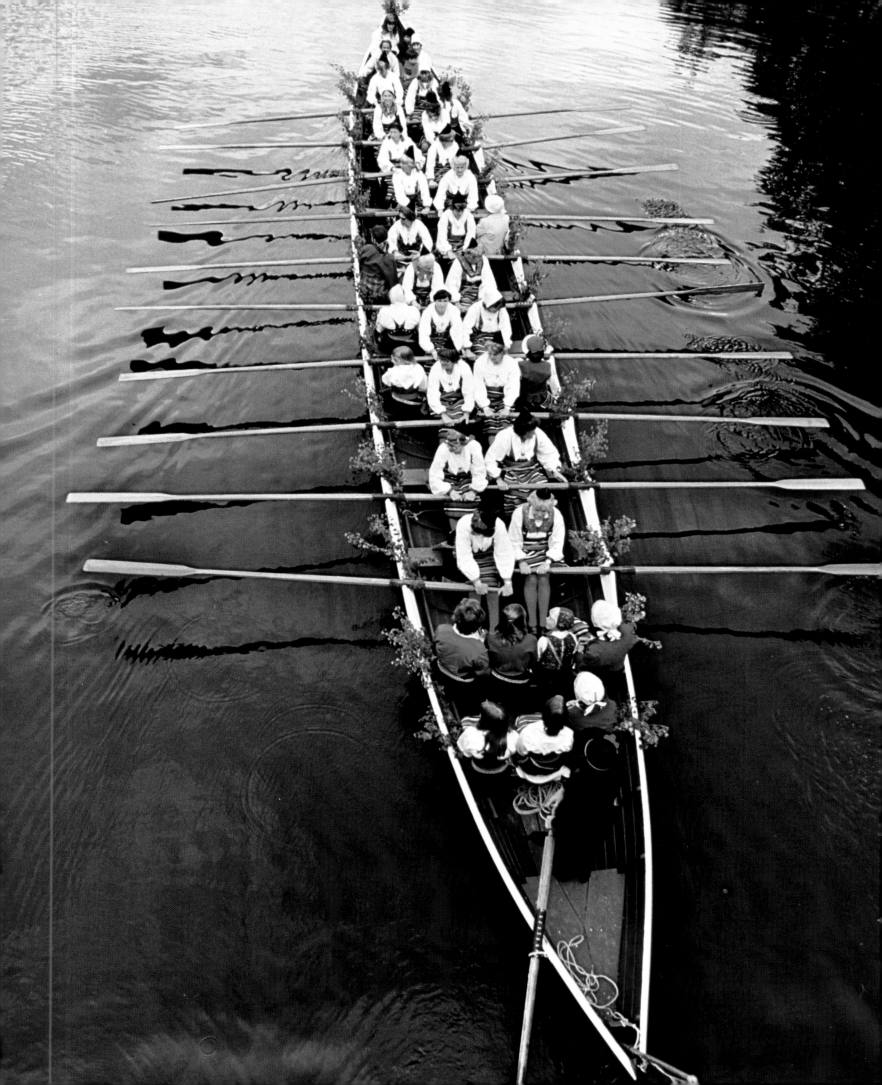

55

56

57

58

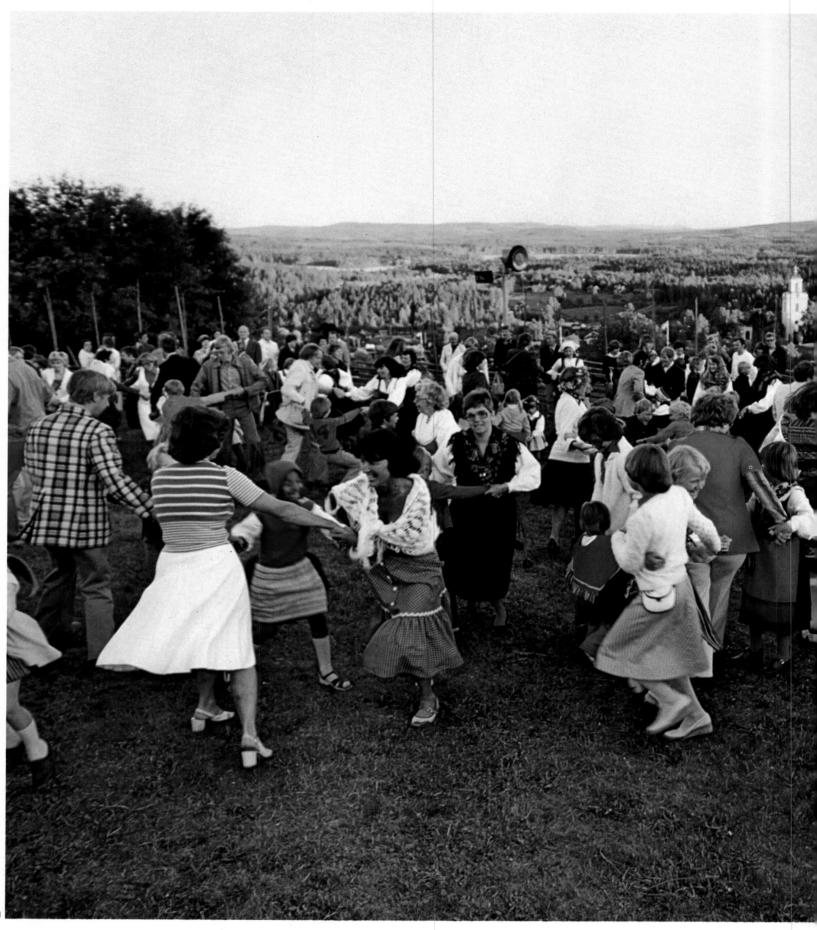

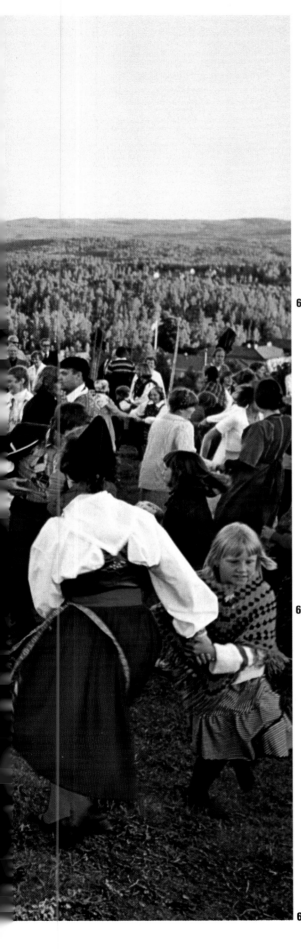

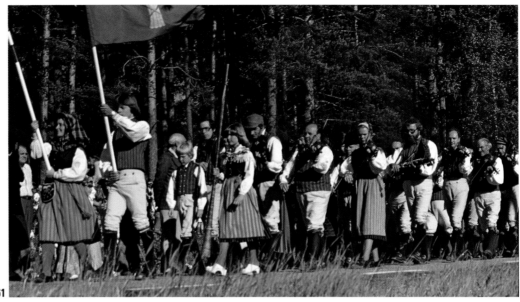

61

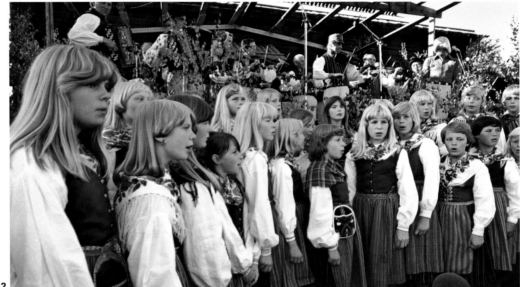

62

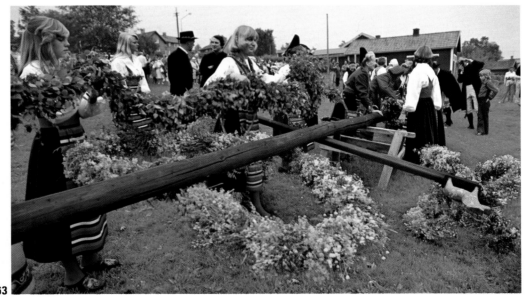

63

53 Church-going by boat on Lake Siljan near Rättvik. In the old days the overland tracks along the lake shore were rather laborious; it was easier to go to church by boat. The tradition is now revived each year for the Midsummer Festival, when the boats are adorned with fresh birch foliage.

54 So many people come to attend the Midsummer Service at Rättvik on Lake Siljan in Dalarna that everyone hopes the weather will be fine, so the sermon can be listened to out of doors. Many of the church stablings below the church date from the 17th century; they are made of logs.

55–59 In spite of its usually entirely modern appearance Sweden has an unbroken relationship with its national folklore. Caring for and wearing traditional costume, especially on summer festivals, is quite common even among the urban population and enjoys a growing popularity.

60 Midsummer dance at Bjursås in Dalarna.

61 Procession of the musicians arriving at the Midsummer Festival at Svärdsjö in Dalarna.

62 Girls' choir at the Midsummer Festival at Svärdsjö in Dalarna.

63 Before being erected the "maypole" is decorated with birch garlands and wreaths of flowers for the Midsummer Festival. Here in Dalarna (Lerdal near Rättvik) the little red Dala horse is an indispensable "maypole" ornament.

64 Girl from Orsa in the heart of Dalarna.

Swedish Life round the Year

In Sweden, as elsewhere, the year starts with a lot of weary people. New Year's Day is not a cheerful morning. It is cold, and a grey sky of snow clouds sheds its gloomy twilight over forests and roofs. A biting wind blows round the corners of the houses. Happily there is such a thing as coffee! After all, the day is a holiday, and gradually one feels sufficiently awake to dress properly. One goes to the telephone and makes a few pleasantries to one's mother-in-law. Slowly the day gets a little brighter. The children want to romp about in the snow for a while and are wrapped up in warm woollies. The neighbour is brushing the snow off his car. New Year's Day is a visiting day, a day for short visits, to friends and relations. In front of every house the Swedish flag flies—that is an old tradition on the first of January. In the South and along the Kattegat and Skagerrak coasts there may be slush and thaw. Gumboots and goloshes are indispensable. In the far North, on the other hand, there is a sharp frost. A proper *brasa*, a crackling open fire, is a joy.

Until relatively recently the beginning of the year was marked by a ceremonial opening of Parliament by the King—naturally in splendid fairy-tale robes. Nowadays things have become somewhat simpler and the ceremony has been moved to the opening of the parliamentary session, the beginning of October.

What has survived is the custom of Knut Day, 13th January. Twenty days after Christmas there is a final dancing and sing-song around the Christmas tree which is then stripped of its remaining goodies and eventually thrown out of the window. This is done nowadays even in the big apartment blocks—with appropriate caution. The next day the refuse collectors cart away the ejected and, by then, denuded Christmas trees. Such an abrupt farewell leaves no time for regrets— but in some families the old tree is kept on the balcony for the rest of winter, hung with strips of lard and bowls of grain to attract the hungry birds.

A good many long cold weeks follow. Throughout the day lights have to be kept on. Time and again snow must be shovelled, cars have to be pushed to start, and heavy warm furs and woollies donned. Before apartments were centrally heated, when bedrooms were still icy, Swedes adopted the habit of tucking their blankets firmly in under the mattress all the way round to make sure no cold air could creep into their beds. When going to bed children still say to their mothers: "Come and tuck me in", although this would no longer be necessary now.

Entertaining customs speed the winter on its way. If nature provides no flowers one just decorates one's homes with colourful feather flowers wired to birch twigs. The warmth of the rooms induce the twigs to bud about carnival time. This is believed to be a very ancient custom. Children, for their part, usually prefer another carnival custom—Shrove Tuesday cakes. These are soft fragrant yeast rolls which are cut open and filled with marzipan and whipped cream. These *fettisdagsbullar* compete with waffles, home-made with waffle irons. These waffles are consumed in March on *Våfferdagen* or *Vårfrudagen,* literally "the Day of Our Lady", that is Annunciation Day. According to ancient tradition the batter should contain newly fallen snow. Still warm, they are eaten sprinkled with sugar and spread with delicious jams made from berries gathered during the previous summer. The most important day in February is the 15th. This is the day when all Swedes have to submit their income tax returns. And that is no carnival joke! The form is signed, "Upon honour and conscience". Will one have to tighten one's belt—or, as they say in Sweden, "eke out the beefsteak with tree bark"? To make sure everybody understands the revenue authority's questions correctly the forms, naturally, have versions in Finnish, Greek, Italian, Serbocroat, etc. for the benefit of the numerous guest workers.

The taxation date is perhaps the darkest day in the Swedish calender. From then ownwards things can only improve. And they do improve! The days get noticeably longer. Thaw heralds the end of winter, even if there are one or two relapses. Already one can see the girls sitting on benches and window ledges during their lunch break, their eyes shut, blinking now and again, drinking in the still somewhat cool rays of the March sun. But the signs of a milder season are still deceptive. Those who can afford to do not trust to them but fly off to the Canary Islands for a couple of weeks to get some real warmth. At home the end of February and the beginning of March is the peak season in cultural life, with concerts, major theatrical events and art exhibitions of an international standard. As soon as the ice melts on the lakes huge flights of migratory birds arrive from the South—swans, geese and ducks. The cats, too, feel the spring and, caterwauling, prowl through the nights of March, the month of the cat.

In northern Sweden winter maintains a firm grip. In Dalarna, Sweden's historical heartland, tens of thousands of people meet for a huge popular feast. For more than fifty years the

123

Swedish nation has commemorated the lonely flight on skis by Gustav Vasa from Mora to Sälen, where the skiers dispatched by the regretful Dalecarlians caught up with him in order to ask him to return to Mora and to head their revolt against the Danish tyrant. Nearly ten thousand skiers, young and old, from all sections of the population, nowadays repeat this annual Vasa Run. The best of them cover the distance of 56 miles in five hours. The last of them, "blueberries", tourists, and children, pant with sore feet, past the finishing post after an average of seven to eight hours.

Spring reveals the Swede's hunger for sunlight in a variety of ways, not merely among the sun-worshippers. The eyes of the houses, the windows, are made to swallow up light and become a place of flowers. They are surrounded by light curtains which frequently are printed with flower motifs. Windows are not barricaded with blinds or shutters as in southern countries. The open view in and out is seen as a friendly invitation. But that is difficult in the modern high-rise blocks in the big cities. Urbanization, now totally accomplished, the adaptation of this nation of individuals to a concentrated mode of living, has demanded sacrifices.

In consequence, whenever possible, people are again going *på landet,* into the country, to the familiar red-painted timber houses in the forests or by a lake. This helps them to endure the concentration and crowding—no matter how convenient these may otherwise be. Ownership of several homes and accomodation for visitors is common in Sweden. Eight and a half million Swedes have over twenty million beds. There has been a marked rise in the standard of living during the present century. In the past centuries life was rather simple until a few generations ago an individual's survival could be threatened by famine. And now look at the prosperity! How has it been possible? Will those countries which are poor today ever achieve anything comparable? Sweden here tries to help. In Sweden, as elsewhere, the family nowadays only comprises two generations. The third (not to mention the fourth) has become detached. The result is loneliness despite economic independence. In the train of urbanization the state has also taken over the social welfare of the elderly. Acceptance of these standards by those concerned has, understandably enough, been somewhat reluctant, though the necessity is being realized. Will future generations find it easier? There is no alternative. The welfare state provides security but it also produces standardization; Sweden is no exception. Standardization concerns everybody and nearly everything.

It starts with the unborn child and the (as a rule) deliberate decision of when it should be born. This is regarded as a matter of course. Home birth? Scarcely conceivable nowadays— even the frequently long journey to hospital is preferred. It is said that taxi drivers should be trained in first aid—"first" being particularly appropriate in this case. The concern of the welfare state for the well-being of the child continues after it is born. The mother receives a subsidy in a lump sum and is entitled by law to a seven-month leave of absence from work during the time preceding and following the birth. The insurance fund compensates her up to 90% for her loss of income. Every family, without having to undergo a means test, receives a series of contributions towards the support of each child. These, in 1978, amounted to as much as 2,260 kronor per year and per child until the age of 16. Since it is now the rule in Sweden that both husband and wife work, there are opportunities for placing the child, even at a tender age, in a day-care centre. If the child becomes ill and needs to be cared for at home, either parent has the legal right to stay away from work. Insurance pays.

Perhaps Sweden can afford such generosity more readily than most other countries because the structural environment is so completely standardized, without the notorious shortages found in a planned economy, that an appropriate uniform behaviour pattern develops subconsciously. That standardization is marked by optimalized efficiency, sound quality, good taste and design. This ensures low prices and a supply of replacements for several decades. Reliance on tool quality, ergonomically designed equipment and spatial dimensions is so complete that the individual unwittingly fits himself into the precise handling of those standards and experiences them as a relief. He is therefore spared the expenditure of creative potential which, in consequence, he can apply to remarkable achievements in constructive and frequently artistic leisure activities. Everyday life does not, as elsewhere, consume the individual's improvisation effort through countless inadequacies.

Instead, the Swede encounters, right from childhood, a wealth of stimulation to give his tastes a satisfying outlet. His sense of colour, shape and sound is formed throughout his life, both passively through his material environment and actively by deliberate stimulation through play, education and instruction. The latter never comes to an end thanks to a highly developed adult education system that has existed for several decades and thanks also to the daily contribution made by the

media. All this takes place against a background of a high level of economic security and therefore leads to a harmonious mode of behaviour such as is achieved in but few societies—and certainly not in those societies which believe that one cannot manage without the crutches of dogmatic regulation. Such a life style provides satisfaction for all age groups and lends not merely entertainment but also content to the individual's leisure. To paint, to make music, to read in order to understand and to learn something new—all these are fundamental opportunities. They ensure an adequate range of personal activity and thereby also stabilize the psychological condition of lonely individuals.

Sweden is said to have a high suicide rate. Possibly so. But the conclusions drawn from this fact are as a rule incorrect. It should be realized that suicide is not regarded as morally reprehensible in Sweden as is the case in many other countries. Moreover, suicide hardly ever puts a dependant in a situation of material need. Any such personal economic dependance would be unusual. In consequence, the pragmatic consideration of whether a life is still meaningful enough to be continued acquires a very great weight in that decision. Suicide in the majority of all cases is an expression of personal liberty, of the claim to dispose freely of oneself in all respects. After all, it is hardly to be expected that the accustomed freedom of personal decision should make an exception over death. Over the past 20 years the total has fluctuated between 1,300 and 1,800 annually. This places Sweden, in proportion to its population total, in eighth place in international statistics. Female suicides are barely one third of the total. Are they more content or less resolute? They very rarely (1–5%) use fire arms (men: 15–20%) but about half of them resort to tablets (men: one-third).

That realistic assessment of the individual's life should be borne in mind too when considering Swedish divorce statistics and, of course, also birth control. Economic considerations are usually of subordinate importance in all three instances. The decisive factor is psychological. And this changes not merely as a result of material considerations. All this makes any interpretation of Swedish population statistics highly questionable. One thing is certain, though—that one's fellow citizens respect any such personal decisions with a great deal of tact.

In spite of all the talk about emancipation there are not yet many countries where a young woman can publicly and joyfully announce the birth of her illegitimate child. In

Sweden she need have no anxiety about her social reputation. There are, indeed, other problems which call for a solution, or for a better solution. Traditional Christian Church morality, especially when it tends towards bigotry and prudishness, no longer meets with a response in Sweden—if indeed it ever did. In that respect, too, many mistaken views have been formed about the Swedes. In Sweden religiousness manifests itself far more often in an intense interest in ethical, social and humanitarian problems. And the Church in Sweden actively participates in that. Thus, in Sweden the Church is by no means to be written off. But its position should not be gauged by the number of church-goers. It has certainly managed to participate in the great population shift from the countryside into the towns. The ancient village churches continue to be well preserved even though they are not much used nowadays. Their (as a rule) rather imposing position in the rural landscape is often emphasized by a restrained floodlighting after dark, producing a scene of great romantic charm. In the new urban residential districts small modern churches are built everywhere. These structures offer young architects wide scope for artistic projection. The Church has at all times been a prosperous and generous patron with an open mind to avant-garde architecture. This applies everywhere.

Strangely enough, alone among the Nordic countries only Sweden hails the advent of spring with joyous bonfires. This happens on Walpurgis Night, 30th April. At traditional spots, usually on some granite outcrop, huge piles of dead branches, dry wood and wood waste, including discarded furniture, are built into a pyre and set alight after nightfall. There is singing and dancing, speeches hailing spring are made, and sausages are grilled while the fire lasts.

The students of Uppsala in particular celebrate Walpurgis Night with the traditional *mösspåsättning*, the donning of their student caps, choral singing and dances at the undergraduate clubs. In 1977, the 500th anniversary of their *Alma mater*, the students of Uppsala observed the day with an exceptional amount of ceremony, including parties and speeches. The following morning, on 1st May, Sweden celebrates what, from an international point of view, must be a somewhat strange political holiday. The proletariat, to whom it is strictly speaking devoted, never existed, or scarcely existed, in Sweden. Nevertheless, the social harmony and security which are now found in Sweden did not drop from the sky either. The continuity and steadiness with which, having been

given a favourable starting point, that trend progressed in Sweden under decades of Social Democratic government since the second world war all too easily makes one forget that a good deal of laborious politics were needed to approach that goal. A good many compromises have been necessary. The welfare state has now been achieved. To preserve it in complete freedom and to improve it remains a continuous and demanding task.

In May the days are already very long and some of them are properly warmed by the sun. Everything is green and in bud. Gardening accounts for every free minute. At weekends and on odd holidays people drive out to some old farmhouse or sail out to the skerries. One's summer cottage has to be repaired, cleaned through and got ready because it will be in increasing use in the months to come. And of course one wants to have it look nice. Many summer cottages have quite recently emerged from abandoned small farmsteads. As a rule a great deal of conversion, extension and maintenance has been necessary. Since the second world war nearly 5,000 old farms have been abandoned annually. This fundamental modernization process in agriculture is only now beginning to tail off. By being taken over by townspeople the old red-painted timber buildings have been saved from ugly dilapidation. Maintenance of old buildings and their adaptation to present-day functions has also preserved some ancient city quarters. Because they are barred to all motor traffic their narrowness is no obstacle. Boutiques, arts and craft shops and antique shops, as well as small restaurants, attract the passer-by and already the first foreign tourists. Stockholm, the capital of the country, in its core closely interlocked with the freshwater of the Mälar, whose rapids force their way past Castle Island, surpasses all other cities. Its ancient streets, its museums and parks are permanent invitations to a Sunday stroll. And the bird's-eye view of the city is fascinating. What a wealth of familiar detail! Quite close to the Old City one may climb the Katerina-hissen (lift tower) or the tower of the City Hall on the Mälarfjärden. An even wider panorama is offered by the 170 m (558 ft) Kaknäs Tower on the island of Djurgården hard to the east of the city centre. The last Sunday in May is Mother's Day. There is a good time ahead—the long school holidays are just around the corner. There is a frantic atmosphere of examinations at all schools and universities. On 6th June the country celebrates its National Day—the Day of the Swedish Flag. Citizens who have earned particular merit receive decorations. Suddenly

Sweden reveals a side of herself believed lost. Summer has come to Sweden and nature is jubilant. The air is filled with a brilliant brightness, the sunshine is wonderfully warm, the day never ends. Flowers and green birch foliage as far as the eye can see, people full of enjoyment—there is time for one's friends, time for the joys of life. The sun no longer sets, it dances about the horizon—this is midsummer. People meet in forest clearings, a tall magnificently decorated festive tree is erected, there is fiddle and accordion music, and the old and young dance in circles or in pairs to a continuous succession of the rythms. In many parts of the country, especially in Dalarna, the old traditional costumes are honoured: white shirts or blouses, yellow, red or blue waistcoats and bodices, chamois knee breeches, striped aprons, brightly coloured ribbons, and tassels at the knees. These, too, are part and parcel of this holiday.

But this is not the only festivity. There is a succession of them well into August—so long as there is any summer left, until the jasmine wilts. During that period the cities empty for a few weeks. Sweden is "closed for holidays". The rush hour becomes more relaxed, parking problems become almost child's play. If possible families stay on in their country cottages beyond father's holiday. He then travels to town either as a daily or weekly commuter or perhaps stays there altogether.

Autumn now takes possession of the tundra, not roughly but with inescapable persistence, and with long strides descends from the Kalfjäll through the forest to the southern tip of this long country. On the ground, the lingonberries are a gleaming bright red, the maples turn scarlet, and the foliage of the birch shines like gold until it falls. The sun is low in the sky; its deep orange glow becomes weaker. The Lapps collect their far-roaming reindeer and prepare for their migration to autumn camps. The migratory birds, too, leave the tundra and in the forest it is time for elk hunting.

Now that September has come the economy is again running at full speed. More than four million persons are gainfully employed, over half a million in the public service. More than half the women in the public service work part-time, usually because of domestic responsibilities. This still entails various problems, even though such a wide supply of part-time occupations (in the case of men barely 4%) represent for many of them a happy solution to the compromise of responsibilities, an urge to be active, and the wish for independence. Because of the high proportion of part-time work among women they

come into the lower wage groups, on a statistical average, far more so than the men. The high social security benefits, however, offer a tolerable compensation. They concern especially the time off needed at the birth of the child and subsequently for looking after it; as has already been mentioned these benefits are paid by insurance. But since, as a rule, the husband has a higher income than the wife, it is generally the mother who takes time off in these cases. This fact, of course, in the long run, has a negative effect on her career.

The onset of autumn also means the beginning of the school year. Compulsory education, as a matter of principle, begins at the age of seven and lasts for nine years. In sparsely inhabited areas the schools for the lower and middle grades are so small that age groups must sometimes be taught jointly in one class, but this is the exception rather than the rule. From the upper level ownwards there are, as a rule, major catchment schools with three to six, or even more, parallel classes for each age group. School buses, and sometimes taxis, take the children to school in the morning and home again in the afternoons, following a pre-arranged route. Boarding schools are an exception in Sweden. The school week, Monday to Friday, consists generally of 6–7 hour days, except for the younger pupils who enjoy shorter hours. All children, as a matter of principle, receive a hot meal free of charge each school day. That, too, makes it much easier for mothers to be employed. September is also the beginning of the political year in Sweden.

September, recharged with summer holiday vigour, also heralds in the sporting year. And that is just as well. In the hectic rush there is hardly time to mourn the vanishing year. October passes swiftly. Already the days are painfully short. In the morning the cars are covered with frost—now it is a good thing to have a garage. From day to day energy consumption rises steeply. All engines are on full revs. Traffic is thick. Heating has to be turned up high and lights are on all the time. As before the Reformation *All Helgona Dag,* All Saints Day, is still a holiday, but is now observed on the first Saturday in November instead of the 1st of that month, in order to avoid wasting an additional workday.

One remembers one's dead, one tends their graves and places the warm flame of a candle on them. There are other aspects to November. The second Sunday is Father's Day. Starting from Skåne Province a culinary custom, the feast of St. Martin, has spread over the whole country. There is roast goose with

red cabbage and "black soup with ruff" (that is goose blood with innards). As if that were not enough to satisfy anyone's appetite, this gourmand's meal is rounded off with Skåne peak cake. This consists basically of egg and sugar. Over an open fire this is built up in rings into an impressive tower. Southern Sweden, especially Gothenburg, also has a special delicacy ready to commemorate the death of Gustav II Adolf. The head of this great king of Sweden, who was killed in the Battle of Lützen (near Leipzig) on 6th November 1632, is reproduced in a chocolate portrait on top of a cream cake—a strange form of veneration.

By now the Christmas season *(Julen)* has begun. Shop windows are more tempting than ever, shopping streets are festively decorated, fresh white snow muffles the sound of the hustling city. But it cannot conceal one thing—*Jul* is the business of the year. It is now entirely up to each mother what Christmas pleasures she prepares for her children in the home, how she decorates it, what she makes and bakes, what songs she sings with the children, what pleasant surprises they think up together for Father or Grandmother. Little packages are sent to friends in distant lands. There are a lot of beautiful small and utterly Swedish presents—a small embroidered cloth, a red Dala horse, very large matches, a mobile of wood shavings like feather-light blond ringlets, *Hemslöjd* things, the well-made traditional artistic craft items, woven, knotted, printed, carved, moulded or wrought. Every year amusing new trifles are added to the list to give pleasure to the recipient. The inventiveness of the workshops is astonishing.

Every Sunday at twilight another advent candle is lit; time passes, and as usual, one finds oneself behindhand with preparations. In Sweden Santa Claus or Saint Nicholas does not come on 6th December with his small pre-Christmas gifts as a friendly yet severe admonition. Here the children have to be patient until 13th December. But something totally different happens: very early in the morning, at five a.m., the bedroom door opens softly, Lucia enters, a girl in a long white shift with a wreath of lingonberry greenery and burning candles on her head, bringing coffee and saffron rolls containing raisins to the bedside. It is Lucia Day, and everybody celebrates Lucia with coffee and *glögg,* a strong mulled wine, even at the office. At midday there are Christmas delicacies, as well as *glögg,* for lunch, and, in the evening, an extra glass of *glögg* because it is so cold outside! School children treat their teachers to Lucia coffee. Dressed in long white shifts,

with wreaths, and, for the boys, starstudded hats in the shape of a dunce's cap, they make their way to school early in the morning to be seen in the streets and on the first journey of the underground. However, the papers, the radio and television have entirely different greater things to report a couple of days earlier: 10th December is the day of the ceremonial presentation of the Nobel Prizes by the King of Sweden in the Golden Room of Stockholm's City Hall. Ever since 1901 those who, during the preceding year, achieved the most important accomplishments in the fields of physics, chemistry, medicine and literature, as well as world peace, are honoured in this way. The Peace Prize is presented in Oslo on the same day, the recipient having been chosen by the Norwegian parliament. The prizes were endowed by Alfred Nobel (1833–1896), the inventor of dynamite.

At home the busy Christmas preparations continue. Gingerbread is baked (with frequent sampling of the dough), nuts are cracked, toys are prepared, new candles are set out, Christmas decorations are made... The shortest day of the year, 22nd December, has only six hours' daylight in Stockholm and only half that amount in Luleå. There, in the far North, there is deepest winter. When the night is clear and Jupiter gleams in the eastern sky there can be a hard frost of –30°C (–22°F, or 54 degrees Fahrenheit of frost). Temperatures of this order may occur even in Stockholm, but rather less often. Christmas trees are on sale at all street corners; they cost most on 22nd December.

And already Christmas Eve has arrived. Everybody is at home, it is a jolly evening, there is dancing around the Christmas tree and the "Yule Goat", a goat made of straw. The Yule goat always stands beside the Christmas tree and is adorned with coloured ribbons. Candles have been lit everywhere. On the tree hang apples or nuts.

The *smörgåsbord* groans under the vast variety of delicacies. There is the Christmas ham (this is the most important component) and red cabbage, herring salad, marinated herring, spiced bread to dip in the broth in which the sausages have been cooked, liver *pâté* with pickled beetroot, spare-ribs, pork sausages with coarsely-ground mustard, *lutfisk* (dried fish) with potatoes and white sauce, a pig's head with an apple in its mouth. And fennel bread *(limpa)* and crispbread and butter and cheese... And, to top all this, rice porridge with milk and a single almond in the bowl. The one who finds the almond is supposed to be the first to be married.

132

Note: This chapter was inspired by Lena Larsson's "Sverige—ett år".

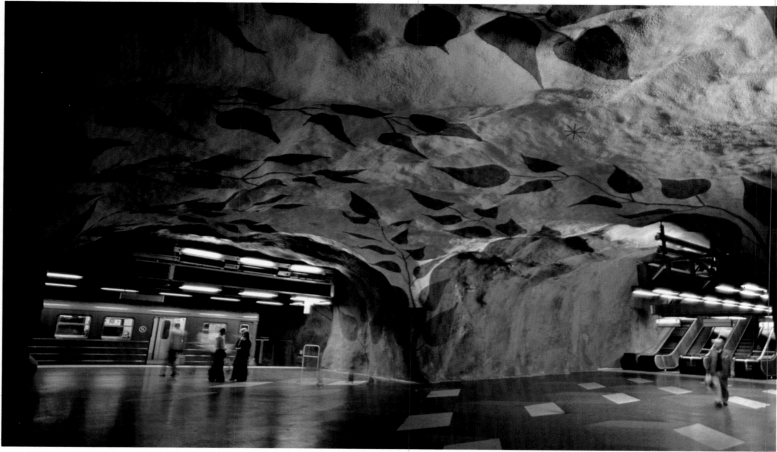

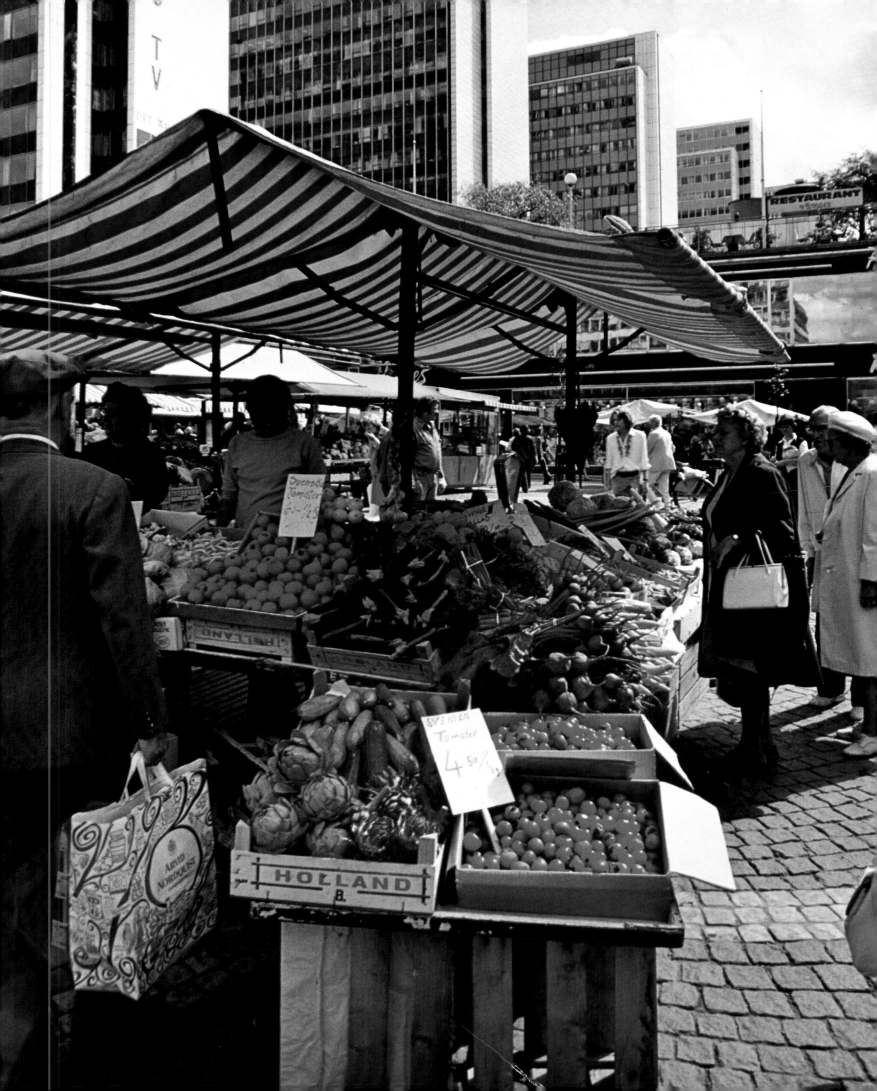

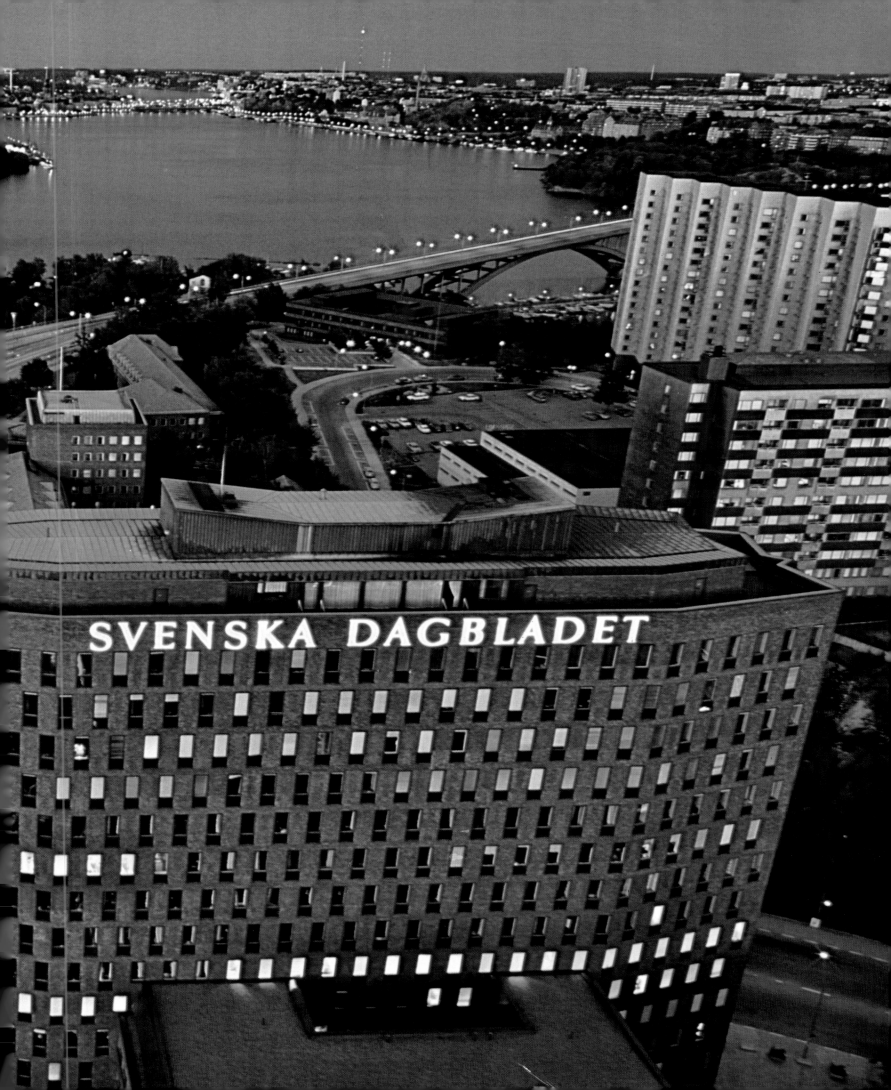

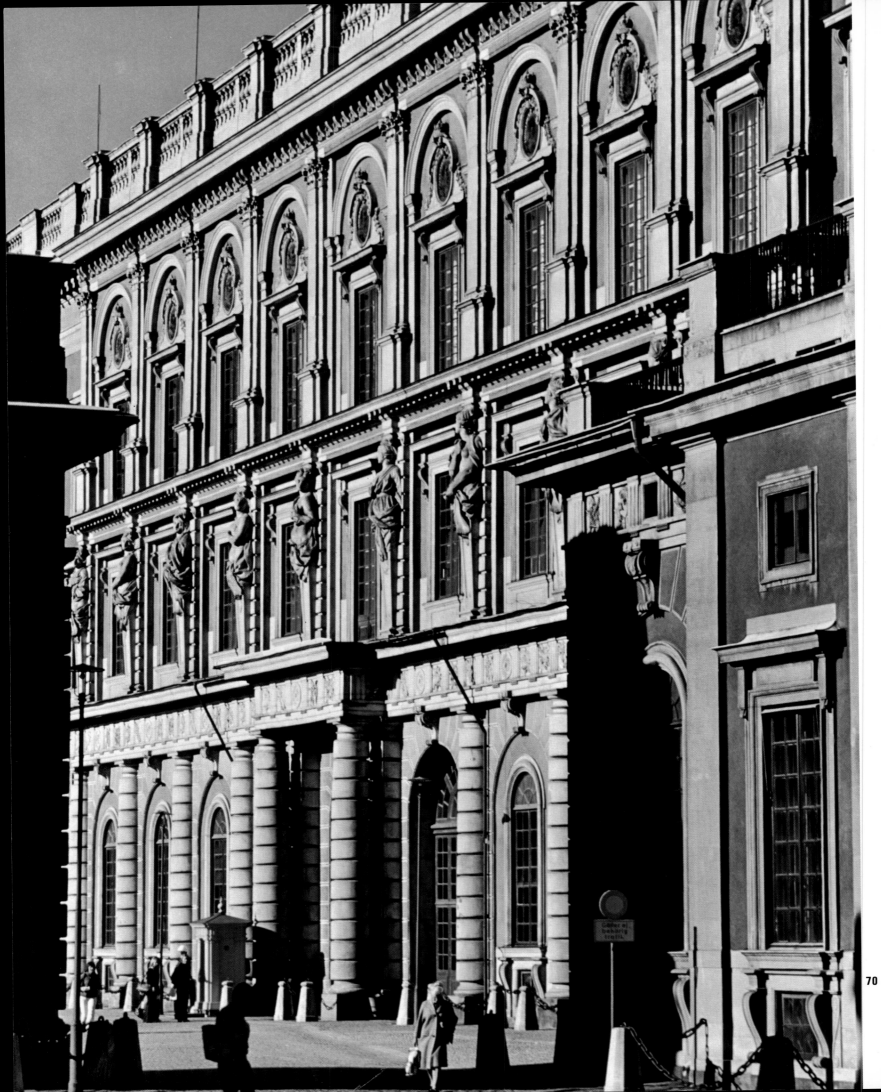

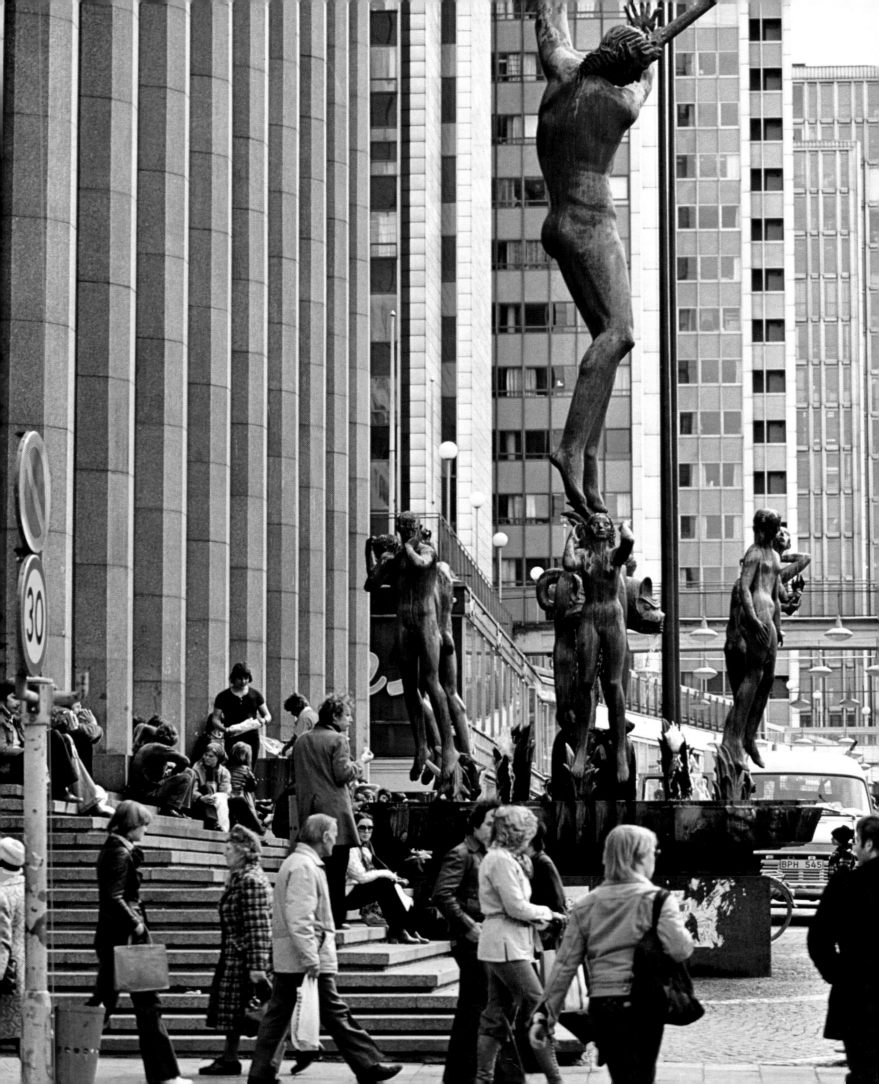

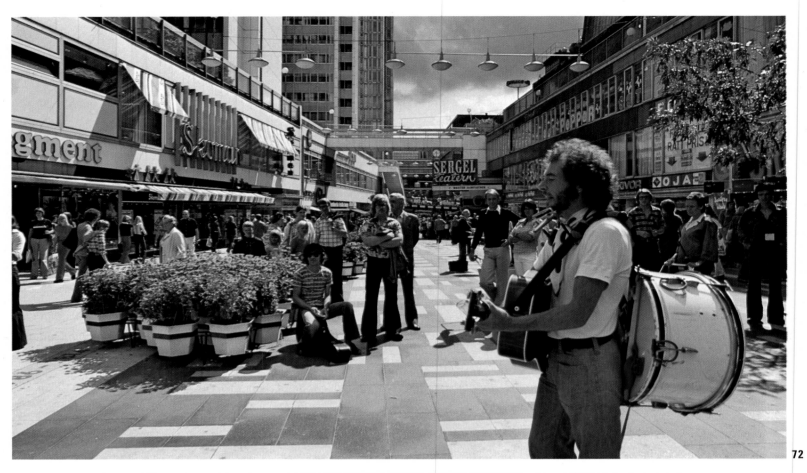

72

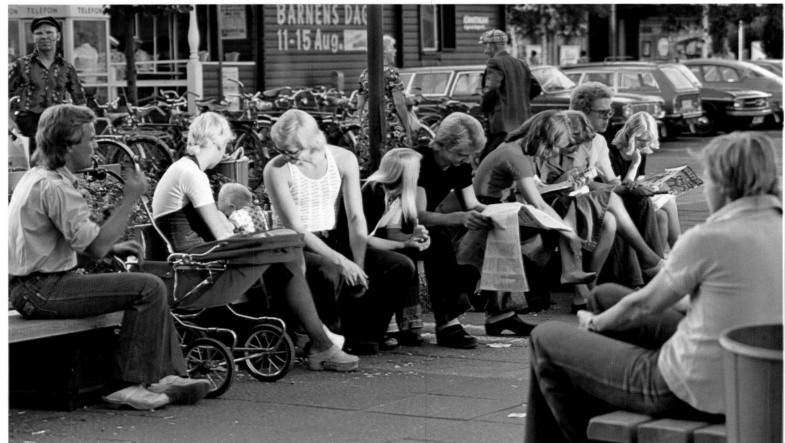

73

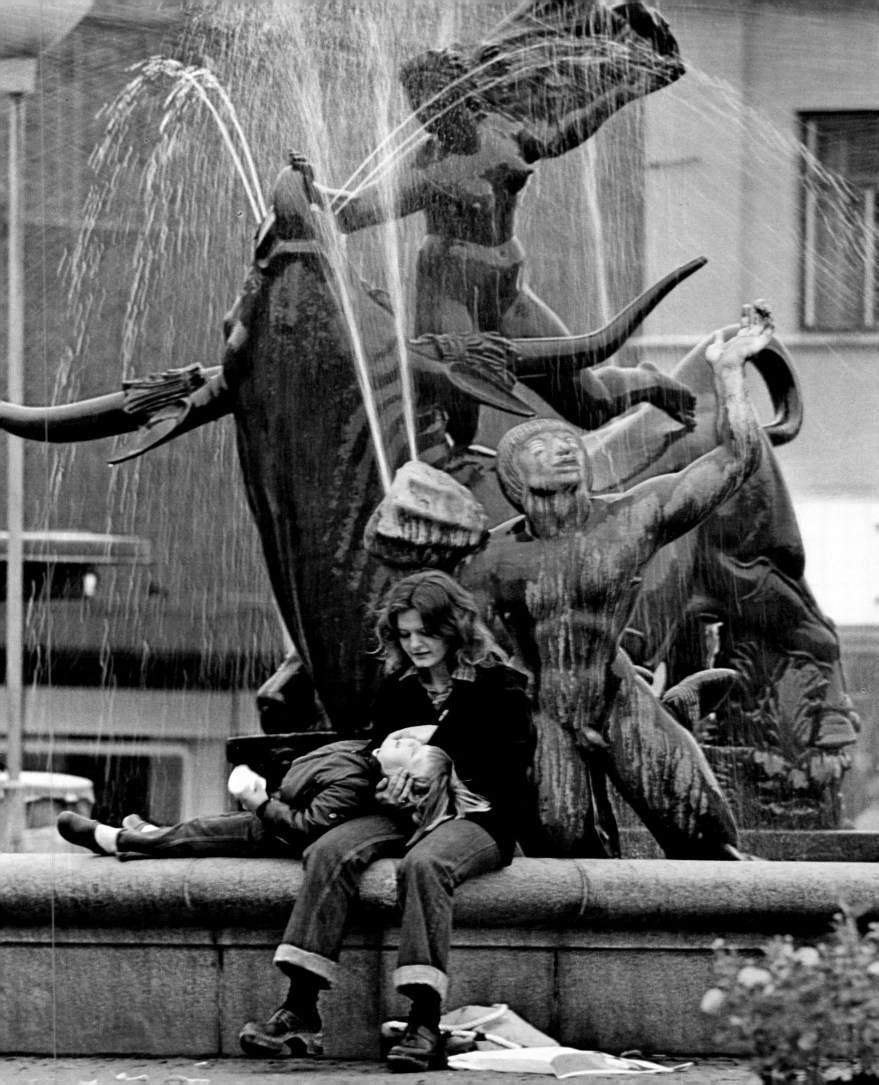

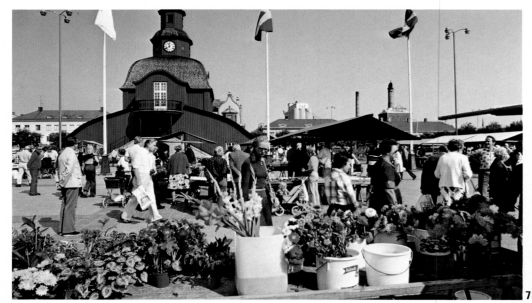

75

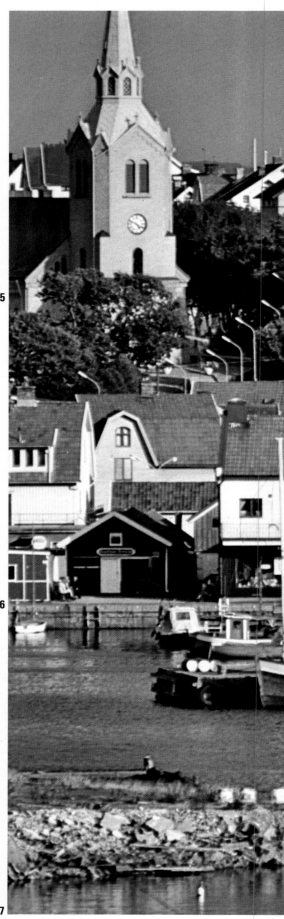

76

77

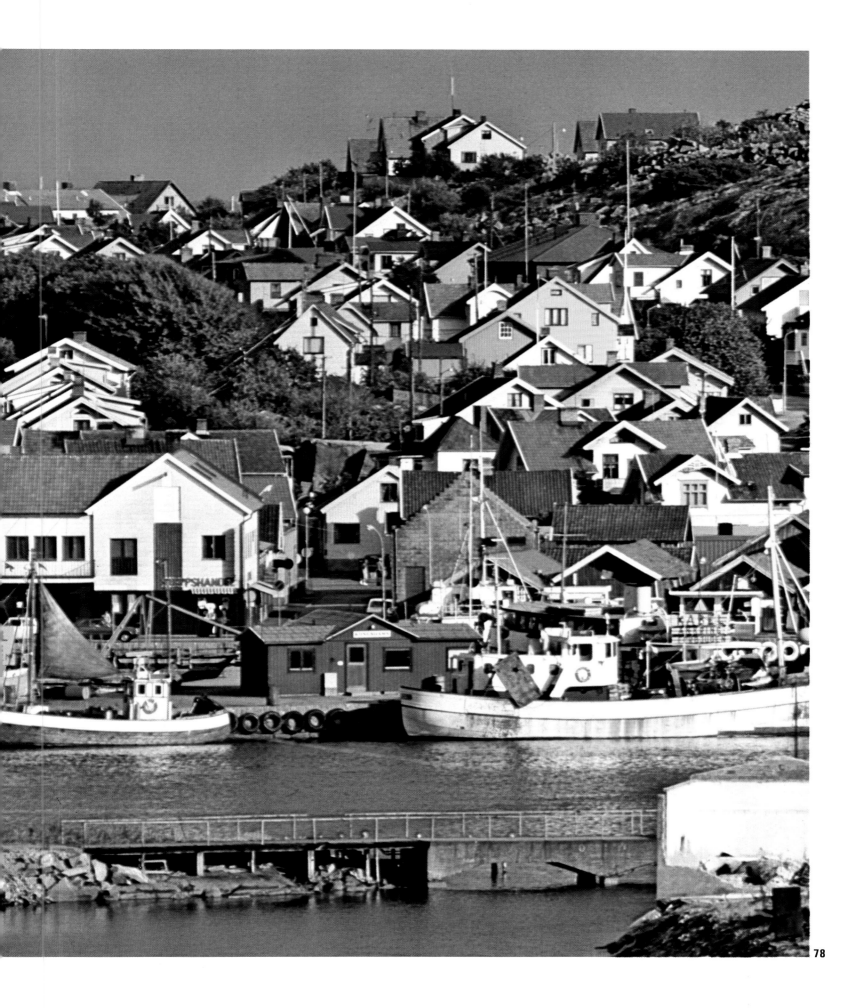

79

80

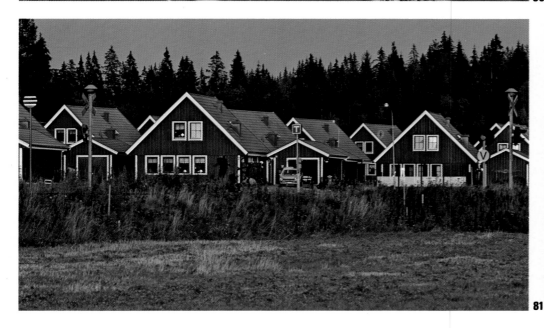

81

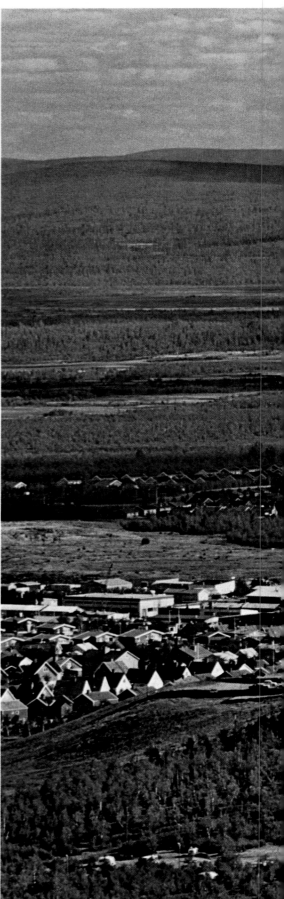

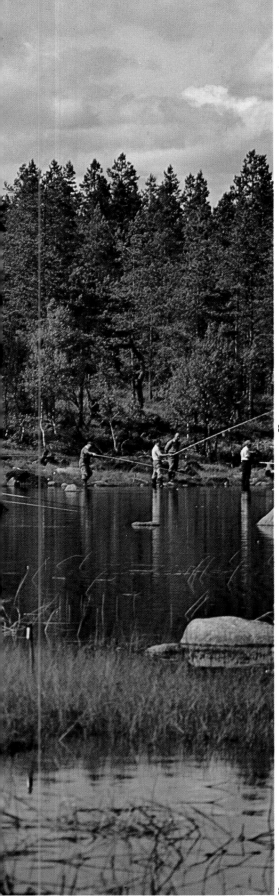

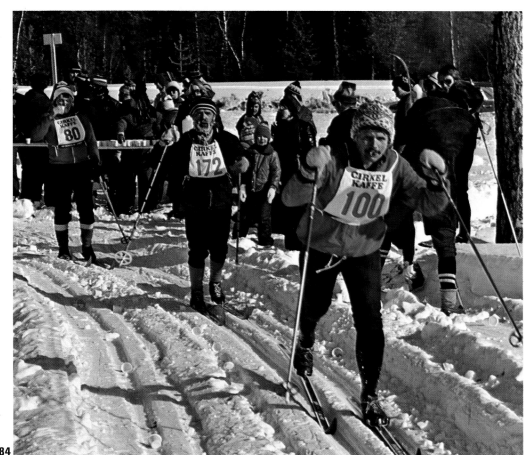

84

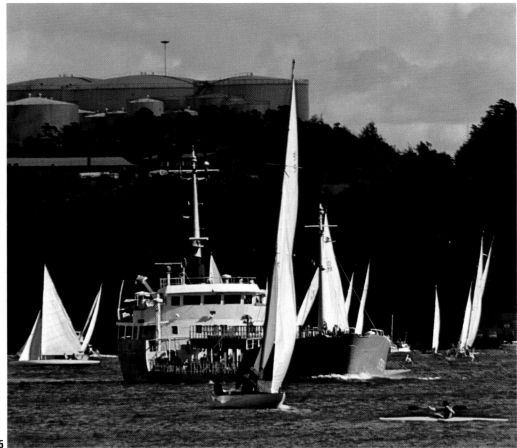

85

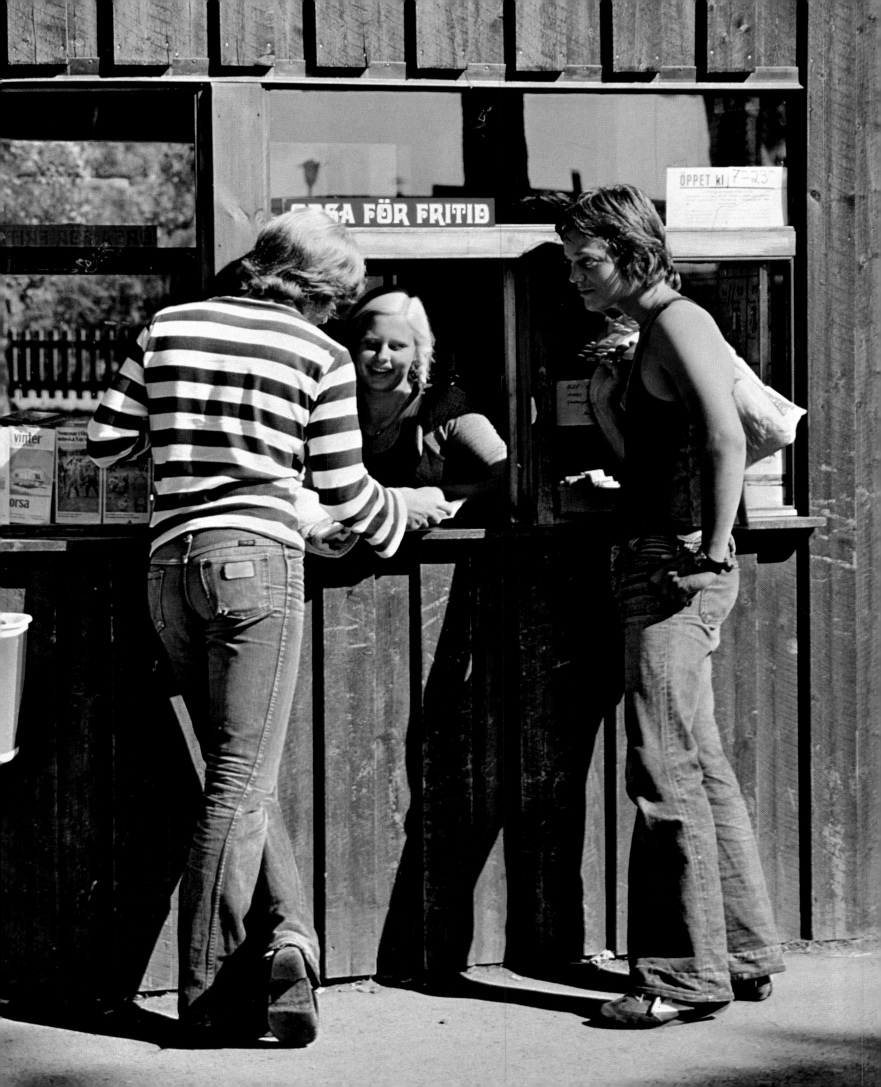

65 *Staden mellan broarna*—"the city between the bridges" over the rapids by which the Mälar drains towards the Stockholm skerry hem, i.e. the Baltic—is the oldest nucleus of the Swedish capital. Although the city's coat of arms bears the picture of Eric the Saint, crowned as King of the Svear in 1150, it is believed, on the strength of a letter from Birger Jarl dated 1252, that it was he who founded Stockholm. Be that as it may, the Mälar had been a Viking trade centre hundreds of years before, with Helgö, Birka and Sigtuna as the predecessors of Stockholm. And it was its trade which led Stockholm—soon after its foundation to become a member of the Lübeck Hansa—to prosperity. Our plate shows the rear view of the ancient medieval merchant city, the "Monks' Bridge" facing the Mälar. From the cluster of buildings the German Church (right) and the Great Church—the coronation church—tower into the sky. The neo-Gothic churches in the background—brought unnaturally close by the telelens—are the churches of St John and of St Engelbrekt, built amidst a middle-class residential area at the beginning of this century. To the South lies the business centre.

66 *Gallerian,* one of the newest parts of the business centre of Stockholm, thoroughly modernized since the fifties. Here a covered pedestrian precinct has been inserted into the interior of the shopping centre and hence protected against the discomforts of an often harsh climate.

67 Since the second world war an up-to-date underground network, step by step, has been developed in Stockholm—the "tunnel railway" whose rails, needless to say, run on the surface in the suburbs. The catchment area of the stations, both in the city and in the suburbs, has been so cleverly planned that the trains are well patronized. In view of the shortage of parking space which exists in the Stockholm city centre, as it does elsewhere, the underground system has appreciably relieved traffic. Where the massive granite forms pillars and vaulting these have been painted and the usual stereotype wall cover by tiles and advertising posters avoided.

68 In the "Haymarket", in the middle of the Stockholm business centre, a regular daily market is held with fruit, vegetables, flowers and livestock produce, both imported and home produced. In the background are modern high-rise office blocks, whose construction towards the end of the fifties inaugurated the renewal of the business centre. Demolition and reconstruction will continue for the rest of the century.

69 View from one of the two newspaper high-rise blocks towards the East, across the Mälar towards the inner city. The time is a late summer evening. The last rays of the sun come in quite flat from the North-West, striking the tall buildings; the rest is plunged in twilight shadow. At the height of summer it never gets really dark. Top right the Väster Bridge, 900 m (3,000 ft) long, spans from Kungsholmen across the prison island of Långholmen to the southern island of Södermalm. On the left, on the northern shore of the Mälar, are Stockholm's oldest penthouses dating from the early thirties. In the background, on the left, the evening sun lights up the five high-rise office blocks at Hötorget, the centre of the business area. At more than twice the distance—6 km (4 miles) from where this picture was taken—stands Kaknästornet, the 170 m (558 ft) high transmitter tower for radio, television and telecommunications with a restaurant on top. The Mälarfjärde is closed in the East by the "city between the bridges" the Old City. Behind it the magnificent cluster of skerries opens out towards the Baltic.

70 The western façade of the Royal Castle of Stockholm, the masterpiece of Nikodemus Tessin Jr. This edifice was erected on the remains of the Vasa Castle destroyed by fire in 1697 and was basically completed in 1754. Much of the ornamental detail is borrowed from the Versailles model; however the Castle of Stockholm is not situated in a magnificent park but closely surrounded by buildings and open only towards the North and the East to the Strömmen, the Mälar outflow and former city harbour.

71 The steps of the Concert House in the Haymarket are a favourite meeting place for Stockholmers. In front stands the Fountain of Orpheus by Carl Milles, one of Sweden's most important artists during the first half of the 20th century. His figures are characterized by weightlessness and delicate dynamics. His home, *Millesgård,* on Lidingö, is a well-frequented museum with numerous sculptures.

72 In Stockholm's modern Hötorg City street musicians, pavement artists and at time amusing hippies entertain the passers-by between business appointments.

73 For a long time Children's Day has been celebrated with merry-go-rounds in the parks, parades, music and lottery ticket sales in all Swedish towns. The money raised by these activities goes to pay for vacations at summer camps for children who otherwise would have to stay in the city.

74 Many Swedish towns are adorned with the works of the sculptor Carl Milles (1875–1955), including Halmstad, the administrative centre of the province of Halland on the Kattegat. The sculpture, "Europa and the Bull", like all the more mature work of Milles, reveals a forceful and yet graceful dynamism, often piquant and precise in detail (see also Plate 71). The town of Halmstad is attested in documents as early as the 13th century. It now has about 75,000 inhabitants. Its economy is based predominantly on the processing of metal into instruments and machines.

75 Market in Lidköping (about 35,000 inhabitants) on the southern shore of Lake Väner, a small, almost idyllic, old-age pensioners' town with only a little industry (Rörstrand porcelain, engineering). It is also the centre of a fertile agricultural area with gigantic grain silos by the harbour. The town received its charter in 1446, but was an important trading centre much earlier. The new city was founded west of the Lida by the lord of Läckö Castle, Count Magnus Gabriel De la Gardie, in the 1670's. He presented the town with the courthouse seen in this picture—a hunting lodge moved across from Kalland Island. It burned down in 1960, but has been rebuilt exactly as it was.

76 Piteå (about 35,000 inhabitants) is one of the towns founded (1621) by Gustav II Adolf in Norrbotten. The town now lies on the northern bank of the spacious estuary of the Piteälv. The narrow tongue of land to the island of Pitholmen is totally built over by the Old City (see plate), whose main shopping street is closed to vehicular traffic. It was only after a devastating fire in 1666 that the town was moved to this spot. Its earlier position 6 km (4 miles) further north-west (Öjebyn) had been less suited to sea-going ships. In 1721 the town was once more consumed by fire and sacked by the Russians. With the advent of the sawmill and later, since the middle of the 19th century, the pulp and paper industries, Piteå acquired a solid economic basis. The drift from small forest settlement in the hinterland to the coastal towns in recent times has led to Piteå's development as a comprehensive urban centre which has more than doubled its population figures. The industrial locations are some way outside the town, mainly at Skuthamn and Munksund.

149

77 Mora on Lake Silja, once a normal Dalecarlian village, has developed into a large community with lively commerce and industry. Sheath-knives, light-metal ladders and television masts are some of the products. The entire region above Lake Silja, as far as Särna and Idre, belongs to the Mora catchment area.

Gustav Vasa and Zorn are two names which are indissolubly linked with Mora. This is the finishing post of the Vasalopp, the ski marathon, which takes place every year on the first Sunday in March with 10,000 participants. Andreas Zorn was born here and in the Zorn Museum one can admire many of his works. The church was originally built in the 13th century. The present exterior with the tower designed by Jean de la Vallée, the architect of the *Riddarhus* in Stockholm, dates from 1673. It has a stately interior with the 15th century vaulting and furnishings from the 17th and 18th centuries.

78 Kunghamn on the Skagerrak is one of the few big fishery settlements in the skerries of Bohuslän on Sweden's west coast. About a 100 years ago the traditional coastal fishing developed into modern high-seas fishing. This meant basically the abandonment of agriculture. The transformation brought the fishermen remarkable prosperity. They could afford a neo-Gothic church and built themselves new spacious houses which are, moreover, very suitable for the accomodation of the numerous holiday visitors in the summer.

79 Malmö, Sweden's third largest city, is situated near the southern tip of the country, on the Öresund opposite the Danish capital Copenhagen. As a result of the decentralization policy Malmö too, since 1970, has been losing some of its population though not on the same scale as Göteborg or Stockholm; nevertheless the population declined by 20,000 between 1970 and 1975, to a figure of 243,591. The settlement goes back to a fishing village and attracted trade even before the existence of Copenhagen. Once before the 14th century Malmö for a short time belonged to Sweden. At that time it was a Hanseatic city. Generally, its rich agricultural hinterland in Skåne always provided a certain compensation for the competition of Copenhagen with which Malmö is linked by intensive ferry traffic. Malmö's industry is characterized by shipbuilding, shipoutfitting, other metal processing industries, as well as the import facilities of its port (chocolate, tobacco) and also the resources of its neighbourhood (farm products and limestone, also foodstuffs and feeding stuff manufacture and cement). Its lively economic life is reflected in the extensive renewal of the cityscape.

80 Skärholmen is one of Stockholm's most modern suburbs. It lies in the South-West between the main exit road, the Södertäljevägen and the Mälar and was completed towards 1970. There is an underground railway link with the city centre 12 km (8 miles) away, and this is reached in a few minutes' journey. Functionally and constructionally Skärholmen certainly deserved the great interest shown by the international specialized press. Nevertheless it is not typical of Swedish residential areas of the past few decades. They are not, as a rule, such an unnatural mass of concrete but are mostly harmoniously interwoven with water, rock and forest. Optimalized solutions on the drawing board cannot replace the natural environment.

81 Of all industrial sectors mining was the first to penetrate deep into the forests of the taiga. The central part of Dalarna, which has belonged to the ore mining region of Bergslagen since the late Middle Ages, has become an industrial region of a particular type; totally urbanized for centuries, without major towns, remarkably decentralized, with only moderate traffic— in spite of a few big metal producing and electrical engineering enterprises—and with downright idyllic small residential neighbourhoods in a healthy forest environment. This picture of Djurås, with its practical prefabricated detached houses of high standard of domestic technology yet in the traditional red-painted timber manner, is typical of hundreds of similar settlements troughout the country.

82 By contrast, the mining towns of Swedish Lapland—as here Kiruna (31,000 inhabitants)—in spite of a certain similarity of detail common to relatively recent foundations, reveal essentially different characteristics. These towns take possession on a more generous scale of the vast solitude of the forest. Their isolation from remote neighbours makes them appear more compact in themselves—in spite of their open spacing internally. Because of the Arctic winter, which here is particularly long, severe and dark, a high level of domestic comfort is even more important than elsewhere. A generally high level of wages makes such conditions possible. Magnificent as the Arctic summer may be, provision for the winter always remains an urgent thought.

83/86 For the Swedish affluent urban society leisure has become a central issue of everyday life. It is a matter of course that leisure should be spent out of doors and used for health-giving exercise. People readily adapt to season and weather since the numerous facilities enable all tastes and ambitions to be satisfied. Some find relaxation in quiet angling in tranquil water (83), others test their strength in crosscountry skiing though the winter forest (84), near Kiruna. Rivers and lakes, as well as the long island-fringed coasts are an irresistible challenge to the water sportsman. More than five-sixths of all Swedes live by the water, all three big cities are coastal cities, and the Viking blood still teems in Swedish veins. A maze such as that of the Stockholm skerries (85) is an ideal playground (not only for the small coastal tanker amidst the swarm of sails); leisure parks are also becoming increasingly popular. These are compact areas with games, swimming and camping facilities, available for what is often only a symbolic admission fee since as a rule they are operated by the municipality, which means that they are subsidized. In most instances these are seasonal facilities, installed also to promote tourist traffic.

As the plant cover once more advanced over Sweden's soil after the glaciation it is apparent that quite minute differences in natural conditions, locally fluctuating nuances of climate, and the accidents of soil and water in the marginal area of living conditions were decisive for the existence or non-existence of vegetation. Inevitably, rural settlement was subject to the same constraints of nature.

Yet there is an uncertain range between existence and non-existence, a range within which the scales can be tipped by man's intervention, his ability to resist those natural constraints by special efforts, by privations, and by his intelligence. That struggle is clearly reflected in the location and character of rural settlements.

So long as the countryman was not linked by trade to his more distant environment, his own sustenance depended upon the finding of suitable soil for the cultivation of grain (buckwheat, barley, oats, wherever possible rye, but not at first wheat). Often a certain minimum of soil fertility was not in itself enough. An area also had to be large enough to produce a sufficient harvest to feed the rural family even in bad years. If the area was divided into several plots, then these must not be too far away from each other. Their cultivability must not be impaired by too many stones, excessive inclination, or too much or too little soil moisture.

In marginal agricultural areas, however, home-grown supplies of vegetables were insufficient for sustenance. Hunting and fishing had to be practised additionally. That took time. Moreover, success was uncertain and varied a good deal with the season. By comparison limited livestock breeding, to supplement crop farming, offered several advantages—the work involved could be shared out among several members of the family, and animals could be used not only dead but also on the hoof. As a result of selective breeding cattle proved more suitable to the utilization objectives (including use as pack and draught animals) than the hunted wild animals, and neighbouring areas unsuitable for cereals could be utilized for pasture and grazing. The decisive question, ultimately, was whether adequate fodder supplies could be laid up for the long winter. Compared with the land requirements for arable farming, pasture and grazing, two other vital location requirements of independent rural settlement in Sweden were much more easily satisfied—water and wood, both for firewood and building timber.

A soil chart furnishes important information on the areas which were first inhabited by a settled farming population in

Important Aspects of the Swedish Agricultural Landscape

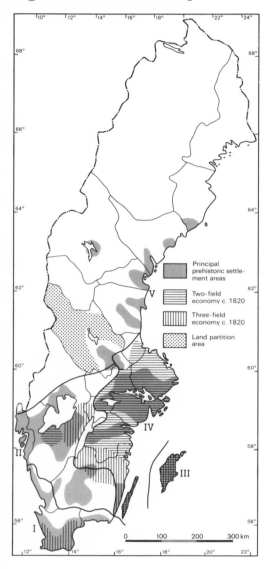

Principal prehistoric settlement areas

Two-field economy c. 1820

Three-field economy c. 1820

Land partition area

0 100 200 300 km

I. Sweden's biggest villages, as a rule farmland villages, are still in that part of the country which, until the Peace of Roskilde (1658), belonged to Denmark. There the formation of aristocratic estates started early. Castles are numerous. The peasants were in soccage. The typical form is an enclosed quadrilateral farmstead.

II. In the rural settlements of southwestern Sweden there was two-field and three-field farming in the lowlands and one-field farming with forest clearance by fire in the forest villages. Among the villages of the *Falbygd,* around the town of Falköping in the Silurian region between Lakes Väner and Vätter, one of Sweden's most ancient settlement areas, there were numerous variants of big farms and villages with irregular, in part archaic, division of land ownership and irregular forms of farmsteads.

III. On Gotland the predominant settlement form was that of individual farmsteads, although small villages have come into existence here and there as a result of farm partition. Both two-field and three-field farming are found. In the 18th century the earlier timber buildings began to be replaced by stone buildings.

IV. Eastern central Sweden is the historical nucleus of the country and identical with the region covered by the agricultural reform of the *solskifte,* whereby, for taxation reasons, uniform large farmsteads were created. Very much older planning ideas, such as a regular rectangular form of farmhouse with clearly separate living accommodation and animal quarters surrounded on all sides, have been integrated into modern developments. In the eastern Mälar area, especially, big manorial farms emerged in the 17th century.

V. In northern Sweden the predominant pattern was that of sporadic settlement *(glesbygd)* instead of village formation. Colonization of the hinterland extended from the Middle Ages to the second world war and, often through the *fäbod* system, resulted in characteristic patterns of meadow cultivation with dairy cattle breeding combined with a modest one-field economy. Hunting and fishing played an important part. The typical form are quadrilateral farmsteads with detached cattle sheds.

acc. to Staffan Helmfrid in: Sverige, Land och Folk

Sweden towards the end of the neolithic period (about 1,800 B.C.). A large-scale morphological map would make it possible to present this general statement in greater detail. These, then, are the residual soils of the ancient Silurian limestone cover and of its ground moraine trains. They lie in those areas where the oldest permanent agricultural settlements are to be found, for example, in the region near Falköping in Västergötland and along the coasts of Halland and Bohuslän, following the gradual rise of the land from the sea. In Skåne also, which lies close to the Continent and thus was most likely to receive innovations, this pattern can be observed. Their distribution largely coincides with the presence of the great stone grave chambers.

Soil quality and relief are, as a rule, also the factors which, singly or jointly, determine the compactness of rural settlement—village, scattered settlement, or isolated homestead. Even the position and structure of farmsteads themselves occasionally depend on the relief. Large-scale farming is possible only where soil quality and relief do not operate against it; agro-social considerations come only second.

The nearer a farmstead is to the altitude limit or the Arctic limit of agriculture, the more its main weight will shift towards livestock and towards additional income from forestry work,

fishing, mining and nowadays industry and services, at the expense of arable farming. With a vegetative period of only 100 days in Norrland nearly nine months remain for activities other than work in the fields.

The economic pattern is reflected in the nature and location of the rural homesteads. The less grain cultivation, the smaller are the barns, threshing floor and mills. Instead, the cattle sheds are relatively large, and, above all, the numerous haystacks on the many meadows are a typical feature of the Norrland agricultural landscape.

As in all marginal agricultural regions specific adaptive patterns have developed for livestock farming also, taking advantage of the mobility of the animals. Similarly to alp farming in the Alps and seter farming in Norway, Sweden had its *fäbod* farming. That means that milch cows, and small cattle, sheep and goats were kept on forest and clearing grazings a long way from the farm throughout the summer, and were tended there by cattle hands. In Sweden and Norway these cowherds were exclusively female. They saw to the milking and made butter and cheese, including whey-cheese. Thus the grassland around the farm was almost entirely given over to hay production for the winter. This utilization pattern was reflected in the buildings, which constituted a miniature farm. It is obvious that the spread and intensity of such a marginal form of operation are principally determined by profitability. In difficult food supply situations—the last time was the second world war, when international trade was disrupted—*fäbod* farming expanded. Since then it has dramatically declined to two or three hundred functioning *fäbodar* in Dalarna, Jämtland, and Härjedalen. That these remaining summer farms are still in use is due to the extensive network of forest roads for motor traffic built in these areas in recent years and to the fact that some *fäbodar* are being used as holiday homes. This trend also has its parallel in the Alps.

Fäbodar

The demand for land and the frequent shortage of sufficiently large contiguous and agriculturally useful areas have resulted, in most Swedish regions, in rural settlements being either scattered settlements or essentially individual homesteads. Villages sprang up only in the few agriculturally favourable areas, mainly in the great plains of central and southern Sweden. With the change in the laws after the beginning of the 19th century the villages were dispersed and the farms moved away from each other. As a result, the character of the agricultural settlements and the appearance of the cultural

Age of Rural Settlement

153

landscape underwent transformations. The traditionally sett-led agriculturally favourable regions reveal traces of habi-tation going back to the New Stone Age, roughly 4,000 years ago. Location of villages and field patterns over 2,000 years old (late Iron Age) have in many instances proved to be the direct predecessors of present-day rural settlements, with boundaries, marked by boundary stones, virtually unchanged since their careful mapping and charting in the 17th and 18th centuries. Recent research increasingly suggests that the roots of rural settlement in central Sweden extend back as far as the early Iron Age, numerous traces of which have been found especially in Östergötland and on Gotland.

Clearance and Land Abandonment

As other European countries, Sweden evidently underwent an appreciable population expansion from the early Middle Ages (5th to 10th century). While this may have been one cause of the extensive Viking expeditions, within the country the ancient agricultural landscapes certainly increased in frequency and intensity. But that was no longer enough: in southern and central Sweden many forest-clearing settle-ments (place names ending in, for instance, -ryd) invaded the forests from the 10th century onwards.

Sweden also participated in the land abandonment period of the late Middle Ages—a phenomenon known also in England and central Europe—though on a lesser scale and not in its northern regions, where, as in Finland, colonization con-tinued to progress. The reasons for the then so widespread abandonment of rural settlements (or rather: of the localities, less often, at first, the fields) are still not satisfactorily clari-fied. Pestilence was possibly one contributing factor. In Swe-den, at any rate, the land abandonment process is found to have been more marked in areas where the population had the alternative of life in the towns. This phenomenon ran parallel to the need for a reform of peasant holdings with the aim of greater marketable production instead of modest subsistence farming. The fact that the (then still tentative) urbanization must be seen as the cause of rural land abandonment emerges more clearly when, in the 16th and 17th centuries, big farming enterprises were more or less systematically set up to ensure the production of agricultural surplus produce for the towns and, of course, also for the army and the navy, and to fill the public grain stores established to safeguard food supplies. Gustav Vasa to this end introduced

Stordrift and Estates of the Nobility

the *Stordrift* system, an agricultural reform, on the model of which the nobility, mainly in the 17th century, laid out

its vast manorial estates with splendid country houses, as for instance in the Mälar area. Many individual farmsteads and entire villages fell victim to those processes, while their land continued to be utilized. In consequence, as an aristocratic class—really a novelty in Swedish social structure—began to establish and stabilize itself economically, so at the same time a lower agro-social class of hired labour came into existence. It was predominantly from this that the drift into the towns was recruited.

Within a few generations, on the threshold of modern times, something approaching the majority of the Swedish population was swept into a far-reaching differentation of livelihood activities. That resulted in a new stratification of incomes and, of course, in a settlement pattern distinguishable according to social class, especially in the countryside. That process began, and reached its most marked expression, in the provinces of Halland, Skåne and Blekinge which, until the Peace of Roskilde (1658), had been Danish provinces, and in a radius of roughly 120 km (75 miles) of Stockholm. From there it extended, especially during the great-power period in the 17th century, also to south-western Finland. These were the same areas which, as early as the High Middle Ages, underwent a cultural-landscape standardization through the agrarian reforms of the *bolskifte* (about 1100) and the *solskifte* *Bolskifte and Solskifte* (in the 13th century). At that period, competition based on the existence of the towns did not yet play any part. Production surpluses would not, therefore, have been marketable. The need for the levying of taxes to finance the incipient state administration at that period, on the other hand, had triggered off the establishment of fiscally equivalent farmsteads. Each such farm had about 12 ha (30 acres) of arable land. A plough had been in use for a few centuries which, though it turned the soil, did not reverse the ploughshare when direction was changed. Because such a plough required considerable traction force in the heavy clay soils of the *Slättbygder*—the villages in the plains—and because change of direction was cumbersome with draught animals, long strip fields were preferred. As a result of this ploughing technique humped fields developed. The plots were in the form of common fields. Cultivation was on the basis of a two-field system with compulsory rotation and with regular fallow. The *Bol* plots were distributed by lot. The *Solskifte* determined the rules of this draw and the intervals at which it was repeated. The *Solskifte* was consistently applied only in eastern central Sweden and concerned only the communal fields. Outside the communal

fields there were extensive grazing and forest commons for pasture, hay and timber utilization. To ensure winter fodder, tree lopping often had to be resorted to. The common land, especially in the widely scattered forest villages, extended without any boundary towards the neighbouring settlement. The "no man's land" in between had almost entirely reverted to the Crown by about 1500.

Regardless of whether a village was concerned with an area of common fields, or the fields of an individual homestead, such areas of agricultural land were, as a matter of principle, barred to free grazing. To keep livestock out they were fenced with palings or with stone walls. They were the equivalent of the "infield" encountered generally in north-western Europe, in contrast to the "outfield", the unhedged, scarcely cultivated and predominantly freely grazed part of the agriculturally used land. The outfield (in this case "field" should not be equated with "arable land") often consisted of water-logged meadows, swamps and forest and—unless belonging to an individual farmstead—was common land.

Land Survey and Taxation

This, as also the *fäbodar,* the summer grazings, was not taxed and hence not charted either in the land surveys of the 17th or 18th centuries. This tax exemption promoted the development of the *fäbodar* beyond their original purpose. Small fields or vegetable plots, and from the late 18th century onwards also potatoes and fruit (apples and red currants, for example), were the result. The next step was the improvement and multiplication of living accomodation on the *fäbod.* Eventually many a *fäbod* became a permanent settlement. One fine day the tax authority would catch up with them also. The gradual expansion of the fiscal territory not only pushed the settlements further and further into the taiga, but these in turn drove the Lapps ahead of them, so that, increasingly, they moved from the taiga into the tundra.

There used to be no division of property through inheritance among Swedish peasants, except in Dalarna, where it was common practice to divide the land without regard to any legal forms, even though the law forbade any such partitions of homesteads. In consequence, several families had to live together in one farmstead. The next step, whenever possible, was the construction of several houses on one farm. With increasing population pressure the division of farms was eventually permitted (from the 17th century, and even more so during the 18th century), on condition that each part possessed its full fiscal strength. That was frequently possible

only at the cost of great privations or not at all in the long run. Emigration to Norrland, to the cities, or into the army was often the lesser evil.

Village size, measured in number of farms, in the 18th century amounted to 30 to 50 farms in Skåne, to 10 to 25 farms on Öland and in Västergötland, to scarcely more than 10 in Östergötland, and rarely to more than three or four farms in the Mälar region. In measuring the size of a farm only the arable area was considered, as also for taxation. Forest, common land and *fäbod* land were disregarded. The old tax registers, however, also contain data on the average hay harvest and on the usufruct of forests, common land and fishing waters. This makes it possible to gain a more accurate idea of the real size of a homestead as an agricultural unit than would be possible merely on the basis of the managed arable land including fallow. *Size of Villages*

The most accurate details are for the central Swedish plain for the period between 1630 and 1650. There a farm had about 12–15 ha (30–38 acres) of arable land, of which one half was fallow at any one time. In the remaining areas the farms were smaller with only 4–10 ha (10–25 acres) of arable. Sporadic records of the forest settlements in northern Sweden speak of 1.5–3 ha (4–7.5 acres) of cultivated fields per farm. As a result of the land partitions of the 17th–18th centuries many peasants were left with less than 2.5 acres for annual cultivation. Unfortunately comparable data for Skåne do not exist for that period. The estates of the nobility amounted to about 40 ha (100 acres), occasionally to as much as 100 ha (250 acres) of arable land, of which fallow often only accounted for one-third. In central Sweden the grassland was of about the same extent as arable, whereas for forest farms it was three to five times as much. Its preponderance grew progressively northwards. The ratio between meadows and arable can only be estimated since the meadows were not surveyed; ancient documents merely record the hay yield.

To put an end to the partition of farmland in favour of economically optimized farms a new legal basis was created in 1827, the *lagaskifte*, following ineffectual attempts towards the end of the 18th century. With the repeated divisions of the land, leading to ever smaller units, the interdependence of neighbours had grown in inverse proportion, and a rationalized use of the land had become increasingly more difficult. The most striking result of this agricultural reform—which was to have a pervading importance for the aspect of the Swedish cultural landscape—was the shift of farmsteads *Lagaskifte*

out into the fields and hence often the break-up of the old village communities, unless these were so small that the parcelled fields could be worked from the old site of the farm. Thus the effects of the *lagaskifte* varied a good deal from region to region. Because of the character of these divisions the plains of Skåne and other similar flat areas favoured the innovations more than other regions. As the costs had to be borne by the peasants themselves, for several decades the reform made but slow progress. Nowadays the state foots the bill. In Dalarna the implementation of the *lagaskifte* was successfully resisted, in spite of repeated attempts; this is still the case today, due in part to costs in our present society. In the 19th century labour was cheap, and the villagers helped to move the buildings to their new locations. The *lagaskifte,* not least through the freedom which it gave the individual farmer, was responsible to a great extent for the rapid development of agriculture in the 19th century. It was simply the prerequisite of efficient agriculture in Sweden.

Transport of Farm Produce Up to the end of the 19th century transport difficulties compelled each farm to be self-sufficient with regard to as many products as possible. For the same reason it would have been unrealistic to pursue a production target oriented towards commercial surpluses. In this respect, too, the central Swedish plains enjoyed an advantage over other parts of the country. The lakes offered the possibility of shipping and, in winter, sled transport over the unobstructed ice sheets. By comparison, pack animals or wagon transport were hopelessly uncompetitive in terms of load, speed and range—i.e. in terms of cost. The exceptionally favourable position of the Mälar cities, especially Stockholm, and the importance of the Göta Canal, linking the great central Swedish lakes from coast to coast, must be seen against that background. Such transportation advantages were an important prerequisite both of the development of the big estates in the Mälar region and in the neighbourhood of the surrounding towns. Nature here had provided an infrastructure without which a modern economy, based on the division of labour, would not have been possible prior to the railway age or indeed prior to the age of the motor vehicle.

The difference becomes most apparent at the other extreme, where the communications infrastructure is particularly scanty or, well into the 20th century, was totally lacking. *Forest Settlements* That applies, above all, to the forest settlements in the north of western Sweden and in the west of northern Sweden. There

are not only no towns but not even villages. The typical pattern is that of scattered individual homesteads or farm groups (frequently divided farms).

Well into the present century they depended almost entirely on their own produce. Agriculturally useful areas were available only in small unconnected plots. This accounts for the farmsteads being widely scattered. Until this abandonment during the last few decades the pattern was still predominantly that of one-field farming, i.e. no crop rotation for lack of alternatives. Yields were correspondingly poor. The basis of livelihood had to be found predominantly in forestry work. But even for forestry improved conditions did not arise until the middle of the 19th century with the development of the sawmill industry as the precursor of the cellulose industry on the Bothnian coast and on Lake Väner. Needless to say, transport facilities were decisive even in this development. Timber, at least, could be floated down the rivers. The rivers, in consequence, also determined both the location of industrial installations and the continuation or re-establishment of forest settlements in the 19th century.

Even these marginal settlements, isolated and scattered though they were, had occasional need of services—and these brought the first beginnings of an urban settlement pattern into the taiga. These were small townships called church towns. With such a low population density churches obviously could exist only at distances of day-long journeys. For many inhabitants of Norrland church visits were therefore possible only if they could spend the night near the churches. For that purpose the farmers set up small cottages near the church, and these were used also in connection with law court hearings or on market days, since these events were likewise held near the church and in conjunction with divine service. That was also the way in which the Lapps received their supplies. They set up log cabins next to the churches. In the past there also used to be small stablings for horses alongside the church town cottages; now they are no longer needed. But the cottages are still maintained, even though the motorcar has of course made a church visit or a shopping trip possible without a nightfall. On Lake Siljan, incidentally, it was customary to go to church at Rättvik by rowing boat (Plate 53). The age of the church towns is uncertain. It seems that they only developed after the Reformation. Nowadays many of them have developed into small local centres or towns (e.g. Skellefteå, Jokkmokk, and Lycksele).

Church Towns

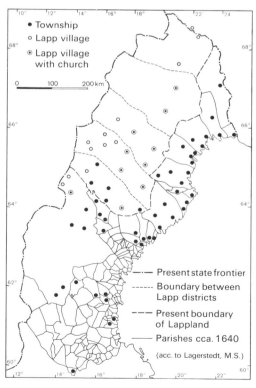

Acc. to R. Bergling

Sweden's sea frontier is 2,390 kilometres (1,500 miles) long, plus 400 km (250 miles) round Gotland. We are regarding the four-mile limit as smoothing out all the skerries, fjords and bays. If, on the other hand, the perimeter of all these inlets is included, we have a coastline of no less than 7,000 km (4,350 miles). It is clear that, with such a long coast, fishing has played a major role at all times. The fishing settlements of today, for example in Bohuslän, are not, however, as old as one would believe them to be.

Fishing has always been a sideline—even an important one for farmers living near the coast—supplementing crop farming, livestock breeding, forestry and mining. This has remained largely so on the Baltic. Those small fishing hamlets and fishing sheds which are found along the coast of Norrland were erected as meeting places during the fishing season. Exceptionally, a fishing village such as, for example, Ulvön off Ångermanland, has developed into an all-year-round community, in this case thanks to the preparation of *surströmming* (fermented Baltic herring), which has created sufficient employment.

On the west coast conditions were at first comparable, but by the 17th century a slowly progressing vocational differentiation (between farmer and fishermen) took place, becoming increasingly apparent as a result of very profitable fishing in the 18th century. There was a good market for the catch, and a sizeable amount of it was exported to Germany and other places. This led to an entirely new type of fisherman's dwelling adapted exclusively to this occupation. Its location was determined by harbour conditions and the proximity of good fishing grounds. Until near the end of the 19th century fishing took place primarily along the coast. A change then began to occur with the use of larger boats, eventually motor-driven ones. More effective equipment permitted fishing in the open sea, and this led to a move to the extreme points of the coastline and to the islands. Here the fishing villages lie close to each other, their commodious dwellings painted in pastel colours and their boat-houses standing in a row along the harbour. These fishing hamlets are now favourite vacation spots for thousands of summer tourists.

Fishing settlements similar to those found in Bohuslän exist also on the Kattegat coast of Halland, along the coast of Skåne and on the Blekinge skerries.

As for herring fishing off the Skagerrak coast, records reveal a strange periodicity—every 111 years huge hauls were made: in 1006, 1117, 1228, 1339, 1450, 1561, 1672, 1783 and 1894.

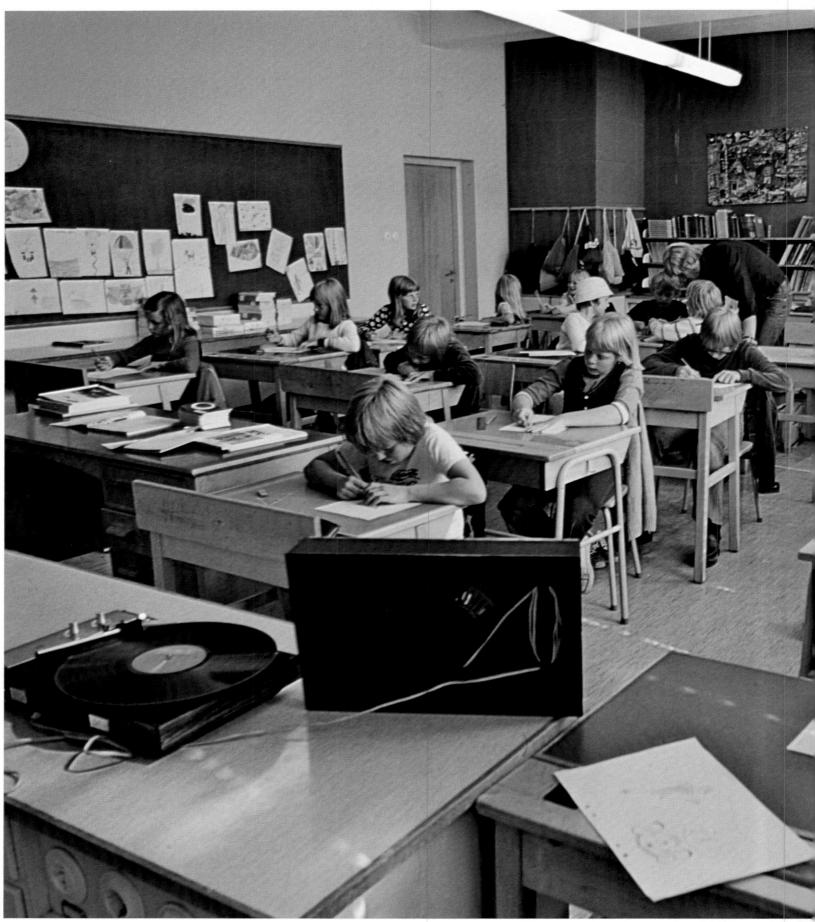

92

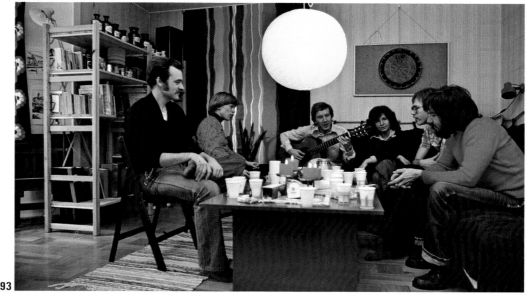

93

94

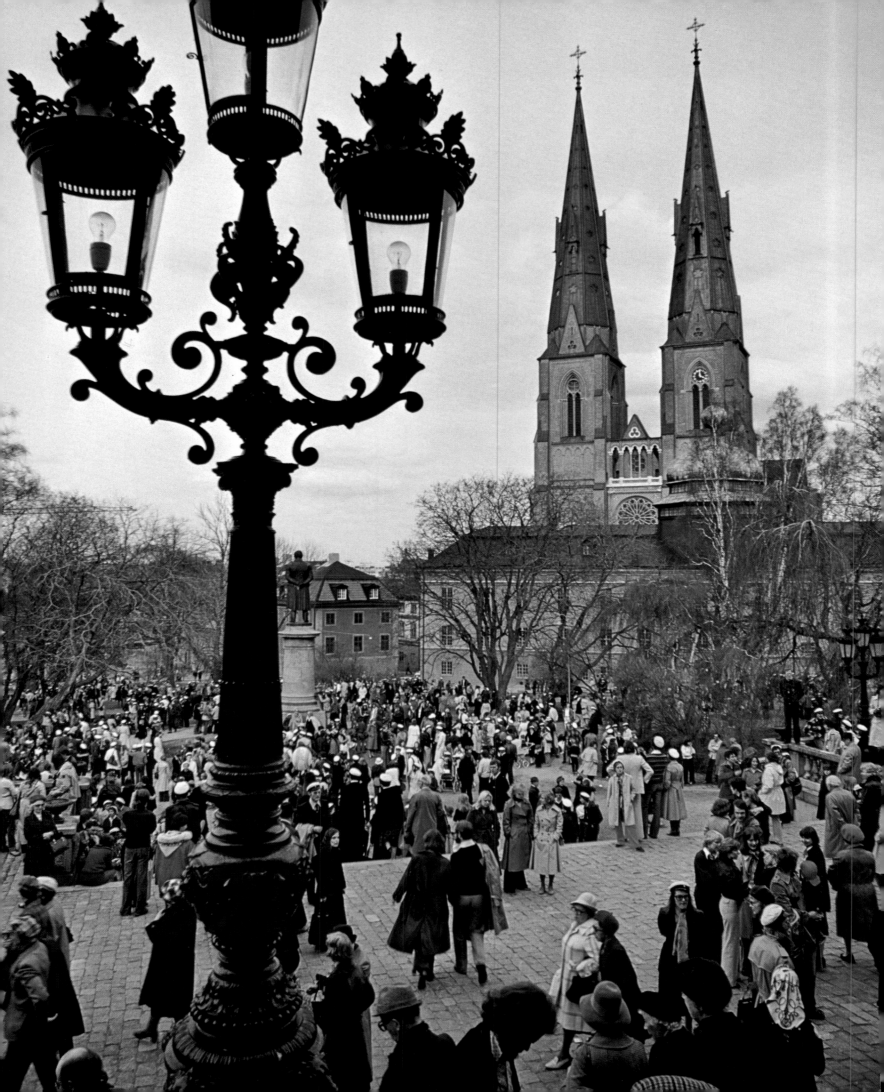

87 The Cathedral of Uppsala is the biggest church in Scandinavia. Begun in the 13th century, it was consecrated in 1435. The magnificent Gothic brick building with two massive towers has repeatedly been plagued by fire. In the Cathedral is the tomb of Eric the Saint as well as of Gustav Vasa and his first two wives. Johan III, Svedenborg, Linné and Nathan Söderblom are also buried here.

88/90 The Cavaliers' House of the manor of Rottneros in Värmland, known as early as the 15th century, has become famous through Selma Lagerlöf's story "Gösta Berlings saga"; in her work it bears the name of Ekeby. The colourful characters in the "saga" lived in the "cavaliers wings". Three houses have stood on the same spot as the present main building shown in the picture. It was erected after the third house had been destroyed by fire on Lucia Day in 1929.
Rottneros park was created between 1943 and 1953 by the foundry proprietor Svante Påhlsson. There are hundreds of sculptures by famous Swedish artists: Carl Milles, Carl Eldh, Per Hasselberg, Christian Eriksson and others. Naturally there is also a statue of Selma Lagerlöf. It occupies the place of honour.

89 Anders Zorn (1860–1920) is one of Sweden's most important painters. He came from Mora on Lake Siljan in the heart of Dalarna. There he also died. A large proportion of his work is housed in the Zorn Museum in Mora. In the artist's rich work, which also includes some sculptures, the people of his homeland and their way of life play an important part. The painting here reproduced shows a girl cattle-hand at a forest grazing of a *fäbod,* the Swedish equivalent of an Alpine *alm.*

91 Art lesson in a primary school in Orrefors in south-eastern Småland. Swedish education everywhere has at its disposal generous and modern equipment. Considerable importance is generally attached to instruction in arts and crafts, and to creative activity. In Orrefors this instruction is particularly important as the town is a significant centre of glass blowing and cutting. The products of this small industry, which here of necessity supplanted the earlier iron production in the 18th century, owe their successful exports to their material and artistic quality, a fact taken into consideration early in the 20th century, when skilled artists were first employed as designers.

92 As classroom instruction in Sweden invariably takes place both in the morning and in the afternoon. the lunch break with a hot meal and plenty of milk, financed by the municipality, is a solid part of the daily school pattern. The lunch break actually performs an educational task that should not be underrated, especially for the only child, and also makes it easier for mothers to pursue their own occupation.

93 Student circle in Uppsala. It has long been the practice in Sweden for students to lead independent lives as adults. This is made possible by numerous modern student hostels as well as apartment blocks. In the decoration of the interiors, even at a modest cost, a great deal of latitude is allowed for individual tastes.

94 Independent creative occupation on long winter evenings or in old age must not be lost even today when the traditional family community, insofar as it comprised more than two generations, is in a state of dissolution. This is why old people's homes provide a variety of incentives and facilities. The plate shows a weaving room in an old people's home in Kiruna.

95 For a number of years now the first of May has been a non-religious holiday in Sweden. It is the day when the workers, as all over the world, gather together to demonstrate their solidarity. In present-day Sweden the parade is also a manifestation of respect and gratitude to the pioneers of the working class to those who fought for and achieved progress in the struggle for a better society.
The red flags in themselves are no indication that these are Communists demonstrating. The embroidered golden crown disproves that. In 1971 the Communists split off from the Social Democrats and have since undergone several further splits. Although together they may at times gain up to 5% of the vote, they are deeply divided internally and have scarcely anything to do now with the labour movement or the trade unions.

96 April 30th, Walpurgis Night is a great university holiday. All Uppsala is out and about. Between the main university building, whose splendid flight of steps leads down to a small park, and the Cathedral stands the *Gustavianum.* This building was the university in the 17th century. Today it houses archeological and ancient culture collections.

Urban Settlements

Towns have existed in Sweden for less than a thousand years; until the end of the Middle Ages they represented rare exceptions among settlements. The origin and basis of the urban type of settlement were trade and cultic-religious services. Frequently the two went together.

Trade depended on suitable transport routes for the movement of merchandise. That meant that a town had to be situated near a waterway since overland transport for major quantities of merchandise was not possible prior to the railway age. The oldest means of transport for major cargoes of merchandise was the Viking ship. Overland feeder services, however, depended on pack animals and, in winter, sleighs. Suitable transloading places proved to be the crystallization points of non-agricultural permanent settlements. In Sweden such a location was, significantly, first found in the Mälar region. During the first 300 years from the 10th to the 13th century, the topographical location underwent a few changes but the geographical location proved right in the long run. Such settlements were Helgö, Birka, Sigtuna and finally Stockholm, of which a Foundation Charter by Birger Jarl survives from the year 1252. Sigtuna had been ravaged by pirates as early as 1187 and was totally destroyed by fire in 1255. A worse blow to the city was the uplift of the land which closed off the entrance to the Mälar, thus allowing Stockholm to develop without competition. In all probability Stockholm had already been serving as a point of transfer for a long time before it was formally declared a city.

The Mälar and Stockholm

Stockholm and its predecessors have confirmed the superiority of their geographical situation regardless of their 300-year-long consolidation phase: the Mälar with its ramifications and tributaries, subsequently to be supplemented by canals, opens up the largest and economically richest hinterland conceivable in Sweden. Throughout the centuries it enjoyed an innovation lead over all other parts of the country with respect to nearly every new development.

The position of Stockholm, central also with regard to the Baltic, facilitated the spread of its economic and political influence to the entire region of that part of the sea. The fringing of skerries favoured the city's defence in past centuries. In spite of the uplift of the land its harbour has remained deep enough to this day. Its primary effect otherwise was to provide more space within the city peninsula on which to build. The rapids of the Mälar outflow to both sides of the Old City of Stockholm moreover attract all North-South land

routes to Stockholm over a distance of 100 kilometres (60 miles). It therefore seems natural that Stockholm should have become the capital of the country.

During the first 100 years of its existence as a city Stockholm had a rival in Visby in Gotland; at that time it was bigger and richer than Stockholm. But Visby was destroyed by the Danes in 1361 and never again recovered its former prosperity. During its early period Stockholm greatly profited from its partnership with Visby—both were members of the Lübeck Hansa. No doubt development would have taken an even more favourable course for both cities if Sweden in the late Middle Ages had generally attained a higher level of development. But even the first bishops' sees, such as Lund, Växjö, Skara, Linköping and Uppsala were unable to trigger off any appreciable trade in goods. For one thing, they were prevented from doing so by their transport situation. With their immediate hinterland most of them represented small self-sufficient economic areas. The predecessors of the present town of Göteborg, i.e. Kungahälla, Lödöse and Älvsborg, had likewise not even been able to take part in the Norway trade which, at that time, was beginning to develop from Copenhagen, Malmö, and above all from Lübeck, even though, from the 16th century onwards it increasingly shifted to the North Sea ports, above all also to Amsterdam. Bremen alone had held a strong position there ever since the Christianization of Norway in the 11th century. From the 14th century onwards, eventually, small trading centres developed in the interior of the country, in association with the bishoprics and crossroads of inland transport, where the transfer from inland ports to overland traffic took place. The numerous Köping localities, among others, belong to that group; the word is etymologically related to German *kaufen* and English *cheap,* meaning *buying,* thus indicating a trade settlement. About the year 1500 there were 53 cities in Sweden, the northernmost being Gävle. By then there were also five Swedish city foundations in Finland —Åbo/Turku, Borgå/Provoo, Björneborg/Pori, Raumo/Rauma and Nådendal/Naantali. Communication from coast to coast was generally beneficial, but occasionally pinpointed also unfavourable locations—unfavourable, for instance, with regard to hinterland communications, such as the Uppland cities of Norrtälje, Östhammar and Öregrund. In the long run they were unable to stand up to the superiority of Stockholm or even of Gävle. In effect, all Norrland shipping to foreign destinations had to be directed through Stockholm.

As already mentioned (p. 155), an appreciable drift from the

The Ancient Bishoprics

Köping

countryside to the towns occurred mainly in the Mälar area, in Uppland and in Östergötland in the 16th and 17th centuries in connection with the *Stordrift* reform. That was accompanied by a wave of mercantile city foundations and the great expansion into Norrland and Finland: Hudiksvall (1582), Härnosänd (1585), Umeå (1588), Piteå and Luleå (both 1621), and in Finland, Ekensäs/Tamisaari (1546), Helsingfors/Helsinki (1550), Uleåborg/Oulu (1605) and Vasa/Vaasa (1606), Nystad/Uusikaupunki (1617; kaupunki = köping), Nykarleby/Uusikaarlepyy (1620), Gamlakarleby/Kokkola (1620), Torneå/Tornio (1621), Tavastehus/Hämeenlinna (1638), Nyslott/Savonlinna (1639), Brahestad/Raahe (1649), Villmanstrand/Lappeenranta (1649), Kristinestad/Kristiinankaupunki (1649), Kajaani (1651), Jakobstad/Pietarsaari (1653), Frederikshamn/Hamina (1653). Incidentally, Hamina is the only town in Finland with a baroque town plan, a concentric octagon which, admittedly, was never completed.

Mining Settlements

From about the 16th century onwards iron ore mining in central Sweden *(Bergslagen)* reached such proportions that modest urban features began to develop in livelihood structure and settlement, though not towns properly speaking. It was not so much the urban settlements developing from the small smelting centres in the forests as the ones developing from the sites of pig iron processing, i.e. the forging and foundry works, that proved lasting. The deposits and hence the mines and galleries, and from the late 17th century onwards also the pits, were rather small but, as a rule, very labour-intensive. The result of this massive manpower investment was that the peasants could no longer extract ore and smelt it merely as a sideline. There was a progressive need for vocational differentiation which, incidentally, resulted at an early date in specific social legislation supplementing the general mining law. Whereas mining law (*bergslag* and *hyttlag*) regulated the utilization of ores, water and forest, basing itself on Central European models, above all the Freiberg Mining Law, the miners also needed protection and incentives for their hard and hazardous work. Exemption from taxes and military services were two important aspects of mining law. One law which had a certain effect on vocational differentiation and on settlement was the stipulation, applied chiefly in Dalarna, that only women were allowed to tend the livestock on the grazing grounds, the *fäbodar*. The menfolk were to be kept available for lumbering, charcoal burning, and work in the mines and smelting plants. Hunting, con-

struction, timber rafting and haulage were jobs for men anyway. Only the elderly, mothers and children, were able to remain on the farms proper. This intentional separation of the sexes was ordered also from concern for the morals of the population. This division of duties greatly contributed to a division of settlements—in Dalarna to the point of land partition—as well as to an increase in the tasks of the *fäbodar* which, at least temporarily, were more suited to ensuring food supplies for charcoal burners and miners than were the distant permanent settlements. Around the forges, on the other hand—driven, of course, by water power—small compact settlements sprang up with quite a number of workers' cottages which, by present-day standards, provided very cramped accommodation. In the vicinity of these workers' cottages, though at a certain distance, there was generally an elaborately designed mansion which served as the centre for the management of the estate. It was basically their location with regard to transport that gradually made some of these small nuclear settlements grow into townships or at least into a *tätort,* a rudimentary town. In Värmland, on the northern shore of Lake Väner, such instances are numerous. Glass blowing and cutting in eastern Småland produced similar effects.

For nearly all urban settlements in Sweden it was vital, well into the 19th century, to retain easy access to grazing, forest utilization and fishing grounds. Facilities for ample independent food supplies were indispensable. In central Europe much the same still applied to the small agricultural towns and market centres. Inadequate communications inescapably called for such provision. It is in the light of this situation that the importance of the railways should be judged; their construction embraced the whole of Sweden during the final decades of the 19th century. The railways *Railway Towns* were a fundamental innovation for the towns and for the possible urbanization of the entire nation. Only now was it possible to set up throughout the country settlements beyond the earlier small and essentially self-sufficient ones. Only now was it possible to exploit economic potentials which had lain fallow and without which the present standard of living could never have been attained. Even though a few small railway junctions and stations were not yet able to make the great leap, as for instance Mellansel or even Ånge (Västernorrland), or did not grow beyond a modest role in overland trade, such as Skurup (Skåne), others managed to develop a fairly lively industry which began to play an appreciable part also in

Swedish exports. Examples are Åstorp, Eslöv and Hässleholm in Skåne, Nässjö, Sävsjö, Ljungby and Värnamo in Småland, Katrineholm and Flen in Södermanland and Bollnäs in Hälsingland. There are even some coastal centres which acquired their main urban function only through the railways, such as the oil import and ore export harbour of Nynäshamn, or Oxelösund, or the ferry port of Trelleborg.

New Ports

Prior to the railway age only 10% of the population lived in cities (1850: 350,000). A century later the proportion had risen to 66.2%. This trend has been greatly promoted, and on a rapidly rising scale, by motor transport since the first world war. The fact that one may now speak of the total urbanization of the Swedish population, regardless of their actual place of residence, is entirely due to the motor vehicle. Total urbanization of the population, however, must not be equated with the total urbanization of settlements. Very few are big enough to reflect an internal differentiation—a fundamental characteristic of the city. Only three cities have developed secondary centres in addition to a main centre, and only those three have grown into big cities—Stockholm, Göteborg and Malmö. All three are ports. Nearly all Swedish towns have a waterfront—on a river, a lake or an inlet of the sea. Stockholm's waterfront is particularly successful in terms of urban architecture—one of the reasons why Stockholm is counted among the most beautiful cities in the world. The history of urban settlement in Sweden makes it clear why medieval town centres are virtually non-existent. In actual fact these are confined to the two Hanseatic towns of Visby and Stockholm (Old City), with typical Hanseatic narrow lanes between the magnificent stone houses of the merchants, leading down to the waterfront. The traditional method of timber construction, incidentally, has hardly survived the centuries, although several Swedish small towns, such as Säter, Arboga, Hudiksvall and Söderhamn provide good examples of 19th century, and even 18th century, timber architecture. Only on the south coast are there a number of half-timbered buildings. Ystad, for instance, owes its ancient appearance to them.

Big Cities

Town Planning

Only the 17th century, with its marked absolutistic inclinations, has left some nuclei of monumental town building. In Stockholm the rebuilding of the Castle by Nikodemus Tessin provided an opportunity—but the plans for the reshaping of the neighbourhood of the Castle were not implemented. Instances of Renaissance city architecture with stone buildings, dating back to the foundation of the cities,

174

are found in Göteborg (1621) and Karlskrona (1680). Niko-demus Tessin also gave Kalmar a homogeneous Renaissance appearance following the town's destruction by war in 1611/12 and by fire in 1647, by moving its site to the island of Kvarn-holmen. Since the 16th century numerous towns, when rebuilding after fires, have adopted a regular grid system of square blocks; survivals of this may be found in various places, and also in Finland. Only in the 19th century was this monotony occasionally replaced by new town planning ideas from France (Haussmann) and England, with wide, tree-lined boulevards (Stockholm, Gävle, Umeå) and generous city parks (Helsingborg), sometimes on the former ramparts (Göteborg since 1808).

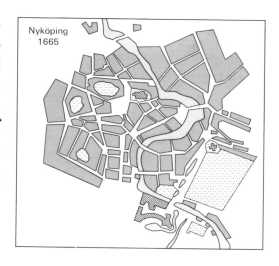

Since the turn of the 20th century three new town planning principles have been establishing themselves in Sweden— (a) villa suburbs of high standard (the first of these was Djursholm near Stockholm which was begun in the 1890's; (b) business centres with high-rise blocks, increasingly on the American model with transport facilities, and big, invariably very modern, apartment blocks in their immediate neighbour-hood; (c) municipalization of the land. This last and very far-sighted measure has proved exceedingly beneficial for fu-ture city planning and has caused land speculation to shrink to an insignificant fringe phenomenon in the Swedish cities. The land belonging to the municipalities, particularly in the neighbourhood of major cities, has been put aside for the construction of small private homes. The lots are not sold, however, but are leased to the owner of the house, who pays a rent for his land to the municipality. As early as 1910 the city of Stockholm bought land earmarked for communities of small homes, for example in Äpplevik and Enskede.

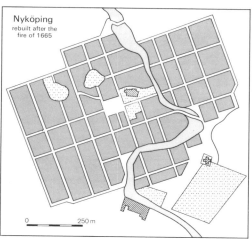

Acc. to L. Améen

Swedish cities today are primarily characterized by the extensive similarities among the commercial centres of the cities, with their large department stores and glittering dis-play windows. As a rule the city plans have not been changed, but the houses along the old streets have been rebuilt or renovated with a resultant uniformity. Around the large cities satellite towns with their own shopping centres have been constructed. They are planned, above all, for a motori-zed population and, as far as Stockholm is concerned, also with regard to the underground network. All in all, though, Swedish town building has reached a level unequalled any-where in the world for facilities in the home, hygiene, comfort, efficiency and aesthetic integration with nature.

Although the runic script was in use in Sweden nearly 2,000 years ago, this does not mean that a wealth of written records of the country's cultural history has come down to us, or that a large part of the population would have been able to use the runic writing. The situation in Sweden was no doubt similar to that in Iceland as recently as 1,000 years ago, in that even the laws were handed down unwritten and had to be recited by heart by a speaker at each Ting. This had the advantage over the present situation that laws had to be reasonably brief and confine themselves to the essentials. Nevertheless, a rich and not merely cultural life existed even during the unrecorded period. As a prop to memory in handing it down the same metre was used in which Icelandic Edda poetry was composed. The subjects were heroic stories, that is the portrayal of models on which the individual's rules of life should be based.

Development of Language and Writing

With the arrival of Christianity Biblical writings in Latin also penetrated to Sweden. Literacy, however, as elsewhere in Europe, was essentially limited to the monasteries and convents. The Cistercian Order founded the first religious houses in Sweden in 1143, at Nydala and Alvastra. Vadstena Abbey, founded in 1384, eleven years after the death of Saint Brigitte, played an important role. The fact that, alongside, there clearly existed a robust and entirely un-monkish literature may be inferred only from post-Reformation records dating back to the 16th and 17th centuries. The fables and farces which characterize it are found also in other European countries at that time. Significantly, the laws of the land were after all written down in the mid-Middle Ages, and not in Latin but in the vernacular. The oldest of these manuskripts is the *Older Västgötalag* of about 1220. A newer, reworked, version was written at the end of the 13th century. Towards the close of that century a whole series of old *lagar* (laws) can be recorded, such as the *Gutalag,* the *Upplandslag* and the *Östgötalag.* A short time later, at the beginning of the 14th century, the *Södermannalag,* the *Västmannalag* and the *Hälsingelag,* among others, were written down. The *Skånelag,* which was also valid in Halland and Blekinge, even dates back to before 1200.

The language of the *Gutalag* is unique. The ancient dialect of Gotland is generally considered to be a Nordic language in its own right, related most closely to Old Icelandic and having strong links with Gothic. On the mainland the Old Norse language had split into an eastern and a western group, the differences being essentially dialectal. Sweden and Den-

mark belonged to the eastern Norse group, from which the Swedish and Danish languages were to develop.

In the 15th century the Swedish literary language was fixed on the basis of the Södermanland dialect. Naturally, this was a chancellory language. At the time of the Kalmar Union (1391–1524) this was greatly permeated with Danish, and hence indirectly also with German, linguistic elements. Shipping and trade, in other words the Hansa, also exerted a direct influence on the Swedish literary language through German vocabulary elements. Hand in hand with the containment of Danish hegemony, and favoured by the introduction of printing, by the translations of the Bible as a consequence of the Reformation, the Swedish literary language was gradually purged of Danish features in the course of the 16th and 17th centuries, and from the 18th century onwards also developed grammatically. The mode of instruction in the 16th and 17th centuries, aiming as it did at the education of clerics and public functionaries, also contributed to this development. To this day Swedish has preserved a very melodious form with an Old Nordic stamp. Even during the age of Reformation, down to the mid-17th century, literature remained predominantly religious and, under the influence of Lutherism, bore a significant German imprint. Not until Sweden's great-power era and the advance of the Renaissance did more intensive contacts come about with Italy, France and Holland. The Stockholm Court gradually acquired the cultural weight of a great residence, with theatre, orchestra and ballet. Only then was the University of Uppsala—which was founded as early as 1477 but had suffered a serious setback through the Reformation—able to develop fully. In 1632 the university at Dorpat was founded, in 1640 Åbo Academy and in 1668 the University of Lund in the newly-acquired province of Skåne—all of them with the aim of establishing closer cultural ties with those parts of the country.

The liberation of the mind from religious dogma enjoyed a full flowering in the 18th century. The Age of Enlightenment in Central Europe was matched in Sweden by the "Age of Freedom" (1720–1772). This was a brilliant period for the rise of the natural sciences. Poetry and music in Sweden at that time were also at the European peak level. Names which spring to mind are the sculptor Sergel, the poet Bellman, whose work still lives today, along with the composer Roman, "the father of Swedish music". During this period there were initially strong ties with England, but subsequently French

The oldest runic alphabet

f u þ a r k g w h n i j p
e R s t b e m l ng d o

The more recent runic alphabet

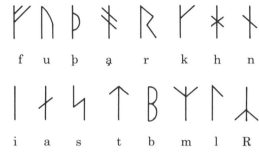

f u þ ą r k h n
i a s t b m l R

Courtly Life

The "Age of Freedom"

177

influence on Swedish culture became predominant. During the entire latter part of the 18th century French was the second language of the upper class.

The tolerant attitude of the Enlightenment towards the world —as Frederick the Great put it: "Let everyone find salvation à sa façon."—and an increasing understanding of the dignity of the individual led to Parliament's decision in 1766 to guarantee the freedom of the press. However, the time was not yet ripe. There were reverses. The full liberal break-through only came with the Constitution of 1809 and the decree of 1812 on the freedom of the press, an edict valid in principle to this day. In the course of the 19th century German influence on Swedish cultural life became increasingly strong and was predominant until the 1930's when contact with Anglo-Saxon culture gained the upper hand.

Within that framework, which at all times permits compre-hensive criticism but no restrictions, cultural life in Sweden has now been able to unfold for nearly two centuries. Its international character has, at the same time, been promoted by Sweden's policy of neutrality and by the fact that Swedish is not a world language; in consequence, intellectual in-fluences from abroad—meaning from outside the Swedish linguistic environment—have unimpeded access without being overwhelmed by the weight of the native language. "Mere barbarism was once patriotic", wrote the poet Tegner as early as the beginning of the 19th century.

A Free Press That universal lack of prejudice is partly reflected in the press. The five biggest Swedish dailies in 1976 had an average total circulation of 1,950,600. Three of the papers are regarded as Liberal or Independent. They alone account for two-thirds of the daily printing (1,324,700). Only one big-circulation daily with a circulation of barely half a million is regarded as Social Democrat, and the smallest of the big dailies, with a circulation of 167,400, is considered Conservative. Com-parison of this press structure with the relative weight of the parties is revealing. Over the past 20 years the Social Demo-crats have attracted between 40 and 50% of the vote, the bourgeois-conservative Centre Party between 13 and 25%, the Conservatives between 11 and 16% and the Liberals with relatively the most floating voters between 9 and 17%. The Communists have always remained between 3 and 5%. This means that, among the voters of all major parties, a large proportion hold liberal views and predominantly choose liberal information. It is important to bear this in mind if one wishes to judge the political situation in Sweden cor-

rectly. All forms of behaviour also include a markedly humane and social component. Even the principle of the free market economy is subject to social obligations.

The high value attached to personal freedom (and, as a part of this, the individual's private life) and to the freedom of movement have proved sure instruments against anarchy. Conflicts as a rule are first resolved by arbitration, by the Ombudsman. Only in serious cases are the courts resorted to. Needless to say, these developments in Sweden do not rule out occasional excesses. But they do not trigger off an over-reaction by the moral force of the public, let alone by the actual power of the state. That imperturbability is occasion-ally criticized by outsiders as a lack of temperament. At any rate, it ensures the flourishing of freedom in Sweden, in an environment of internal security which most critics would have a long way to go to achieve. Sweden never produced a Macchiavelli. But anyone seeking suggestions for the skilful management of a state would do well to take a good look at this country.

Even in Sweden perfect solutions do not grow on trees, but have to be devised by hard work, as anywhere else. Even in Sweden there are fierce debates about, for instance, the position of the women in society. True, the starting point is somewhat different from most other countries. As far as is known—as throughout the Germanic world—there used to exist no prerogatives for either sex at the expense of the other prior to the advent of Christianity. This does not, of course, mean that there had been no division of duties in accordance with biological differences. Even among men the deliberately unequal division of rights and duties only sprang from practi-cal considerations, and then only on the basis of choice, for a limited period and until countermanded. For the free men there were no classes, no castes, no (hereditary) nobility. Only closer contact with the Christian West and its Levantine models involved a leading stratum in often quite savage con-flicts about the validity of alien social patterns of life. These conflicts essentially continued for a good four centuries, from the 14th to the 18th. The position of women in Swedish society suffered as a result.

Legislation aiming at the complete equality in law of women and men began only in—or: as early as—1850. It has since been facilitated by industrialization which rendered a divi-sion of labour based on differences in physical strength less and less relevant. It was further facilitated by the increasing equality in education and training which has saved women

Women in Society

179

from being relegated to low-regard and, accordingly, low-pay manual services or clerical duties with little chance of decision-making. Even though the legal objective may be regarded as having been formally attained, there will remain great individual variations, and there will, obviously, remain the essential biological difference with a certain unalterable division of labour and tasks as its consequence. After all, no-one can seriously want to upset that essential aspect of human life. What matters ultimately is not rights or privileges; what matters is mutual respect. And that is an educational rather than a legislative problem. The schools play their part in discharging that educational task. Domestic science and child care are obligatory subjects jointly for girls and boys in the statutory nine-year primary schools. No less important is the universal teaching trend which is oriented in all subjects towards the unrestricted equality of sexes, age groups, nations, races and religions. Nevertheless, the two sexes in Sweden do not differ fundamentally in the choice of their further schooling and training or their vocational life from their coevals in other developed countries. What differences exist are scarcely identifiable by statistics and would not be sufficiently explicable by that method. It is a fact that, among the younger generation also, the girls pursue their vocational training with appreciably less purposefulness than the young men, who as a rule are able to consolidate their lead in their subsequent vocational life. One has to assume that young Swedish women voluntarily accept this state of affairs. This does not mean that at certain phases of their life they may not regret this decision which then they can no longer satisfactorily put right.

Whereas in 1930 only 10%, and in 1950 only 15%, of all married women were gainfully employed, the proportion is now close to 40%, which means more than half of all employed are women. Over those decades, however, families have become smaller or, more frequently, completely childless; simultaneously child care outside the home has been vastly improved, the preliminary occupational training of women appreciably extended, and part-time work, extremely popular among married women, considerably increased. This development has now led to the following result: three-quarters of all gainfully employed women are employed in no more than 25 of altogether 300 occupations. Whereas 50% of gainfully employed men but only 20% of gainfully employed women are found in mining, construction and industry, the ratio is almost exactly reversed for commerce, public admin-

istration and other services: there the figures are 45% of gainfully employed women against 15% of gainfully employed men. In the lowest wage groups 67% of all employed are women, while women only occupy 5% of all top jobs. Ultimately, however, such figures, accurate though they may be, reveal little about the true importance of women in Swedish society—as may be seen from another piece of statistical nonsense: in Sweden, too, 100% of all mothers are women.

It is therefore impossible to define accurately the extent to which the work of women is reflected in education. Among teachers women very clearly predominate. And surely daily contact with young people is no less a moulding influence than subjects or syllabus. The organization of the Swedish educational system and its teaching objectives have undergone great changes especially since about 1950. There is by no means full agreement on their effectiveness.

Education

Earlier types of schools have been amalgamated, in several stages, into a standard school. The compulsory school age is seven and the statutory schooling covers nine years of primary school. This is sub-divided into three levels of three years each. At the lower level weekly teaching periods increase from 20 to 30 hours. The range of subjects covers Swedish, mathematics, local study, religious instruction, music and sport. From the third year there is workshop instruction and two periods a week of English. At the middle level weekly teaching periods rise to 35 hours; from the fifth year onward there are four weekly periods of English. At the upper level, from the seventh year onward, five or six of the 35 weekly periods are available for alternative obligatory subjects. About 60% of these are used for learning a second foreign language (French or, by preference now, German).

Teaching takes place, as a matter of principle, within the class group, with numbers at the lower level limited to a maximum of 25 and thereafter to 30. The teaching of handwork and domestic science, along with instruction at the lower level, as a rule is in half-classes. Children with learning problems and those with handicaps, of whatever kind, receive their instruction, as far as possible, in the normal schools. If this proves impracticable special classes may be organized, for example, for those suffering from visual or auditory defects. In difficult cases instruction takes place in special schools or at a clinic. On an increasing scale entire groups of teachers, under the direction of a specialist teacher at a high level and possibly with the participation of the school psychologist, the school nurse and the school welfare worker, provide

class-transcending course instruction. The purpose of this is practical preparation for real-life requirements and close co-operation with the parents. Although the schools are municipal institutions, with a considerable say on the syllabus, they nevertheless come under centralized state supervision to ensure a uniform standard throughout the country. This is also supported by school broadcasting (school radio and television), a special division of the Swedish national broadcasting system, which discharges an important function especially in the sparsely inhabited parts of the country. The municipalities are obliged to bear the costs of teaching and learning aids and of school meals for primary school children. The school bus system is also publicly financed.

Upon completion of their statutory schooling about 80% of all juveniles continue their schooling at a grammar school or equivalent institution. Most grammar schools are able to offer several two-year, three-year and four-year courses which are grouped in three sectors—humanities with social sciences; economics; and natural sciences and engineering. Some 45% of the capacity is accounted for by vocational two-year courses, 35% by three- and four-year courses (humanities and arts, social sciences, economics, natural sciences and engineering) and 20% by two-year theoretical studies. The last option is losing out in demand in favour of the first. Students are free to interrupt their grammar school studies or instead to take part in full-time or part-time courses, such as the municipal programme for adult education (for organizational reasons this is not yet possible everywhere), in order to have time for extra-scholastic interests such as vocational training. Only the nine-year primary schooling is obligatory. This option is also of benefit to young mothers. Most recently the municipalities have been put under an obligation to remain in touch for at least two years with primary school leavers in order to encourage them to undergo further schooling, or help them if they cannot find employment or vocational training. As a logical consequence—though possibly a debatable one—of the social welfare state (no existential struggle) there are no examinations of any kind either in primary schools or grammar schools. Anxiety about the so-called school stress even goes so far that the schools no longer adequately fulfil their otherwise key task of providing appropriate preparation for life.

Within the school staff structure, the teachers are assisted by other professional groups such as librarians, administrators and catering staff, as well as school psychologists, school

welfare workers and school doctors. Even the running of the school is increasingly being taken over by administrative personnel, often against the opposition of the teachers' union. Teacher training is gaining ever-increasing importance, and more particularly the in-job further training of teachers. Although education is the biggest item in the municipal budget, 60% of the costs have to be met by state subsidies. Although the Swedish grammar school, with its three- and four-year courses in principle qualifies a pupil for admission to higher education, provided his or her report shows at least average marks, there are also optional so-called higher special courses as a specially qualified preparation. Most university students have graduated from *gymnasier,* but work experience, too, can give the right to university entry. According to the so-called 25:4 rule a person is entitled to go to university provided that he or she is at least 25 years old, has been actively employed for at least 4 years and possesses a knowledge of English corresponding to at least two one-year courses at *gymnasium* level.

Just as the numbers in the grammar schools have risen by a factor of 10 over the past 30 years, so have those of students. In 1970 it reached its highest peak so far, with over 120,000. Since then it has declined to nearly 108,000. That increase demanded an unprecedented extension of the universities, as well as new and branch foundations. In 1963 a start was made on the Norrland University in Umeå, in 1971 on the Technological University at Luleå, in 1972 came the foundation of a College of Librarianship at Borås. In addition, secondary campuses of universities have come into being since 1965 at Örebro, Linköping, Karlstad, Växjö, Sundsvall and Östersund. In parallel with that development the sixties witnessed a vigorous extension of teacher training and social science colleges. In addition, there exists a broad spectrum of specialized colleges. Student places are assigned, in principle, through a Central Office. Syllabuses have been extensively brought in line with the worldwide trend, the courses being largely dependent on the reading material.

Higher Education

This aims at training rather than education as such. Even so-called research training leads, practically without any risk, to a career. Autonomous administration of the universities, which at least used to be the rule in many countries, is not strongly developed in Sweden. On the other hand, the residential People's Colleges are much more independent. These were established as early as the middle of the 19th century. Their aim is the raising of the general educational

Adult Education

level of adults and young people through courses running for longer or shorter periods of time. At present there are 110 residential People's Colleges in Sweden. They cater for something like 50,000 participants per year. Other non-residential educational, further education and training facilities have long outstripped the residential People's Colleges, at least in quantity. About 250,000 study groups of the people's educational organizations and municipal adult education centres cater for roughly 1.7 million participants annually— although Sweden has only about five million inhabitants of post-school age over 20 who are no longer enrolled in a regular institution of learning. These study groups cover a great many different interests. Many deal with languages. One can also study geography, art, literature, music and numerous other subjects. Some of these courses are aimed at retired people. Some study groups lead to university entrance qualifications, others are specifically tailored to the needs of handicapped people or the numerous guest workers. A further adult education institution, catering for about 200,000 participants annually, provides retraining and further training with a view to preventing or mitigating unemployment. Especially in the conurbations a confusing multitude of facilities exists. Radio and television, by means of carefully harmonized programmes, provide an important share in the overall educational options. Their relative importance is particularly great in small and remote settlements.

The Penal System Adult education in Sweden is available also to convicts, right up to university level, in a special penal institution in Uppsala. In 1973 the Swedish Parliament passed a law for the comprehensive reform of the penal system. The principle of punishment has been abolished and replaced by the aim of guiding the offender to an understanding of society's conventions. What has remained is the need to protect society. But that can largely be achieved by not only re-socializing the offender (which is a matter of course) but ideally by preventing him from becoming de-socialized in the first place. This aim is served above all by "serving a sentence in freedom".

On 1st July 1975 the number of offenders sentenced to protective surveillance, whose sentences had been conditionally suspended, was about 16,500. They were being helped by nearly 20,000 partly full-time and partly voluntary probation assistants. Even so, this form of serving a sentence is cheaper than custodial treatment. The number of persons in prison amounted to only just over 4,000. Two-thirds of the roughly 10,000 offenders sentenced to imprisonment each year receive

a sentence of less than two months, only about 7% receive one of more than 12 months. "Life" occurs once every few years. There is, of course, no death sentence. It would be the most macabre denial of the fundamental goal of re-socialization. The most common offence is drunken driving (38%). The prison sentence for this offence is just as much the object of public criticism as the punishment by imprisonment for refusal to do military service (8%). This legal provision is in strange contrast to the generally lenient assessment of foreign draft dodgers by the Swedish public and the Swedish authorities, as instanced in the case of American Vietnam deserters. But then, what country is free from inconsistencies? A striking fact, finally, is that the number of women sentenced to terms of imprisonment accounts for only about 2% of all offenders sentenced. It is an unresolved question which are the social circumstances that render Swedish men so much more prone to punishment than women.

A feature which impresses outsiders is Swedish housing and, *Housing* alongside it, urban construction and hence the urbanization of the population. Urbanization means changing people's way of life. In this the second world war played a major part. Several years of greatly restricted import facilities, combined with very considerable simultaneous exports, resulted in a massive accumulation of capital. At the same time an extraordinary baby boom began in the forties and persisted for about 20 years. Both led to a solid upswing in the economy. Capital was able and obliged to work, and through the continual creation of additional assets it produced a high level of prosperity. This process took place almost exclusively under a Social Democrat reform-minded government. That, alongside other factors, explains why the persistent growth in prosperity occurred very predominantly through activities of the public purse, such as road construction, education and housing.

Qualitatively even the thirties had shown what the goal should be. But at that time about 70% of all homes were simply too small. They consisted of one or two rooms only. Within 25 years the proportion of small homes had declined to roughly 40%. During the same time the proportion of homes with four and more rooms rose to over 30%; more than half of these are in one-family houses which means that they meet the demands of family life to a particularly high degree. The technical standards and the integration of new buildings in the infrastructure of settlement or urban neighbourhood are, as a rule, outstanding.

185

These achievements have been made possible by a far-reaching elimination of the profit motive from housing construction. This starts with the provision of building land from public property, chiefly the municipalities, by way of leasing. Land speculation is, in consequence, almost totally excluded. Ownership promotion from public resources is concentrated on the one-family home (40%); rented apartments are predominantly in municipally-owned (25%) or co-operative (15%) multi-family buildings which are likewise managed without a profit motive. For new buildings since 1960 the percentages are 40% from public finance, 18% for co-operatives, 30% for one-family houses. This leaves only 12% for private rented accommodation.

Generous bank and state loans and rent subsidies ("accommodation money" up to over 50% of the rent) enable the broadest strata of the population to live at a standard of comfort which is probably unequalled in the world. Yet there is no longer any rent control (since the housing market is approaching a certain saturation) so that the supply of homes finds its own level according to the working of the market without any bureaucracy—that is, if one disregards the housing shortage which, even in Sweden, exists in many places. Altogether more than 2,130,000 accommodation units were newly built between 1951 and 1975, that is one for every four inhabitants. That is a good figure but not quantitatively overwhelming. The decisive point is the extraordinary improvement of the standard of accommodation, i.e. in quality. As this phase of housing construction very largely proceeded in the form of entire urban districts their population as a rule is fairly homogeneously structured. The overall social security (assured tenure of jobs, right to permanent residence) diminishes the mobility of the population. In consequence the inhabitants of new buildings unmix only very slowly. Their infrastructure requirements, therefore, change predominantly without locational change as their own age advances (nursery–school–discotheque–old people's centres). Satisfaction of these gradually changing requirements is difficult. Rebuilding and supplementary building have become necessary.

Public Health Public health, like housing, has succeeded in reaching a very high standard over a very broad base. Organization of care for the sick is in the hands either of Provincial administrations or those of the three big cities. These administrations are responsible for running the hospitals. In rural areas there are district physicians, each one responsible for health care in his district. He treats patients within the districts according

186

to a fixed tariff and, if necessary, refers them to the proper hospital. The district physicians are appointed by the medical board. Pharmacies are state-controlled, the prices of medicines are fixed (they are, furthermore, subsidized—no one paying more than 20 kronor regardless of the actual cost of the medicine) and the profit which the owner of the pharmacy may make is restricted to a certain amount.

Doctors in private practice now account for only 20% of all non-hospitalized patients. The capacity of the hospitals is fairly high by international standards: 17 beds per 1,000 inhabitants (10.5 for the organically sick, 2.5 for the mentally sick, 4 for other psychiatric treatment). Added to this there are seven places per 1,000 inhabitants in old people's homes. Home visits by doctors are relatively rare. A proportion of home visits are made by district nurses. In most provinces, moreover, round-the-clock medical advice is available by telephone. Hospitals are structured into small local "standard hospitals", "central hospitals" with 15 to 20 departments, and "regional hospitals". The last have between 1,200 and 2,300 beds, are highly specialized and conduct medical teaching and research.

The fact that public health is the business of the public authorities is something that Sweden has experienced since the 17th century. Even independently practising doctors were public employees at that early date. Only 10% of the total of 14,000 doctors (1974) are in private practice. It is believed that the total of doctors can be increased to 26,000 by 1985. This number and more will be needed if the proposal under discussion today—to reintroduce the old-time family physician, a general practitioner—is adopted. Such a physician would have a clearly defined number of registered patients with whom he, in time, would become familiar. They, in turn, would be able to make an appointment to see him at short notice, and he would be able to make house calls. It is thought that such an arrangement might appreciably diminish the need for comprehensive and expensive examinations by specialists at hospitals, and thus make available a large number of beds. Medical care would generally become considerably cheaper without its effectiveness being impaired.

As with other countries the cost explosion in the health sector is at present in an alarming proportion to all other sectors of life. For all other forms of consumption there exists an extensive package of consumer protection laws. It looks as though public health might have to be subjected to similar control.

187

97 The importance of rivers as transport routes and hence as keys to the country's industrial development prior to the railway age cannot be overestimated. Several factors of importance to the economic development of the Swedish forest coincided at that time. By the beginning of the 19th century the forests of Scotland had been destroyed. The timber requirements of the British mining industry were joined by those of the newer Belgian and German mines. The steam saw had been sufficiently improved, making the location of saw mills independent of waterfalls. The building boom in the industrial towns engulfed ever greater parts of Europe. Sales prospects for Swedish timber experienced a permanent peak. The forests of Värmland grow faster and lie closer to the markets, and also have a less long winter than those of Norrland. The Klarälv (shown near Deje) thus became one of the country's principal rafting routes.

98 The sawmill industry was followed by the wood pulp, cellulose and paper industries. These are situated by preference on the estuaries of the rafting routes. Gruvön's paper mill, which is owned by the Billerud Corporation, is located at the point where the Norsälv flows into Lake Väner. Billerud is one of the big timber concerns which recently merged their forest operations with those of the Uddeholm Corporation. Their combined forests encompass a great part of Värmland. Some of the cellulose and paper is partly further processed in factories belonging to the Corporation and some is sold. Exports are by boat, leaving Lake Väner via the Trollhätte canal and the Götaälv and proceeding to ports around the North Sea.

99 The declining use of timber floating has many causes. It demands too much effort, some of it dangerous (see the plate). When the logs jam it is sometimes necessary to separate them by blasting with dynamite. Log jams can cause floods and can demolish bridges. The many electrical power stations on the rivers make it necessary for the logs to be gathered together from time to time and to be towed. All these operations have made timber rafting a costly business. The number of logs floated has diminished considerably, and the total length of waterways available for floating has decreased from 26,000 km (16,000 miles) in the early 1960's to 7,000 km (4,300 miles). This trend is expected to continue.

100 At the sawmills and cellulose factories all handling of timber in the yards is highly mechanized. The plate shows the *Mälarskog* sawmill at Elinge in northern Uppland.

101 Charcoal burning was one of the foundations of the Swedish smelting industry well into the 19th century. Nowadays, as everywhere, only coke is used. The charcoal kilns no longer smoke in the forests as of old. There was a revival during the second world war, when charcoal for producer gas was needed. There is now a certain demand for charcoal for barbecues.

102 Fruit and berries are delicacies much in demand. High labour costs, however, militate against marketing. The pick-yourself practice has therefore become widespread. To facilitate charging, standard-weight cardboard pannets are used which can be carried in convenient wooden frames. The most northerly major strawberry region is around Östersund in Jämtland, in an area which has been a favourite agricultural enclave ever since prehistoric times thanks to its climate and its calcium-rich soil upon Silurian limestone.

103 Öland is sometimes called "the island of the sun and the winds", as well as the island of the many windmills. At the beginning of the 19th century there were considerably more than 1,000 windmills on Öland. Today there are still a few hundred left, but no longer in use. Formerly every farm had its own mill—it was a question of status. No one wanted to be obliged to ask the neighbour for the favour of using his mill to grind the corn—any more than we would nowadays ask a neighbour to lend us his car. We all run one ourselves. The picture shows the Lerkaka mill wheel, on the central eastern side of Öland.

104 The agricultural high-yield heartlands of Skåne in the extreme South of Sweden are situated in the South-West and the South-East, the Kristianstad lowlands. The farms here are among the most modern enterprises in Europe. In the 19th century a farmstead such as this on the coast of Landön would still have used the offshore islands, the Ängholmer, as pastures. In present-day circumstances they are better utilized for holiday homes.

105 The agricultural reform which has most affected the visual aspect of the Swedish countryside—not to mention its importance for the development of agriculture in general—was the *laga skift*. This land reform law began to be enforced in most villages after 1827. A previous attempt at land consolidation had been made in 1810—the originator of the idea was Rutger Maclean of Svaneholm in Skåne—but it had been too radical and therefore too difficult to carry out. The principle of the *laga skift*, however, demanded that each farm in the village should, if possible, consolidate its property. It therefore frequently became necessary for the farm buildings to be moved

out of the village to new holdings. As a result, as far as the agricultural communities were concerned, the entire pattern of the Swedish countryside was transformed in the course of the 19th century. The result is clearly visible on the plains of Skåne: only isolated farms, such as can be seen on this picture taken in the vicinity of Malmö. The church marks the location of the former village.

106 Mining in Sweden readily transcends settlement boundaries provided a deposit is worth working. Kristineberg in Västerbotten is such an isolated mine in the taiga. It extract mainly pyrites. However, this working also supplies copper pyrites, zinc blende and certain admixtures of silver and gold. The mined mineral is carried for further processing along one of the world's longest cable-ways (96 km = 60 miles) to Boliden, 10 hours away, and thence down to the coast near Rönnskär (see also Plate 111).

107 The Stekenjokk pit, just as Kristineberg, belongs to the Boliden non-ferrous metal concern. It is situated up in the mountains near the point where the borders of Norway, Jämtland and Västerbotten meet, not far from the Stekevare mountain (in the background) which is 1,037 m (3,403 ft) high.

108 Sweden's best known mine is the huge ore mine of Kiruna in Lapland. Since 1898 it has produced high-quality 60–70% phosphatic iron ore from a seam 5 km (3 miles) long and 40 to 200 m (130 to 650 ft) wide. The deposit alone contains at least 1.5 billion tonnes of ore down to about 2,000 m (6,500 ft). That is not even half of all reserves in Lapland. Since 1962 the former open-cast working at Kiruna has given way to deep mining. The extracted ore, 12–15 million tonnes annually, is carried by rail partly to the ore port of Narvik on the permanently ice-free Norwegian coast and partly to Luleå on the Bottenvik.

188

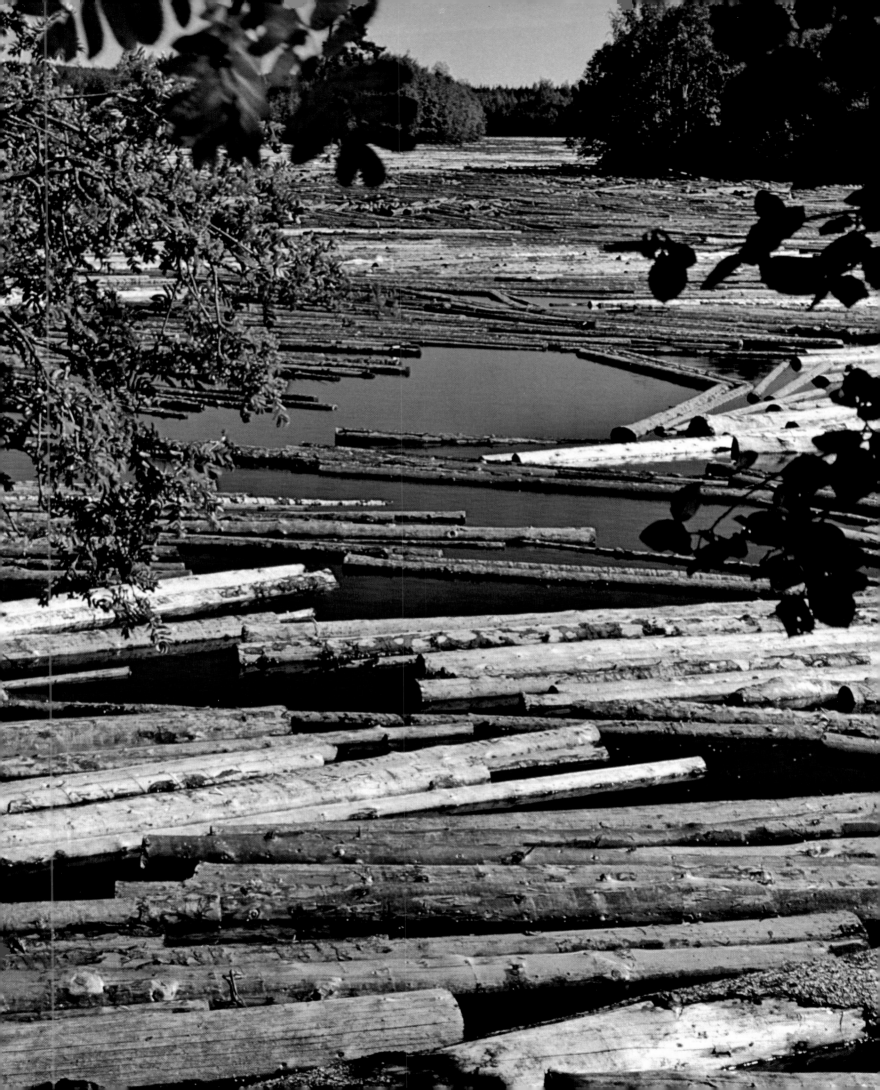

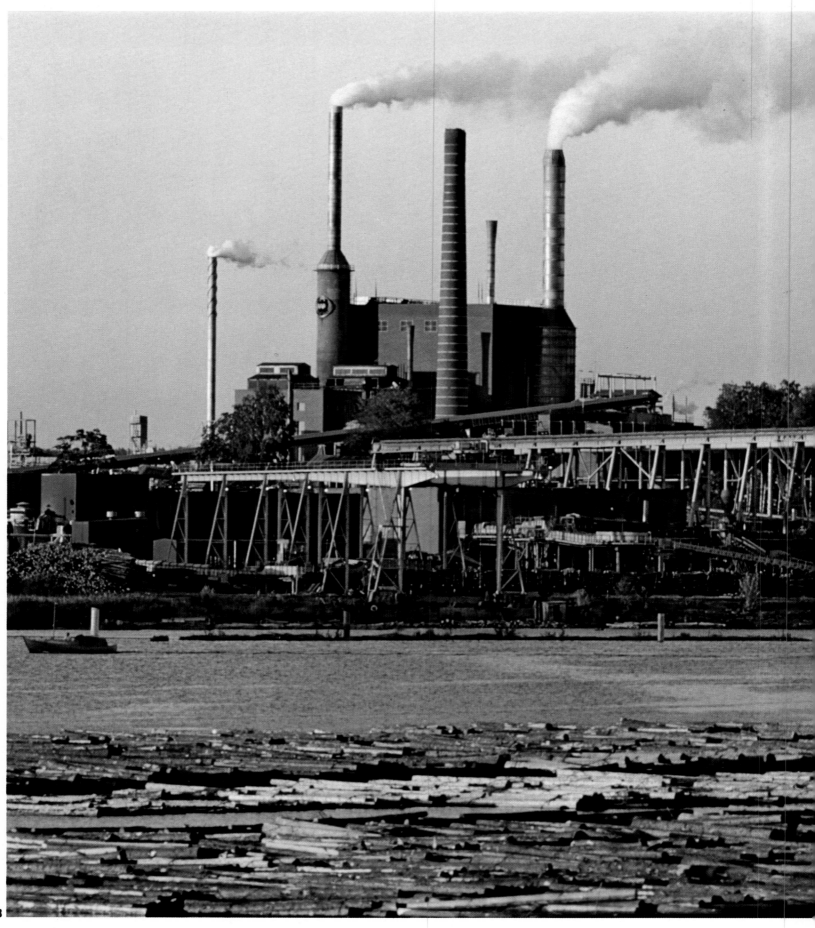

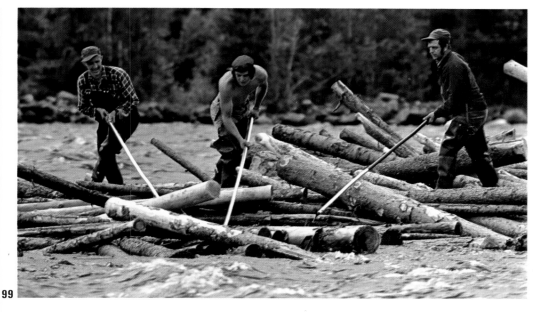
99

100

101

102

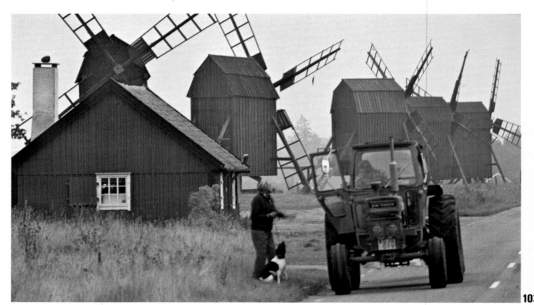

103

104

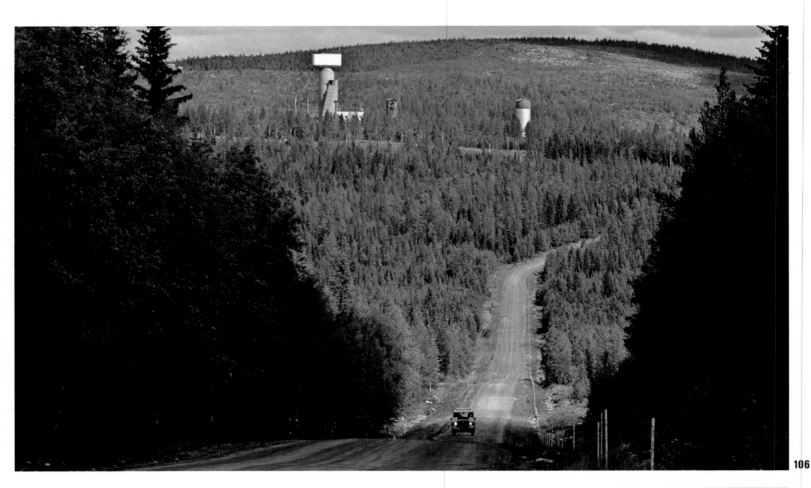

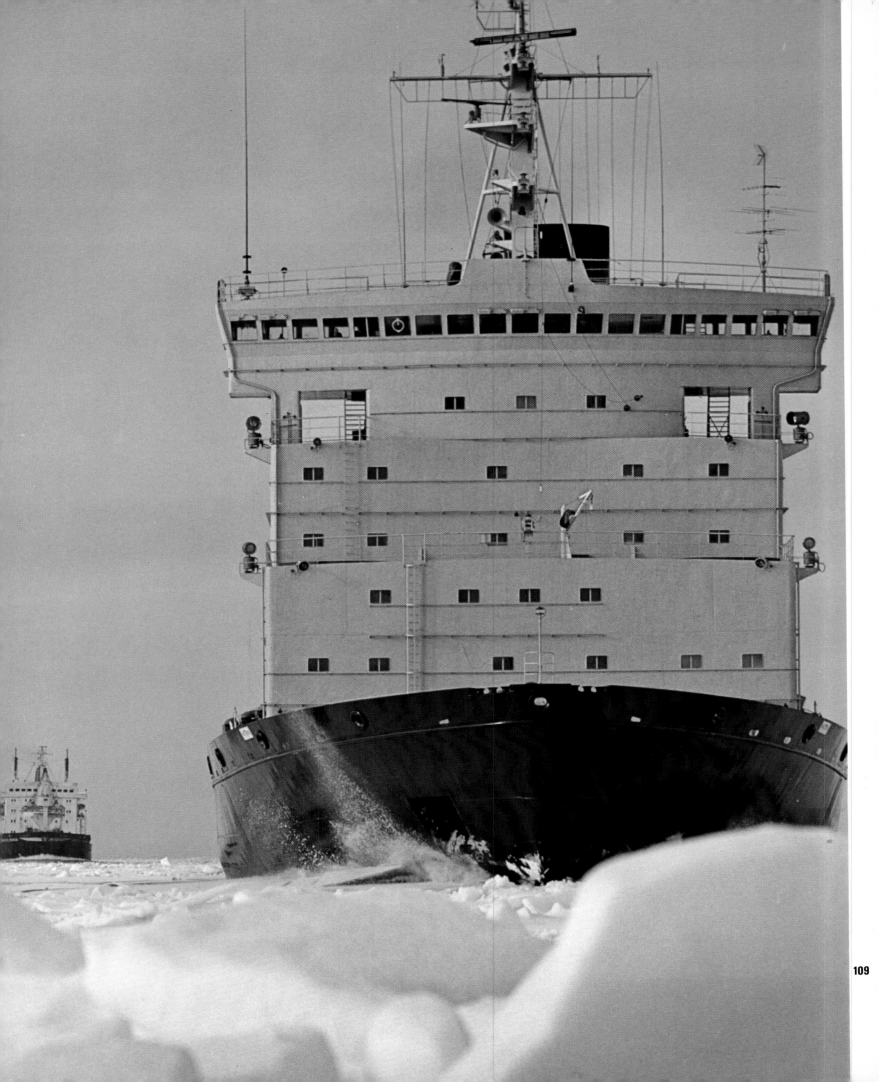

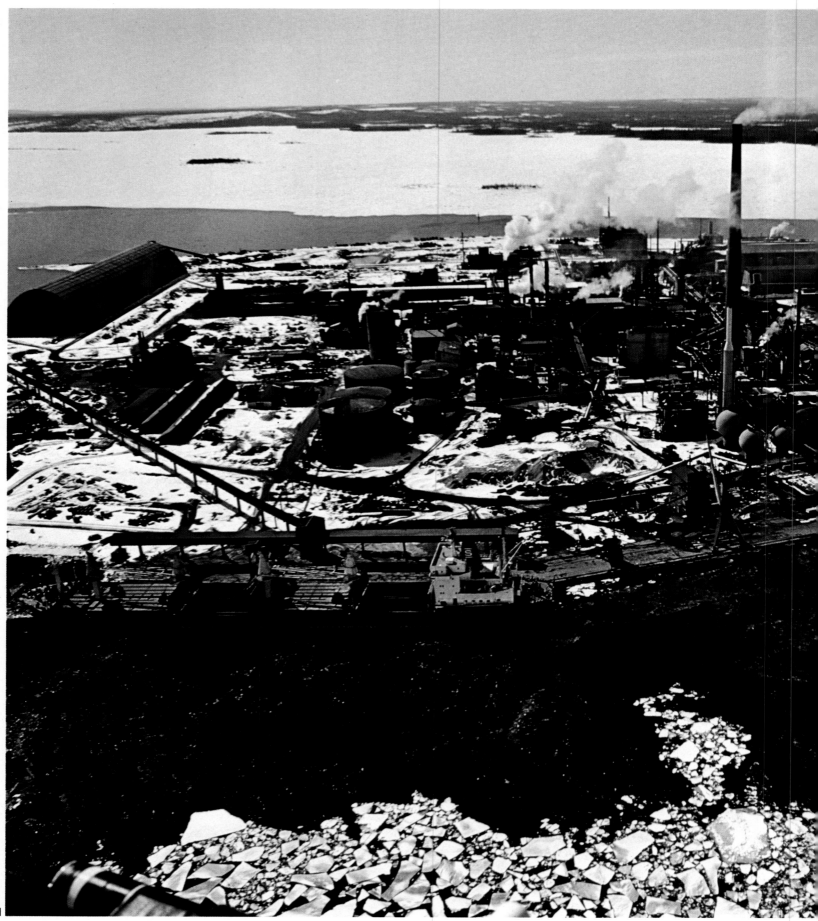

112

113

114

115

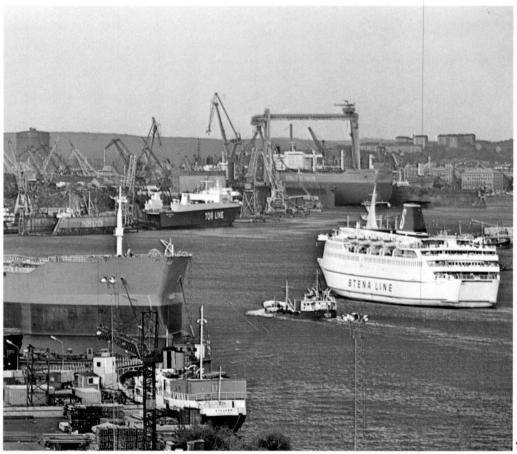

116

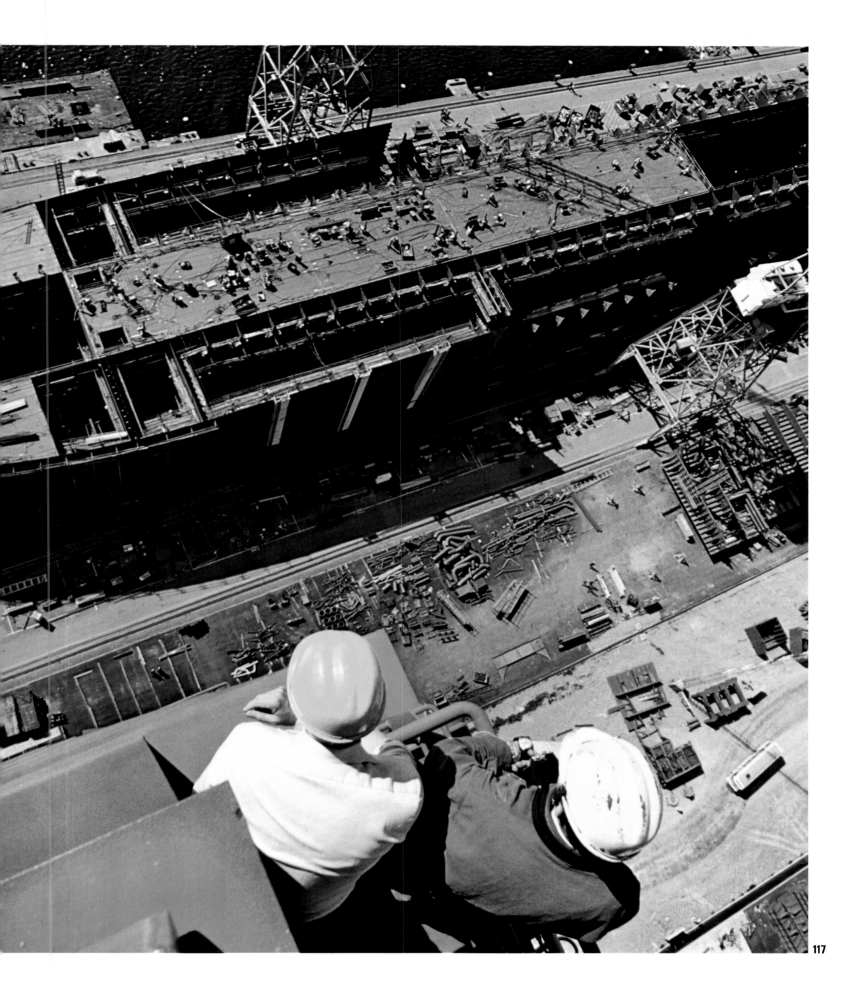

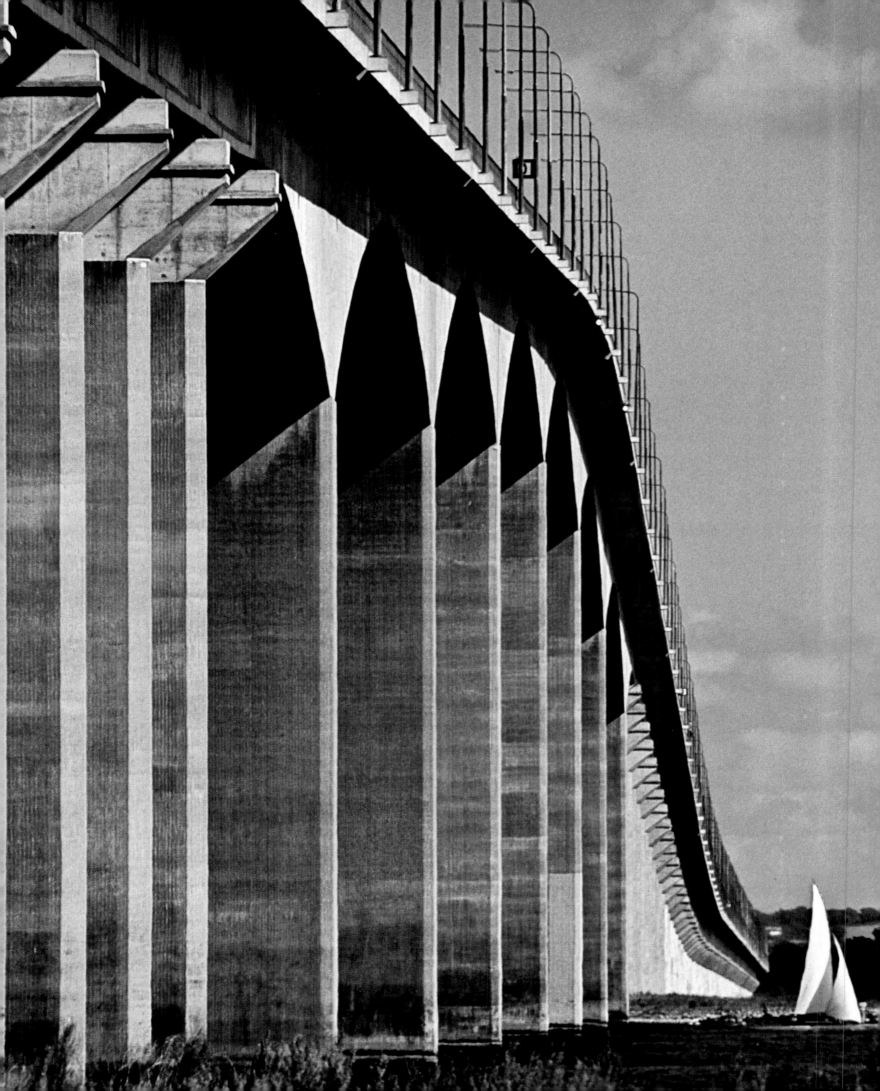

109/110 The Baltic is of fundamental importance as a line of communications for the development and economy of Sweden as well as Finland. In its northern and eastern lobes, however, it can be frozen for several months during the first half of the year, the ice being formed there more readily because of the reduced salt content. Food supplies and the timber economy have long adapted to this predictably prolonged suspension of transport by the establishment of suitable warehousing and processing facilities in the ports. The same applies to ore transport. Since the second world war these facilities have been further extended by smelting works at Luleå and also on the Finnish side. In recent years the employment of very powerful ice-breakers has heralded in a new phase. These now make it possible, even in very severe winters, to ensure all-year-round access to the piers for ore carriers. The ice service, however, is not only a question of power. The indented coastline, the clusters of skerries with their cliffs and countless rocky shallows—difficult to discern in the ice when buoys and booms are covered up—freezing fog and brief periods of daylight all make extreme demands on the navigational skill of the men on the bridge (Plates 109 and 110—the ice breaker Atle and its captain at work in the Bottenvik) and on the reliability of electronic beacons on shore. In the event of shipwreck help in the ice is particularly difficult (see map page 20).

111 In the catchment area of the Skellefteälv there are several important deposits of non-ferrous metals. They have been mined since the beginning of the 20th century in pits often several hundreds of feet deep (see Plates 106 and 107). Dressing and smelting of the ore is largely performed at the metallurgical and chemical works on the island of Rönnskär on the estuary of the Skellefteälv. For a time effluent containing sulphur and arsenic, as well as waste gases, triggered off dangerous environmental problems which have been controlled only by costly technological efforts.

112 Volvo, the Swedish motor manufacturers with their main factory in Göteborg, has not only gained worldwide fame through the quality of its products but has also caused much attention by its forward looking experiments designed to humanize work on the conveyor belt. These include the combination of the most diverse possible operations at one point of the conveyor belt in order to reduce monotony, as well as an extension of breaks during working times.

113 In central Norrland at Sundsvall three major rivers run into the Baltic in close proximity—the Ångermanälv with its big tributary the Faxälv, the Indalsälv and the Ljungan. These rivers not only provided rafting routes from the forest, thereby making the Sundsvall district the biggest concentration of the cellulose industry in the world, but their water power potential has been utilized to 4.7 million kW, providing particularly ample electric power to the Sundsvall district. Small wonder that electro-metallurgy has cashed in on this opportunity. It actually pays to bring in bauxite from the tropics and smelt aluminium from it here. The steaming hot smelting furnaces are arranged in long rows and require only few operators to supervise them.

114 The glass industry only developed in south-east Sweden about the middle of the 18th century, to provide alternative employment following the decline of bog iron ore mining in Småland. It is based to this day on small craft enterprises. Its success is due principally to the high artistic quality of such products as goblets, glasses and chandeliers. Kosta glass and Orrefors glass are justly world famous.

115 Although Sweden is situated on a peninsula its international overland connections play virtually no part compared with traffic across the sea. Many highly important partners can be reached after a very short crossing. In the South-West, in particular, the ferry ports are all close together. One of the most important is Helsingborg (101,685 inhabitants) at the narrowest point of the Öresund. It is linked with Elsinore on the Danish island of Zealand by several lines, some of them exclusively for passengers, as well as by a rail ferry. Some of these ferries operate at 20 minute intervals.

116 Göteborg, only founded in 1621 by Gustav II Adolf (admittedly on the site of several earlier settlements) and nowadays Sweden's second biggest city with 444,600 inhabitants, is Sweden's gateway to the world. Most of Sweden's more than 600 sea-going ships with approximately 7 million gross registered tons have Göteborg as their home port, and many indeed were built there. Göteborg is predominantly an import centre for bulk cargoes such as grain, coal, cotton and, above all, mineral oil. Accordingly it is equipped with mills and refineries. Göteborg is a trans-shipment point for the intensive north-European coastal traffic. It is an export centre for timber, pulp and paper. Göteborg is also a fishing port and the base of ferry connections to Britain, Holland, Denmark and Germany. It is the centre of Swedish oceanological research.

117 The shipyard of Uddevalla is one of the biggest in Sweden, specializing in the construction of large tankers. It is now owned by the state, which had to invest several billion kronor during the hard times of the recession in the seventies— a crisis that greatly affected shipbuilding yards throughout the world.

118 These young visitors to the Taiga Zoo of Lycksele (see Plate 48) demonstrate impressively how comfortably warm the summer can be in Lapland.

119 Construction of the 6 km (4 mile) Öland Bridge at Kalmar had been under discussion for 50 years before it was realized in the seventies. It crosses Kalmar Sound from slightly north of Kalmar to Färjestad on Öland. The desired increase in industrialization and, as a corollary, in population has not been realized. There has indeed been something of a population growth but this is because people working on the mainland have bought homes on the island and now commute. There has, however, been an explosion in tourist traffic. More than a million tourists visit Öland during the summer months, most of them, of course, only for the day by car or bus. During its first year the bridge was used by 3.3 million vehicles.

Agriculture

Only 0.75% of Sweden's territory consists of arable land. That makes 3 million ha (7.5 million acres). In addition there are 375,000 ha (926,625 acres) of cultivated pasture-land and meadows. But only a small amount of the entire acreage is used for grain cultivation. The larger part, more than two-thirds of the area, is given over to fodder growing, especially grass cultivation for hay-making, grazing and green forage (1,000,000 ha = 2.5 million acres under timothy, clover and lucerne). Oats, mixed crops and barley are cultivated on nearly 1.2 million ha (3 million acres). Most of the crop is used as seed for fodder. For cereal growing for human consumption—including part of the barley and oat crop—along with the cultivation of potatoes, beet and rape-seed, there remain less than 1,000,000 ha (2.5 million acres), of which about 100,000 ha (250,000 acres) lie fallow.

However, unit yields are so high—for winter wheat the average over the years 1971–1976 was 4.8 t/ha (1.9 t per acre)—that one hectare can meet the grain requirements of about ten persons (1 acre those of four) since the foreign balance of trade for bread grain and products manufactured from it is almost in equilibrium. Behind these brief data from Swedish agricultural statistics there lies concealed, scarcely perceptible to the layman, a barely imaginable degree of efficiency of Swedish agriculture. This oldest sector of Sweden's economy deserves closer consideration.

It is known that since prehistoric times the same relatively limited parts of Sweden have always been used for agriculture. We are, in fact, on the margin of habitable nature. The demands of nature are stern. Agriculture requires arable soil. The loose layers of earth existing before the Ice Age were effectively scraped away by the massive inland ice. The unsorted (often coarse-grained and boulder-filled) moraines which the inland ice left in its wake are not particularly well-suited to agriculture. But the clays which flowed out with the ice rivers, and which were deposited on the ocean floor and lifted up from the sea as the land rose, became a good agricultural soil. Such deposits also occurred in fresh water after the end of the Ice Age, as well as at later dates. Many of these, admittedly, are too small in area, unfavourably situated or too stony.

In conjunction with the Silurian areas some very fertile calcium-rich moraine clays or deposits with calcium content can be found. What matters, basically, is that they should lie within the area of a sufficiently long vegetative period, that they can be drained to the extent necessary, and that they

should be in an acceptable position with regard to markets. In other words, in addition to the constraints of nature there are also the effects of agricultural technique and profitability to consider—though the latter has not had any great importance until quite recently. It is often believed that agricultural technology can wrest certain favours from nature; but in fact it just as often leads to a narrowing down of opportunities for exploitation—especially when it arises together with the principles of economic viability, as has been the case increasingly for the past few centuries. Applied to the country as a whole, the importance of profitability varies a good deal in the development of the agricultural structure, as far as utilization of potential arable land is concerned. The result has depended on opportunities for agricultural trade—in other words, on transport facilities. For this reason alone relatively self-sufficient farms have managed to survive right into this century.

It is a universal and world-wide characteristic of agriculture in marginal areas, as here in Sweden on the edge of the habitable world, that crop farming is bracketed with livestock breeding or other forms of livelihood such as fishing, forestry, mining, or small crafts. All these combinations have been known in Sweden since earliest times. Even the most modern big farms are based to this day on at least the combination of crop farming and stock breeding. Hence the two-thirds share of fodder crops on tilled soil. Livestock, so to speak, improves the primary agricultural product fodder into a high-grade human foodstuff in a way that is not possible otherwise. Three-quarters of a total harvest is fed to animals. And agriculture derives four-fifths of its income from livestock. Nevertheless, one-third of all farms today are without any livestock.

Fluctuations of livestock populations are principally the result of price changes at a given time. Even so, some long-term trends can be identified. Dairy cattle decreased by 75,000 to a total of 740,000 over the same period—with a simultaneous increase in milk production per cow of between 10% and 15% over the past 15 years. Although meat production plays an important part, store cattle declined from 627,000 to 590,000 head, and calves from 600,000 to 550,000. Up to a point that development has been offset by an increase in the sheep population by 7.5% to 370,000 and, especially, the pig population from 2.07 to 2.45 million. Major fluctuations—between 8.5 and 7.7 million—were recorded for poultry.

Livestock Breeding

207

A century ago more than 70% of the Swedish population were farmers. At the turn of the century this number had shrunk to 55%; in 1940, 35% of all gainfully employed persons were engaged in agriculture. Now this number is scarcely 6%. Machines have taken over the task. This development is clearly reflected in the relationship between horses and farm machinery through different periods. At the beginning of the 1970's there were 600,000 horses in Sweden, but only 5,000 tractors and 250 harvesters. Today, at the end of the 1970's, the number of horses has dropped to 5,000, while there are 182,000 tractors and 50,000 harvesting machines. At the beginning of the 20th century the annual wheat crop reached a maximum of 140,000 tons. Just before the second world war 670,000 tons were produced, nearly five times as much. In 1976 the wheat crop was 1,750,000 tons. Sweden today has an export surplus of grain. The acreage devoted to cereals, however, has not increased greatly since the turn of the century. Then it amounted to about 500,000 ha (1,250,000 acres); now it is only slightly more.

Consequently it is the yield per hectare that has increased. Between 1945 and 1973 the yield from autumn wheat increased from 2.4 to 4.2 tons per hectare. Many factors lie behind that development, factors valid not only for increased wheat production but also for other types of grain. One may point to subsoil drainage and to increasingly effective means of working the soil. Improvements in breeding have produced high-yield varieties, which are more reliable for cultivation, more resistant to winter conditions and produce stiffer straw. Development of improved varieties of seed is estimated to account for 20 to 25% of the increase in production. But, above all, the increased use of artificial fertilizer has augmented crop yields. In 1950 artificial fertilizer worth 200,000,000 kronor was applied, with the result that the increased value of the crop was estimated at 600,000,000 kronor. Its use continues steadily. In 1974 Swedish agriculture imported 750,000,000 kronor's worth of artificial fertilizer. This and a comprehensive and effective chemical campaign against weeds, have been the most important factors. From the mid-sixties to the mid-seventies the number of agricultural enterprises diminished by one-third to 132,000 (1976: 130,955). That process almost exclusively concerned farms with less than 20 ha (50 acres) of land. At the same time the number of farms of more than 30 ha (75 acres) increased by one-third. There were 2,820,000 farms in Sweden in 1951, but only 131,000 in 1976. Small farms have been abandoned, and their

acreage incorporated with the larger ones. These are almost entirely family farms. Admittedly, the high average age of the farming population gives rise to concern—55 years. The extent of the total agriculturally used area (excluding forest grazing) has remained almost constant but has increasingly concentrated on the potentially best soils. The total value of agricultural production (corrected for inflation) rose by nearly 20% between 1955 and 1975. This was achieved hand in hand with a reduction in working hours to one-third (281 million). Thus Swedish agriculture today presents itself as a structurally extraordinarily healthy sector. Its contribution to the gross national product amounts to about 5%. The high standard of Swedish agriculture is no doubt to be explained also by the good training system. For agriculture and horti--culture the grammar schools offer two-year courses, which may be supplemented by practical work, and various specialized courses. Naturally, there is also an Agricultural College. It is located in Ultuna outside Uppsala and there maintains extensive experimental fields and stock-breeding units. It moreover continually conducts nationwide trial programmes throughout Sweden for the purpose of comparing results obtained under different conditions.

As in other industrialized countries, Sweden, too, is faced with the difficult problem of maintaining the efficiency of its agriculture on a sufficiently high level by appropriate political protective measures to ensure that people's food supplies are adequately guaranteed even in an emergency. All measures pursuing such aims are bound, as a matter of principle, to come into conflict in one way or another, often in an unpredictable way, with the interplay of forces in a free market economy. In consequence they trigger off an unending series of state interventions. That may be undesirable but it is unavoidable. It is the price of secure supplies. The present agricultural policy has been fairly consistently *Agricultural Policy* pursued ever since 1947. By means of protected prices and deliberate promotion of rationalization measures in production, on the one hand, and by the extension of social security for the agricultural population, on the other, it is thought that a level of self-sufficiency of 85% was achieved by Sweden for 1970, allowing for annual fluctuations in harvest yields. However, it is now felt that one might be able to reduce that level of self-sufficiency to 80% before 1980. Supportive measures, of course, are regionally differentiated. Particular importance is attached to facilitating an appropriate continuation of living conditions also in northern

Sweden, where natural conditions and remoteness of markets have proved such powerful factors that agriculture has ultimately become no longer feasible.

At the beginning of the 19th century a type of agricultural organization first came into existence on the form of rural-economy associations; in addition to an advisory role, they functioned as co-operatives for the purchase of artificial fertilizer, livestock and equipment. The latter role was taken over by the many farmers' organizations which were formed towards the end of the 19th century. These increasingly took on the character of co-operatives, with the aims of upgrading and marketing the agricultural products. In 1965 they came together in 17 central associations with a common national organization. This amalgamated in 1971 with the Farmers' Union to create a unitary confederation, the Farmers' National Federation *(Lantbrukarnas Riksförbund)*. In addition to the distribution of agricultural products with a suitably weighty influence on price formation the National Federation also participates in training, management and legal advice. Marketing, following increasingly high-grade improvement of agricultural primary products through the National Federation, has reached 99% of total Swedish milk production and 85% of butchers' goods. Swedish agriculture thus represents a powerful agricultural cartel. Without it there would have been an almost unimaginable dramatic decline in agricultural land use in Sweden.

Forestry As, in the course of the present century, agriculture established itself in an independent and strong market position it was able to loosen, and in many respects entirely to dissolve, its traditional links with forestry. Even though an extensive, if very scattered, acreage of forest continues in peasant ownership, these plots are to an ever-increasing extent under forestry management and in timber-economy utilization. Approximately 50% of the area of productive forest is in private hands, 25% belongs to corporations, and the remainder to the public domain, primarily the Crown. Around the turn of the century the large timber and pulp firms bought up a great deal of peasant-owned forest, a fact which has, naturally enough, greatly increased its timber economy efficiency. To an even greater extent and at a markedly faster rate the lumber industry has become mechanized. This applies primarily to the exploitations of large forests. It began with the use of the motor-driven saw which became common in the 1950's. The horse, previously regarded as indispensable for timber collecting and haulage, has, for all practical purposes, been

replaced by the tractor and different vehicles. Other machinery —such as processing machines which trim branches while preparing the trees—have completed the process. These large machines, which are only moved when the need arises, have resulted in huge bare tracts—a conspicuous new element in the landscape. To transport the machines, the lumberjacks and the timber many miles of motor roads have been built through the forests. In just one year, 1975 2,683 km (1,667 miles) of such roads were completed for the forest industry.

In order to achieve better reafforestation the spreading of fertilizer by aircraft has begun. For this purpose no fewer than 369 landing strips existed in 1975. In fact, all new growth within the larger-forest industry is now due to planting. In 1975 this comprised 163,535 ha (404,095 acres).

The number of persons employed in forestry, as a result of far-reaching rationalization, decreased from a total of 120,000 at the beginning of the 1960's to 75,000 in 1972. Of these just under 50,000 were employed full-time. Forest work is no longer part-time employment for small farmers and crofters but all-the-year-round work for specially trained personnel. It is estimated that jobs in the forest industry during the 1970's diminished by half in spite of an increase of 30% in the yield. The effect of rationalization is revealed by the amount of time needed for one cubic metre of cut timber: in 1950 1.1 workdays were needed, as against only 0.18 in 1972. A worker with his mechanized equipment is thus six times more efficient in the modern forest industry.

Formerly, especially in northern Sweden, the larger part of the timber was allowed to float down brooks, streams and rivers to the sawmills and pulp factories on the coast. These, therefore, were generally located in Norrland, at the mouths of the rivers. During the spring floods it was possible, with the aid of dams, to use even the smallest waterways. But there, as well as in the rivers, comprehensive measures were required to allow the timber drift without obstruction. At the end of the 1950's there were no less than 26,000 km (16,000 miles) of such developed waterways in Sweden, and, during the summer months, 40,000 men were engaged in logging work on the rivers, though most of them for just a few weeks. On a big river, like the Ångermanälv—one of the few where logging still takes place—20,000,000 logs per year are floated down. A lot of work was also required at the river mouths. Here were huge facilities occupying large areas, where men and women with long boathooks manipulated the marked logs

into their proper compartments. At the old sorting yard at Sandslån on the Ångermanälv 575 such workers were employed. Following the introduction of fully automatic sorting facilities in the middle of the 1960's it was possible to reduce the workforce to 85. That is why logging still takes place on the Ångermanälv. Elsewhere it has just about ceased to exist. It required too much labour in proportion to present-day wages. A lot of timber sank and was lost; the hydro-electric dams were responsible for areas of stillwater where the logs had to be gathered and towed. Road and rail haulage have replaced this mode of transportation.

Of the commercially useful timber stands about 37% are pine (*Pinus silvestris*), 36% spruce (*Picea abies*) and 10% birch (*Betula verrucosa* and *Betula pubescens*). Pine and spruce wood is particularly suitable as a raw material for cellulose. According to the latest forestry statistics (1968/1972) the average annual increase for the country as a whole is roughly 70 million cubic metres (2.5 billion cubic feet) and the total stands amount to 2.36 billion cubic metres (83.35 billion cubic feet). The annual cut has for the past few years been slightly higher than the natural increase.

In northern Norrland, in the provinces of Norrbotten and in Västerbotten one hectare of forest only produces 1.6 cubic metres of new growth (1 acre produces 17 cubic feet). In southern Norrland the figure is twice that amount, and in Götaland three times. In the South, moreover, there is a considerably higher density of timber stands, as well as better accessibility and closer proximity to markets. That explains why the price of forest land in the South reaches over five times that in the North. The further south one goes the greater also is the proportion of peasant-owned forest.

The forest is not used merely industrially. It is an immeasurable source of recreation. The "common right" entitles every Swede to wander wherever he wishes, regardless of whoever owns the forest, provided that he neither cuts down trees nor injures new growth. Within the crown forests there are large areas set aside for nature reserves with extensive overnight facilities, bathing places, and marked trails for hikers and skiers—all to encourage the outdoor life.

Fisheries Fisheries, too, have been undergoing a continuous structural transformation. Over the past few years total catches fluctuated between 200,000 and 240,000 t with a value of 264 million kronor. About two-thirds of the catch were landed on the Skagerrak coast. The value of the catches has remained

fairly constant. The Baltic catches are clearly, relatively speaking, more profitable because of their high proportion of quality fish such as eel and salmon, of which the weight of the total catch admittedly only reaches 1,300 and 600 t, respectively, per annum. The increasing productivity of labour is due to the employment of effective fishing gear and bigger boats, following the disappearance about a generation ago of the earlier pattern of fishing as a secondary occupation. Since the beginning of the sixties the number of vessels has decreased to less than half, at present slightly over 6,000. At the same time, however, their value has doubled. The number of active fishermen has likewise dropped to about half and now only totals something like 4,600. To meet its fish consumption Sweden's foreign trade provides a surplus of fish imports which are worth double the value of the native catch. The principal suppliers are Denmark and Norway, each with about two-fifths of the total value of fish imports.

Sweden has been a mining country since prehistoric times. *Mining* Iron ore has played the principal part—for about 2,000 years as swamp ore. Extraction in pits, galleries and eventually shafts began during the twelfth century—it was then that iron ore mining proper began to play a vital part in the economic, social and political development of Sweden. Iron was more important than timber. In exports the timber industry only caught up again in the course of the 20th century. But foreign trade statistics do not make for a plausible comparison.

The mining of iron ore and with it the mining of copper at Falun gave rise, in more or less marked imitation of similar processes in Central Europe, to a complex system of laws whose sphere of validity embraced the whole of central Sweden from Småland to Dalarna: *Bergslagen*. That part of Sweden which is today called *Bergslagen* is the former central area extending from eastern Värmland across Västmanland and southern Dalarna.

The immigration of Walloons during the 17th century contributed to the development of new techniques and, in order to protect the already dangerously overtaxed forests, gave rise to a decentralization of smelting and forging plants, in principle in a concentric pattern around the mine. The locations of the present-day high-grade steel works of Hofors (the biggest special steel plant), Sandviken, Surahammar, Fagersta, Avesta, Hällefors, Bofors and Hagfors are due to those measures. Domnarvet, the biggest steelworks, was

built only at the end of the 19th century, when the operation of several of the small concerns of Stora Kopparberg was concentrated there. Nevertheless, by present standards in that sector, output was rather modest. Even 150 years ago Swedish iron ore mining and the associated iron manufacturing industry produced a mere 60,000 to 85,000 t of pig iron and 50,000 to 60,000 t of cast iron a year. More important to industrial development was the initial (until 1875) ban on the export of pig iron in order to be able to upgrade it as much as possible within the country.

In earlier times the iron ore came from a countless number of small central-Swedish mines with high-percentage ores, rich in phosphorus. The phosphorus-rich ore, which was to be found fairly extensively, could not be used—it produced so-called "cold-short" iron—until the basic, Thomas, process came into use at the end of the 19th century. At that time the mines of Grängesberg instantly became the chief iron-ore producers of central Sweden. Part of the ore goes to Domnarvet and part to the Oxelösund steelworks.

The possibility of using phosphorus-rich ore aroused interest in the iron ore resources of Lapland, which had been known about for a long time, and especially those in Gällivare-Malmberget and Kiruna. With the construction of the ore railway from Gällivare to Luleå in 1892, extended in 1902 via Kiruna (Plates 82 and 108) to the permanently ice-free port of Narvik on the Norwegian coast, these iron ore resources were able to be exploited on a full scale. The ore from Gällivare is sent primarily to Luleå for export or refining at the Norrbotten steelworks. The Kiruna ore is exported via Narvik. Information on the size of Sweden's iron ore resources is the object of constant revision—upwards. One can say that they increase with the growing effectiveness of ore technology. With this reservation it is possible to cite statistics for the Lapland ores which vary between 3 and 4 million tons. These are, of course, phosphorus-rich but high-grade (60–70%) iron ores.

Thus the regional centre of gravity of iron ore extraction, always somewhat important in Swedish history, has been shifting further to the North. Whereas from the Iron Age to the Middle Ages it was essentially based on the swamp ores of Småland, *Bergslagen* assumed the leading role in the late Middle Ages. In the 20th century Lapland has now moved into first place, by a considerable margin; it accounts for more than three-quarters of Sweden's annual extraction which now totals over 31 million tonnes (1975).

Mining of non-ferrous ores has similarly shifted its emphasis northwards. The copper ore deposits of Falun rightly enjoyed world-wide fame. Since the second half of the eleventh century they have supplied something like 400,000 t of copper. During the 17th century they produced a maximum of 3,000 tons per annum. It is commonly believed that the Falun deposits are exhausted but this is far from being the case. Ore is mined there even today. A few years ago a new concrete pithead tower was erected. The amount of copper, admittedly, is not very great: about 2,000 tons, with 15% copper concentrate per annum. But six times that amount of zinc and lead, as well as 60,000 tons of sulphur ore concentrate are extracted. For more than 900 years the Falun mine has been an active place of work,—a kind of world record. From the old heaps of weathered iron pyrites, the so-called *rödmull,* Falun raddle or red ochre dye, is made—an inexpensive and effective timber preservative. That is why most houses in the countryside are painted red, a fact which surprises foreigners.

The silver mine at Sala "Sweden's national treasure chest", had been exploited for more than 400 years when it was closed down in 1920. In 1947 new ore-bearing veins were discovered and for a few years the mine actually yielded more silver than during the time of Gustav Vasa. Now, however, its operation seems to have come to an end for good. In the middle of the 1920's the systematic search by geologists resulted in the discovery of a new extensive and complex group of deposits. This is now Sweden's third biggest ore district, to both sides of the Skellefteälv. From a string of small mines various (predominantly sulphite) ores are being extracted with copper (Plate 106), zinc, silver, gold, lead, nickel and arsenic, and these are for the most part smelted at Rönnskär outside Skellefteälv (Plate 111). Non-ferrous metal production fluctuates between 500,000 and 700,000 t from year to year.

Sweden is not blessed with fossil fuels such as coal, oil or natural gas, and nowadays depends on importing its entire requirements. The demand for firewood, charcoal and peat, of course, can easily be met from domestic resources. Such important primary building materials as clay, gravel and limestone are available in adequate quantities, though unevenly distributed. The cement industry, in particular, which finds itself confined to the south-eastern periphery (Gotland) and to the limestone area (the *Falbygd*) between Lakes Väner and Vätter is appreciably affected by transport problems.

Energy

215

Geographical discrepancies also make the utilization of water power potentials for the generation of electricity a costly business. The main demand is in the southern third of the country while the main resources are in the North. About two-thirds of the total potential of over 20 million kW have been developed, about 80% of these in Norrland, mainly on the Rivers Luleälv, Skellefteälv, Umeälv, Ångermanälv, Faxälv, Indalsälv, Ljungan and Ljusnan, and on the southern edge of Norrland on the banks of the Dalälv. No other Swedish river, not even the Klarälv or the Götaälv, matches the performance of any of the above. This has made it necessary for a number of roughly 1,000 km long high-voltage transmission lines of up to 400 kV to straddle the country from North to South, and in the southern third of the country, along the coast, for several thermal power stations to be operated to equalize peak demand. Hydro-electric power stations, moreover, have their lowest efficiency in winter, just when energy demand is highest. Thermal power stations already account for more than one-quarter of all power generation in Sweden. Their proportion is rapidly growing, mainly as a result of the speedy construction of large nuclear power stations. Although their capacity in 1975 still only amounted to one-third of the capacity of conventional thermal power stations, they were able to supply 10% more current than the conventional ones. Their superiority is beyond dispute. The first went into operation in 1972. Nuclear power stations are the subject of lively controversy, and the question of whether those already built should be used, and, if so, how many of them, led to a government crisis in the autumn of 1978. It now seems that the maximum number will be 11.

Consumption of electric energy has been doubled in Sweden over each of the past few decades. Sweden's favourable supply situations thanks to its native water power does not by any means make it immune to the energy crisis. Imports of mineral oil, admittedly, have not appreciably changed for some years in terms of quantity—about 30 million t—but their price trebled between 1970 and 1975. Three-fifths of those imports, incidentally, consist of finished products which can be distributed direct to many ports in relatively small tankers, which in consequence reduces the need for inland transport. Over 35% of mineral oils are used for heating purposes, just short of 30% for industrial production, and just short of 25% in transport. To date there are four oil refineries in Sweden. Three of them are on the west coast in Göteborg and Bohuslän and can be approached by tankers

of up to 200,000 t. The fourth is situated at Nynäshamn, south of Stockholm, approachable only by tankers of up to a maximum of 100,000 t.

In central Sweden there is Silurian oil shale. This was used during the second world war, partly by way of underground gasification. However, it was not economic and production was halted in 1961. Since, however, that deposit contains 250,000–300,000 t of uranium it remains of future interest. Uranium has also been found in northern Sweden but the largest deposits are around Billingen in the *Falbygd*.

Industry

Sweden's assortment of resources clearly determined the country's industrial development. Until the end of the 19th century the foodstuffs and glass industry retained its predominantly craft aspects. Things were similar at that time in shipbuilding. This was based on the carpenters' skill and was pursued at minute shipyards along the southern part of the east coast and along the southern coast; the small fast schooners built there became famous as manoeuvrable sailing ships.

Metal Processing

The first beginnings of industrial method were in metal production—as early as the 17th century—and subsequently, with a slight delay, in metal processing. These at first gained Sweden an important position in foreign trade. After all, about the middle of the 18th century Sweden was producing 40% of the world's iron ore. In the smelting and processing of iron and special steel into castings and forgings Sweden, in terms of quality, has maintained a leading position among all industrialized countries to this day. On this basis a broad spectrum of metal-processing industries developed in the course of the 20th century, from cutting tools through mining equipment, electric machinery, timber processing and textile machinery to vehicle and shipbuilding (now almost exclusively on the west coast) and precision parts such as ball-bearings.

The share of metal goods production in the value of Sweden's total industrial production has increased since the beginning of this century from 9% to 39% = 75 billion Swedish kronor (1975). There are also a number of large-scale enterprises in this sector. Three of Sweden's shipbuilding yards are among the world's biggest. At the present time, in 1978, the shipbuilding industry is going through a world-wide crisis, and the Swedish yards are now—with state aid, the subject of radical consolidation measures.

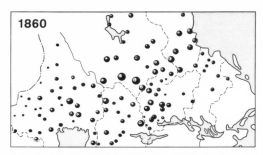

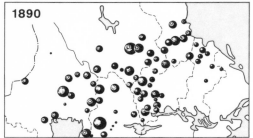

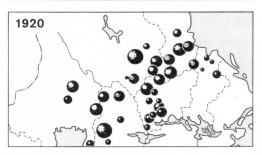

Concentration of ferrous metallurgy locations in Central Sweden between the middle of the 19th and the middle of the 20th century (acc. to W. William-Olsson, 1946).

Some 45% (= 305,000) of all persons employed in industry and mining are engaged in metal-processing. This upswing owes a great deal to a number of outstanding inventors. Gustav de Laval (1845–1913) constructed a new type of steam turbine and revolutionized milk processing by his separator. In telecommunications the name of L.M. Ericsson (1846–1926) occupies a place of honour. J. Wenström's (1855–1893) invention of three-phase alternating current has alone made it possible to transmit electric energy over great distances economically. G. Dalén (1869–1937) received the Nobel Prize in 1912 for his development of automatic beacons for navigation. S. Wingquist (1876–1953) succeeded in constructing self-adjusting ball-bearings.

Although a cotton mill existed at Alingsås, north-east of Göteborg, as early as 1730, that industry only began to be gradually developed following Napoleon's continental blockade. In time this industry provided employment for a great number of workers and found its most important centres in Norrköping on the east coast and around Borås in the region of Västergötland's *Sjuhäradsbyg*. In this region the development of the clothing industry created a very one-sided and particular industrial environment. The textile and clothing industry has suffered seriously from competition from low-wage nations and has therefore experienced considerable setbacks during the last decade. Measured against the background of the metal industry and ore mining the timber industry is surprisingly recent. Not until the middle of the 19th century, when forests in the British Isles, especially Scotland, had been finally destroyed and when mining, industry and urban construction in Western and Central Europe were triggering-off an ever-increasing demand for timber, did capital in the industrialized states turn towards the forest regions of northern Europe. In rapid succession the country was overrun by hundreds of steam-driven sawmills. For some provinces that boom came at the right moment to offer a new opportunity of livelihood for the alarming surplus of the rural population. In Värmland, where the mines and forges were just then dying on a major scale, the transition to the timber industry was not accomplished on the same adequate scale. That was why, in the last century, several thousand people from that region had to seek new opportunities in North America. Some, however, were content to move to the sawmill districts of Norrland.

Ever since, the Swedish timber industry has been marked by violent dynamics. The building of the railways introduced

a new yardstick of the value of a location. In some areas the natural increase of the forests did not keep up with demand. Finland appeared as a serious competitor in the international market. The first world war abruptly dislocated foreign trade relations. Then followed the depression of the thirties, and once more war. This was followed by yet another revaluation of locations through the rapidly increasing role of road transport.

Timber meanwhile had also found new uses. The cellulose and paper industry, and also furniture, timber products, timber goods and prefabricated housing manufacture had all opened up exceedingly important forward processing opportunities for the raw material timber and given rise to new and important industrial locations. The coastal area around Sundsvall has grown into the world's biggest timber industry centre. It is supplied not only with rafted timber from the closely adjacent estuary of the Ångermanälv, but also by marine rafts from more distant river areas and right across the Gulf of Bothnia from Finland. And, of course, a large part of the timber is carried by truck. A second concentration of the pulp industry is to be found in Värmland, where the big pulp factory of the Uddeholm Corporation in Skogshall stands at the spot where the Klarälv flows into Lake Väner. The co-operatives of forest proprietors own large pulp factories and sawmills on the southern Swedish coasts, in northern Halland, Blekinge and on the coast of Småland.

In the past the paper industry was located primarily in southern Sweden. Klippan in Skåne and Lessebo in Småland are among the oldest factories. A certain concentration is to be found along Lake Väner and on the Göta älv. In recent times paper manufacturing has been largely integrated with pulp production in Norrland (Modo, Iggesund). The rest of the wood-processing industry is scattered over the whole country, although there is a clear concentration in Småland. The following comparative figures for 1975 may be helpful for a proper assessment of one of Sweden's most important industrial sectors:

Industry	Enterprises	Employed	Value of output mill. kronor	Added value mill. kronor
Foodstuffs	1,227	72,076	25,239	8,654
Textiles and leather	1,218	57,066	6,959	3,579
Timber products and furniture	2,152	86,758	14,278	6,386
Cellulose and paper	1,205	104,145	26,148	13,069
Mining	167	15,023	3,309	2,349
Metallurgy	188	70,702	16,489	6,037
Engineering and vehicles	4,558	436,587	74,950	38,784

Transport Although Sweden is situated on one of Europe's great peninsulas its land bridge to the continent—in contrast, for instance, to the Appenine Peninsula—is so remote that it scarcely plays an appreciable part. In other words, Sweden is virtually an island in terms of transport geography. During the early post-glacial period that situation had very obvious consequences for nature itself since the land bridge in the far North was then still covered by inland ice and its eastern forefield remained covered for several thousand years by the predecessors of the Baltic (see p. 55). At certain times the situation was actually reversed—when the present Danish Straits, the Belt, was dry land and the southern Swedish uplands (Småland) were a peninsula of central Europe. But that former link was no use to man. He only arrived on the scene later. And by then he could only approach across the sea. His ability to cross the Kattegat, the Belt and the Baltic runs like a red thread through Sweden's entire history (see p. 67). Immigration, expansion towards the North and East, and again towards the South, the great-power period and Sweden's present-day economy would be inconceivable without mastery of the surrounding area.

Navigation There is good reason, therefore, why navigation is assigned such a prominent position compared with all other forms of transport in Sweden that the official statistics treat it in a section of its own. It is also significant that all movements of ships in Swedish ports are covered, down to small vessels of only 20 t capacity. This makes allowance for the great importance of coastal shipping which, by way of the Södertälje Canal and the Hammarby Channel, includes the Mälar and, via the Götaälv and the Trollhättan Canal, Lake Väner. The through link between Skagerrak and the Baltic by way of the Göta Canal, however, is nowadays used almost exclusively by leisure craft. Nevertheless, shipping is able to reach nearly all the important towns and a major part of the industrial locations. In consequence, about 15% of the annual transshipment total of sea-going vessels in Swedish ports, a total of well over 100 million tonnes, is accounted for by inland traffic. Railways and road haulage of goods each carry only just five times that quantity, 61 and 69 million tonnes respectively (1975), but these figures include foreign trade cargoes. This means that coastwise transport appreciably relieves inland transport, even though the Bothnian coast is closed in winter for weeks or even months through ice blockages.

With a transhipment of more than 17 million tonnes and 35,000 ship movements per year Göteborg clearly heads the list of all Swedish sea ports. But only one-quarter of that turnover is accounted for by exports. The ratio is similar for Stockholm, Malmö, Norrköping and Nynäshamn—each with a total of about 3 million tonnes. The imbalance arises principally through mineral oil imports. The opposite picture is presented by the ore export ports of Luleå (10 million t, of which 8.6 million t are exports) and Oxelösund (4.3 million t of which 2 million t are exports). In both instances industry, locally and in the hinterland, together with the types of ships predominant there, trigger off an appreciable import of solid fuels, mainly coke, from Poland. These imports (2.4 million t) also play a part at Gävle for the requirements of the steelworks in the hinterland (see map p. 218) Sweden's biggest export harbour lies in Norway. It is Narvik, the port of shipment for iron from Kiruna. The remaining Bothnian ports of Norrland enjoy a relatively modest and almost balanced traffic: Sundsvall 717,000 t against 769,000 t, Umeå 333,000 t against 548,000 t, Skellefteå 324,000 t against 290,000 t and Örnsköldsvik 297,000 t against 268,000 t (in all cases unloadings against loadings in 1974). By comparison the Mälar ports show a very different pattern: Västerås 551,000 t against 303,000 t, Köping 327,000 t against 172,000 t and Karlstad on Lake Väner 60,000 t against 342,000 t.

As a result of its insular position and its traditionally brisk trade relations with its opposite coasts, especially Denmark, Germany and Finland, Sweden's ferry traffic attained overwhelming importance. It now mainly serves the road haulage of goods. This is true even for the three railway ferries Helsingborg–Elsinore, Malmö–Copenhagen and Trelleborg–Sassnitz. There is no rail ferry to Finland because the Finnish rail system uses the Russian wide-gauge track. By far the most important ferry ports are Helsingborg (turnover of ferried goods 1975: 3.376 million t of a total turnover of 6.7 million t) and Trelleborg (3.698 million t of 4.1 million t total turnover). Only by the construction of the rail ferry to Sassnitz in 1909 did Trelleborg emerge from the quiet life of a little-known fishing village; however, since the end of the second world war traffic to Sassnitz has shrunk to insignificance. The biggest part of what is left is accounted for by transit to West Berlin. At the same time, the Trelleborg–Travemünde link is experiencing an extraordinary boom. A certain increased activity through container traffic has lately come

from the preference given to Göteborg for marine mixed cargo from the German Democratic Republic and a few other CMEA countries.

Merchant Fleet The Swedish merchant navy has been rapidly enlarged since the early sixties, from about 4 million to roughly 7 million gross registered tons. As part of that modernization process the number of ships over 100 grt has been reduced from about 1,000 to 600. Half the ships—all over 10,000 grt—are less than 10 years old. In 1974 the turnover of the merchant fleet was 7.5 billion Swedish kronor. This figure decreased by a few hundred millions at the end of the 1970's due to the economic recession.

Railways and Roads Sweden's rail network was the prerequisite of the modern industrialization and urbanization of those parts of the country which could not be reached by shipping. In competition with road haulage of goods and passenger air traffic it is now shrinking to a "healthy" level. Before the second world war a large number of private railways existed side by side with the state-controlled railway network. In 1939 Parliament decided that, in principle, all railways should be nationalized, and this was essentially accomplished in the mid-fifties. As rail operations were rationalized most of the unprofitable sectors were closed down. Stripped railway tracks and empty stations are now a common sight. Of the "unprofitable" services only those of cultural importance remain. Rationalization means that rail traffic is concentrated on main lines and that trains no longer stop at small stations. In 1976 the combined length of all lines was 12,000 km (7,500 miles). In 1938, at its height, the network embraced 16,866 km (10,480 miles). Competition from road haulage and air traffic is keen, both for freight and for passengers.

The length of the public road network, outside built-up areas, in 1977 was eight times that of the railways, or 97,000 km (60,000 miles). Some 98% of the national highways and 53% of the district roads are surfaced. Only 715 km (444 miles) have been upgraded into motorways. In addition to the public roads there are 65,000 km (40,000 miles) of private roads, constructed and maintained with state subsidies, which means that they are open to public traffic. The number of private motor cars, trucks and buses was slightly over 3,000,000 in 1976. In 1977 there were 4,326,320 licensed drivers in the country. Every year 150,000 driving licences are issued on an average, 40% of them to women. At the same time between 11,000 and

222

15,000 driving licences are withdrawn annually, predominantly for dangerous driving. Driving under the influence of alcohol results in the mandatory withdrawal of the licence. Only 6% of these withdrawals affected women.

Air Travel

It is interesting that for the past 10 years or so the railways have been capturing a better share of the passenger market. The number of travellers rose from 59 million in 1967 to 81 million in 1975 and utilization of seating capacity rose from 30 to 37.4%. Over the same period, the average length of journeys declined by more than 10%. Long journeys are being increasingly taken over by air travel. The performance of domestic civil aviation over the same period (1965–1976) more than trebled from 303,000 to 925,000 passenger kilometres (190,000 to 580,000 passenger miles). Regular scheduled services use 28 airports, with a passenger frequency ranging widely from a few thousand passengers to that of Stockholm's large international airport of Arlanda which clocked up 2.7 million passengers out of a total of 6.7 million for all Swedish scheduled-service airports together. Nevertheless, in the intercontinental traffic of the Nordic countries Arlanda cannot compare with the leading position of that aerial crossroads airport of Copenhagen.

Tourism

Sweden's economic standard and the accustomed unrestricted openness of trade in all directions well support that fondness of travel which—as history teaches—beckoned even the remote ancestors of the Swedes to foreign parts. One needs a change of scene, even if one merely swops appartments with friends or even with strangers on the basis of a newspaper advertisement. The coast and the skerries are the favourite destinations. To the Swedes bathing and vacation are synonymous. Many, though, also travel to the mountains or to the woods of Norrland. Forests with tempting opportunities for hikers exist in most provinces. A large percentage of Swedes have a summer home or cabin, often a former farmhouse. They either own or rent it. This is not viewed as a luxury. There are thousands of cabins available for rent on a weekly basis or for longer periods, providing opportunities for winter sports or summer vacations.

Most families own a car and this is very much in use during vacation times, sometimes with a caravan trailer, unless one packs a tent. Swedish camping grounds have a yearly total of 6 million overnight stays. Hostels, which likewise benefit the mobile type of summer life, provided 555,000 overnight

223

lodgings in 1977. Some 80% of the guests at these hostels were travelling by car.

Summer in Sweden is beautiful—for the most part, and provided it does not rain in July, the vacation month for industry. Many Swedes prefer a simple remote life in the country, in cosy surroundings and with a measure of comfort. Sweden has none of those centres of mass tourism with their typical palatial hotels, promenades, fashionable shops, spa parks, and such-like. There are no "lidos" or beaches with their innumerable fees. Such a situation would be incompatible with the rights of the general public. Here one can bathe wherever one wants, on the sandy beaches or from the gently sculptured cliffs of the skerries. Seaside resorts and watering places used to provide the usual summer pleasures for the upper classes in the old days, but not much of this remains today. Medevi on the northern end of Lake Vätter is possibly a miniature museum survival of a feudal life-style around one of a few mineral springs. The primal rock in Sweden's subsoil no longer lets any thermal springs well up.

At best a sporting fixture or a folklore event may give rise to special tourist centres, particularly in Dalarna. Foreign tourists in Sweden are well aware of that and glad of it; indeed that is just what they seek.

Sweden's balance of payment for tourism is negative. Swedes carry about three times as much out of the country as strangers bring in. An exceptional part is played by aerial package deals, chiefly to the sunny shores of the Mediterranean and to the Canary Islands during the winter season. The Swedes have always been hungry for sunshine. They do not stint themselves when it comes to appeasing that hunger, and they are fond of choosing a different destination each year in order to appease their nostalgia for distant lands and in order to see something and learn something of life elsewhere. That motivation as a rule is more important than superficial entertainment. About one Swede in ten takes part in a group or charter flight each year. Nearly half of them go to Spain and its islands. Greece, the next most popular destination, has still not reached even one-quarter of the Swedish visitors to Spain. Foreign impressions both satisfy and stimulate the open-mindedness of the Swedes. They feel that at home they are among fellow citizens and abroad among fellow humans.